CARAVAGGIO

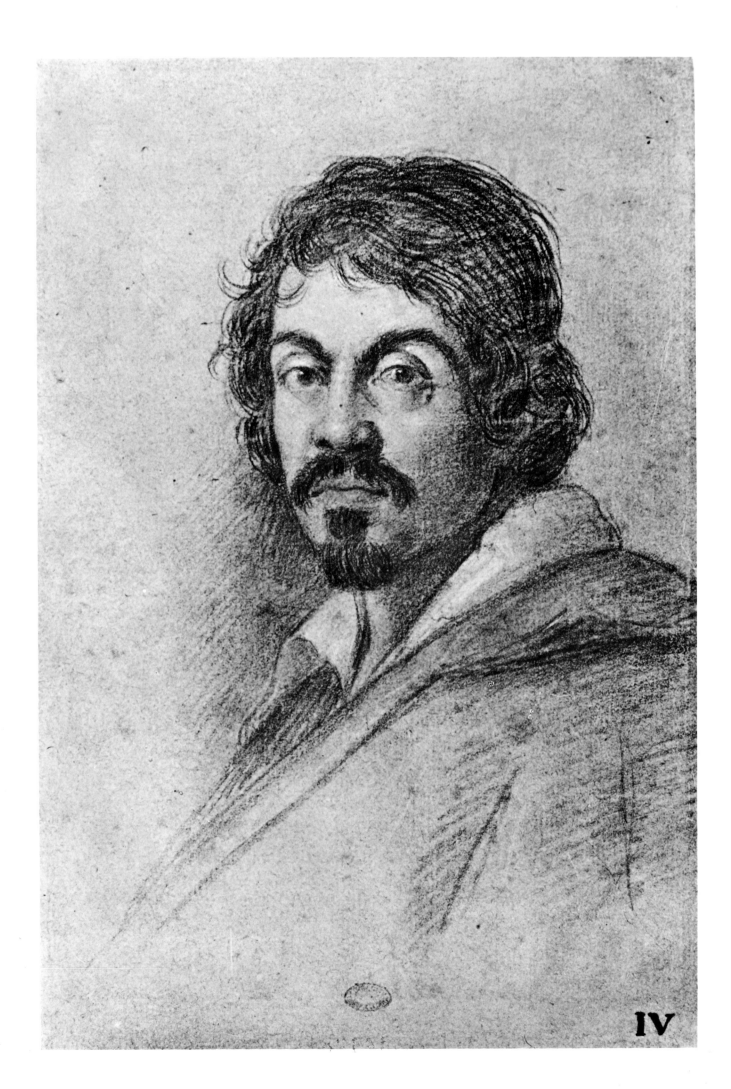

IV

JOHN GASH

CARAVAGGIO

JUPITER BOOKS *Publishers*

(*frontispiece*)
Ottavio LEONI
Portrait drawing of Caravaggio
Florence, Biblioteca Marucelliana

ACKNOWLEDGEMENTS

I would like to thank the following for their assistance and advice on a number of matters:—Professor Lionel Butler; Isa Cochrane; Professor C. H. Gimingham; Antony Griffiths; Dr David Mannings; Mrs Stella Mary Newton; Miss Joyce Plesters; the late Benedict Nicolson; Homan Potterton; Dr Wolfgang Prohaska; Dr E. Schleier; Ann Whyte; Christopher Wright; Z. Baranski and Donal Byrne.

To My Parents and Annie

First Published in Great Britain by

JUPITER BOOKS (LONDON) LIMITED, 167 Hermitage Road, London N4 1LZ.

ISBN 0 906379 40 7

This book was produced in Yugoslavia

CARAVAGGIO

THAT CARAVAGGIO'S ACHIEVEMENT as an artist in Rome, Naples, Malta and Sicily at the turn of the sixteenth and seventeenth centuries is now well recognized is in great part due to the pioneering researches of a small band of dedicated scholars, including Roberto Longhi and Denis Mahon, whose systematic and frequently brilliant work on matters of attribution has led, during the past seventy years, to the establishment, out of a tiny corpus of definite works and a whole sea of misattributions, of a substantial and still expanding *œuvre*. Works previously thought to be copies of lost originals form one of the most significant categories of newly 'discovered' paintings, and their recovery owes as much to modern techniques of cleaning and restoration as it does to the discerning eyes of connoisseurs. This scientific partnership in fact extends to nearly the whole range of Caravaggio's paintings, many of which have by now been stripped, restored and X-rayed. Cleaned paintings obviously provide the connoisseur with a more accurate idea of the artist's technique and 'handling', but the process of restoration has also provided restorers with invaluable technical information which has enabled them to contribute successfully to the subsequent identification of original works. It seems possible that certain outstanding problems of attribution and perhaps even some of dating will be resolved in the future by such an alliance of expertise.

We now possess, therefore, what we did not have earlier in the century, a significant body of paintings, uncluttered by later Caravaggesque additions (fig. 1), from which to analyze Caravaggio's achievement. The arduous activity of attribution over a lengthy period has already prompted some cogent definitions of his style, but the area of definition has also been both extended and deepened by means of stylistic comparison. Many modern scholars have endeavoured to characterize Caravaggio's art by stressing its qualities of direct, realistic observation and dramatic *chiaroscuro* which separate it both from the retrospective classicism of Annibale Carracci's mature Roman style (figs. 2 and 3), inspired by the High Renaissance, and the residual Mannerism of the Cavaliere d'Arpino's work (fig. 4). It has, however, also been recognized that most of the better artists of the late sixteenth century, including Caravaggio, Annibale and d'Arpino, were, in differing degrees, motivated by a similar desire to supplant the highly artificial artistic canons of late Mannerism with some new blend of observation and stylization.

An equally necessary activity is the plotting of specific influences from the art of the past which can be shown to have contributed directly towards the formation of an artist's style. This has been done in the case of Caravaggio, with exemplary skill and thoroughness, notably by Walter Friedlaender, who, while exploring other kinds of formative influence such as the religious background of the period and the idealized art of the High Renaissance, also shows how fundamentally indebted Caravaggio was to Lombard and north Italian traditions, which had always tended to prefer realistic detail and dramatic effects of light to the more abstract conventions of sixteenth-century central Italian art.

The precise relevance of an artistic 'source' to the work or artist apparently manifesting the 'influence' is, however, often difficult to determine. When Caravaggio culled the figures of the recumbent saint and the alarmed acolyte from Titian's famous *Martyrdom of St. Peter Martyr* (fig. 5) for inclusion in his own *Martyrdom of St. Matthew* (Plate III) what exactly was his intention? Did he mean merely to 'quote' the Venetian master in a way which had become immensely popular among the culturally conscious, allusive artists of the *Maniera*, in order to display his own artistic literacy and perhaps also to provoke a comparison between himself and Titian? Or did he simply find the poses convincing ones for his subject, after all very close to Titian's, and seek to reproduce them for expressive purposes? Furthermore, if either or both of these reasons played some part in his thought processes, what does that tell us about his relationship to Titian, given that the rest of Caravaggio's *Martyrdom* is demonstrably different from what we know of Titian's *Martyrdom* in its composition, lighting and formal rhythms?

Similar problems arise when the supposed derivation has to do with an artist's broad sympathy for another artist's approach, rather than with matters of specific borrowing. It is, for example, easy to accept on one level the evidence so well presented by Longhi and Friedlaender concerning the influence on Caravaggio of the Cremonese painter, Antonio Campi, whose combination of bold *chiaroscuro*, compact figure groupings and realistically observed facial types seems very notably to anticipate Caravaggio's own later method. Some impor-

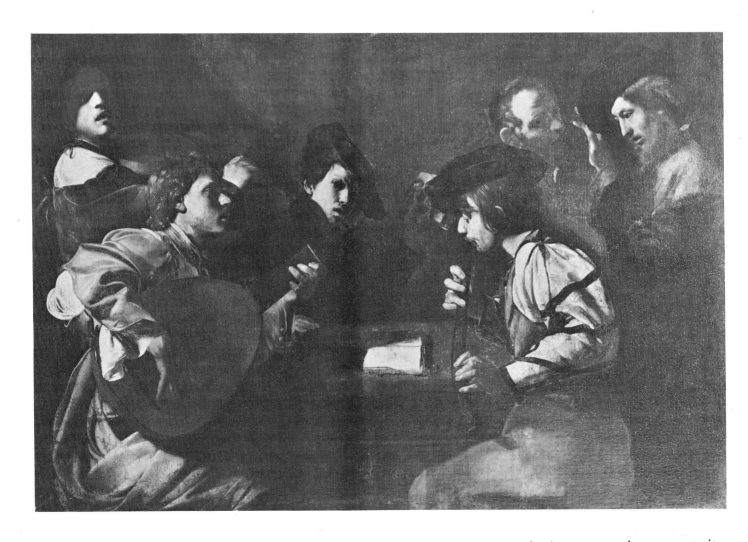

fig. 1 Bartolommeo MANFREDI
The Concert Party
Florence, Galleria degli Uffizi. c. 1616. Canvas
130 × 189·5 cm.

From the late seventeenth century to the
twentieth century *The Concert Party* was
attributed to Caravaggio. Longhi then correctly
re-attributed it to Manfredi on the basis of an
inscribed engraving in Teniers's *Theatrum
Pictorium* of its pendant picture, *The Card-
sharpers*, also in the Uffizi. Such long-term
critical confusion indicates how comparatively
ignorant people were of Caravaggio's *oeuvre*
from an early date and also how they tended
to identify him with low-life genre scenes, of
which, in fact, he executed very few. Manfredi
himself was the real influence behind the
adoption of such subjects by the second-
generation Caravaggesque painters.

shade as a metaphor for human emotion seems quite
probable, but it has to be recognized, as Friedlaender
suggested, that Campi's paintings were themselves pro-
ducts of a revival of interest in the dark, expressive
manner which, deriving ultimately from the theories of
Leonardo da Vinci, had been popular in Lombardy in
the first half of the sixteenth century. It would appear
that, possibly through the agency of Campi, possibly
through his admiration for a work or works by one of
the earlier Lombard exponents of 'black' painting,
Caravaggio became conscious of a whole tradition of
darkly dramatic but realistic religious art which in-
cluded Leonardo, Savoldo, Romanino and Moretto and
which stood in marked contrast to the pale colours and
artificial poses of more recent Mannerist works. Further-
more, there was a delay of several years after he left
northern Italy in the early 1590s before he actually
began to explore systematically the effects of *chiaroscuro*
in his own art, by which time, it is arguable, Caravaggio
could only have recalled the basic 'schema' of Campi's
paintings, especially as he does not seem to have kept
drawings. He had in the meantime become in-
creasingly aware in Rome of the refined, monumental
but still natural poses and figure groups of High
Renaissance classicism. And it might be felt that the
combination in his work of realistic detail, poetic
chiaroscuro and dramatically articulated gestures owes

tant works by Campi in this style were painted in
Cremona in the 1560s, but he revived it with particular
vigour in certain altarpieces, such as *The Beheading of
John the Baptist* (fig. 6), which he executed in Milan
during the 1580s, around the time when Caravaggio
was being apprenticed there to Campi's more con-
servative and 'Mannerist' colleague, Peterzano. That
such works opened Caravaggio's eyes to the possibility
of a veristic style which uses strong contrasts of light and

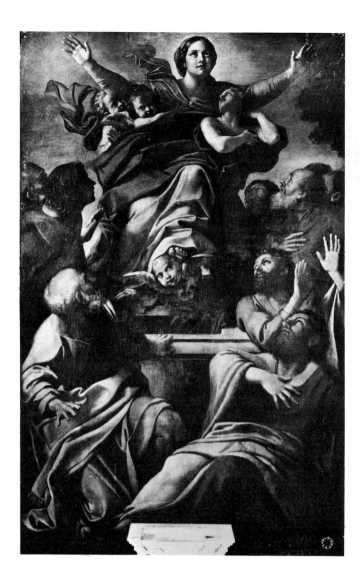

fig. 2 Annibale CARRACCI
The Assumption of the Virgin
Rome, Church of Santa Maria del Popolo,
Cerasi Chapel. c. 1600/01. Panel
245 × 155 cm.

considerably more to Caravaggio's own imaginative re-interpretation of the art of the High Renaissance than it does to a close scrutiny of Campi's paintings. It would, indeed, be difficult to argue that Antonio Campi acted as anything other than a catalyst to Caravaggio's more powerful and sophisticated imagination.

A borrowed pose or system of lighting, even an analogous mood, are in themselves ambiguous pieces of information which usually tell us more about the artistic vocabulary available in any historical period than they do about the particular and, indeed, unique manner in which the language is used by an artist of genius. Of course, the fact that Caravaggio by and large rejected one language system, Mannerism, in favour of the more natural language of another tradition tells us a great deal about his preferences. But the fragments of raw material out of which he constructed his own means of expression should not be thought of, except in the most tangential sense, as an *explanation* of his art. Such bor-

rowings and derivations may, in some instances, aid the definition of Caravaggio's style through a process of contrast and comparison, but on other occasions they merely serve to remind us of the similar conventions and poses used by painters of the sixteenth and seventeenth centuries in their efforts to render the drama and psychology, the significant human action, of religious or mythological stories.

Caravaggio's success as a purveyor of images was, in fact, rooted in his ability to invest such inherited conventions with a new appropriateness and vitality which derive from his constant sensitivity to the potential of subject-matter and his passionate interest in human nature. These two characteristics helped to make him one of the great poet-dramatists of art, and their combination and application need to be examined in detail. Yet it would not be possible to understand his art without a knowledge of certain other factors, superficially more peripheral yet in some cases decisive in the stimulus which they provided for a new way of presenting imagery. These include the state of religion in the second half of the sixteenth century and the ideas and attitudes of Caravaggio's patrons.

It is now considered axiomatic that the pronouncements concerning the visual arts issued on 4 December 1563 at the end of the twenty-fifth and final session of the Council of Trent had a profound and far-reaching effect on the nature of visual representation in Roman Catholic countries. But it is also necessary to remember that these decrees represented a compromise between several different and sometimes conflicting viewpoints and were consequently applied with very varying degrees of commitment and with numerous nuances of interpretation by the regional church authorities in subsequent decades. Their central tenets, that religious art should be clearly intelligible and in no way misleading to the simple worshipper and that it should be free of any hint of impurity (i.e. sensuality), were nominally subscribed to both by ecclesiastics who were deeply attached to the sophisticated, complex and frequently nude-dominated art of the late Renaissance, as well as by those who, verging on the views of the more extreme Protestants, were doubtful about the morality of employing any kind of images at all. And it was only after the council's edicts had been further publicized and elaborated on, although not significantly altered, by a succession of self-appointed commentators (Gilio in 1564, Molanus in 1570, Paleotti in 1582) that the precepts enshrined in the original compromise began to have a decisive impact on the practice of art in the last years of the sixteenth century, at the very time when both Caravaggio, in Milan and Rome, and Annibale Carracci, in Bologna and Rome, were embarking on their careers.

The emphasis which the Tridentine decrees and the subsequent literature pertaining to sacred images placed on clarity of meaning, simplicity of expression

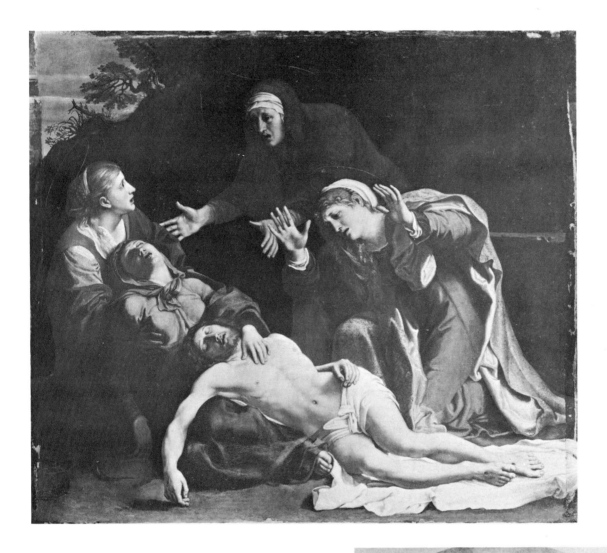

fig. 3 Annibale CARRACCI
The Dead Christ Mourned
London, National Gallery. c. 1606. Canvas
92·8 × 103·2 cm.

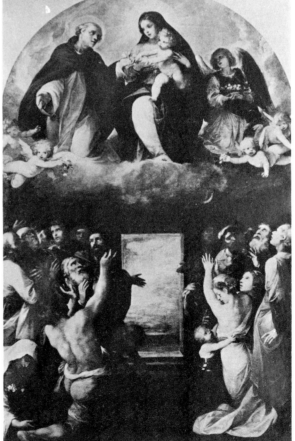

fig. 4 Giuseppe Cesari, Cavaliere D'ARPINO
Madonna of the Rosary
Cesena, Church of San Domenico. 1601.
Canvas 330 × 210 cm.

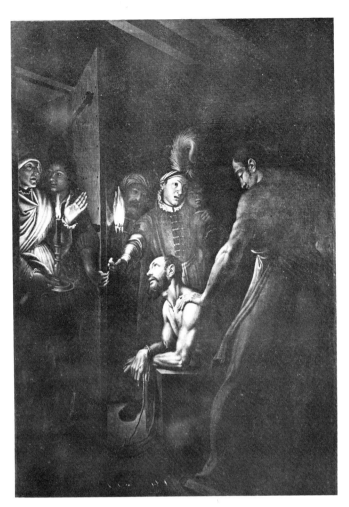

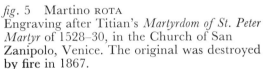
fig. 5 Martino ROTA
Engraving after Titian's *Martyrdom of St. Peter Martyr* of 1528–30, in the Church of San Zanipolo, Venice. The original was destroyed by fire in 1867.

fig. 6 Antonio CAMPI
The Beheading of John the Baptist
Milan, Church of San Paolo. 1581.

and the need for religious pictures to be readily comprehensible to the widest possible public was in part motivated by political considerations. Such precepts reflected the wish to present a lucid and emotionally satisfying vision of Roman Catholic doctrine as a counterweight to the criticisms of Protestants. Pictures which, through their realistic and sympathetic depiction of the Christian saints and martyrs, would act as *libri pauperum* or books of the poor, and attract ordinary people back into the Roman Church, were an important instrument in the battle for men's minds. They would familiarize the illiterate with the articles of faith which the Protestant threat made it all the more necessary to reinforce and help to entice humble worshippers into the new, large-scale Counter-Reformation churches, such as the Gesù in Rome (begun in 1568 and finished 1584) which were built in the hope of accommodating vastly increased congregations of the faithful. And this approach was felt to be all the more useful in that the Protestants were, for the most part, opposed to the extensive use of religious images, which many of them

considered idolatrous, and were, therefore, from the Roman Catholic standpoint, deprived of an important weapon in the propaganda struggle.

But Roman Catholic teaching on art was directed as much against the prevalent paganism of Renaissance culture as it was against the Protestant heretics. It was no mere accident that the precepts outlined by Roman Catholic reformers ran contrary to many artistic ideas about the desirability of complex compositions, difficult poses and the inaccessibility of the work of art to the vulgar mind. Gabriele Paleotti, Archbishop of Bologna and author of an influential book of 1582 entitled *A Treatise on Sacred and Profane Images*, felt that the obsession of many connoisseurs and artists with the art of antiquity was a root cause of the disjunction which had emerged in much sixteenth-century art between subject-matter and style. In this his view was fairly typical of the reformers in the Church. It seemed to him that the adulation extended to statues of pagan deities as aesthetic objects verged on the idolatrous and was an especially dangerous example for the illiterate poor, who were not

capable of distinguishing between aesthetic and religious responses. But above and beyond this cultural conflict lay the even more insidious development whereby many artists, basing themselves, according to Paleotti, on the example set by their pagan forebears, had become more concerned with achieving fame through displays of artistic virtuosity, which patently disregarded the nature of the subject being depicted, than with the more necessary and central task of conveying religious meaning. His comments on the misleading and perverse nature of overcrowded compositions, and of pictures in which the artist either usurped the narrative centre of the composition with genre-type figures incidental to the action, while relegating the central religious episode to the background, or indulged in wildly inappropriate characterizations through an excessive love of invention for its own sake, strike us today, whatever our aesthetic preferences, as at least accurate descriptions of certain features in certain kinds of picture that we designate as Mannerist (figs. 7, 8, and 9). Paleotti's criticisms were a reaction to the stylistic divergence of the period, a divergence which, though it preceded the Counter Reformation, was made more acute and self-conscious by religious controversy. The division was between those, on the one hand, who believed in imitating nature as accurately as possible and those, on the other, who thought that it was more important to imitate other artists; between those who felt that it was the artist's duty to record with sensitivity and precision the colours and lighting of the external world and those who saw colour as a component, together with line and form, in a process of pattern-making which was also a distillation of thought; between those who valued observation more than style and those who placed style before observation; between those who espoused the primacy of subject-matter and those who stressed the pre-eminence of invention, the imagination, the artistic 'idea'. Inevitably many artists hovered, or vacillated, between these viewpoints, which were not often seen as straightforward polarities, although the general lines of demarcation are clear enough. It was a demarcation which was to some extent also geographical, the artists of northern Italy (Venice and Lombardy) tending to remain closer to observed reality, those of Florence and Rome veering more in the direction of stylization. But it would be inaccurate to view what was a pervasive dilemma as simply the result of a conflict of ideology between regional schools. In origin such problems of method were related to the Renaissance's dual emphasis on imitating nature and perfecting style, aims which, if pursued without due regard for their delicate balance and careful interaction, could all too readily become contradictory.

The religious reform of the mid-sixteenth century acted as a powerful incentive to the clarification of this situation because of its reaffirmation of the importance of subject-matter and realism and its doctrinaire aver-

sion to any kind of artifice or rhetoric that did not illuminate meaning directly. Gilio even objected to the comparatively mild and, to us, frequently subject-related idealizations of High Renaissance art, because he thought they placed an aesthetic veil over religious significance. This attitude did not simply drive artists of religious works towards a wholesale rejection of contrivance in favour of undiluted realism but compelled them to reconsider, with some urgency, the perennial problem of the correct balance and proper relationship of style and content in a work of art. And in the sense that he responded to this challenge, Caravaggio was very much a product of the Counter Reformation. In canvas after canvas he appeared to be no less than a dutiful son of the Church, attempting to bring religion to the people by every means at his disposal and especially by asserting the contemporary relevance of religious stories. Not only was his depiction of the Apostles as people from humble backgrounds scripturally accurate. By insisting on the ordinariness of the saints, and, in such canvases as the *Madonna of the Pilgrims* (Plate 40) and the *Madonna of the Rosary* (Plate VII), actually including poor spectators in the composition alongside the saints whom they adore, he also admirably fulfilled the official requirement that the ordinary worshipper should be induced to identify with the religious mysteries which he saw enacted in paint or stone.

Such renderings were a profound response to the sensibility of the Counter Reformation and heralded that direct and overwhelming dramatic rapport with the spectator which distinguishes so much Baroque art. Indeed, Caravaggio's popularity as a creator of images in this vein is firmly attested by the constant flow of commissions, so much so that he does not seem to have painted more than two non-religious subjects (Plates 34 and 58), apart from portraits, after his success with the Contarelli Chapel pictures in 1600. It is, therefore, at first sight all the more surprising that certain of his works [the first version of *St. Matthew and the Angel* (Plate 25), the *Madonna of the Serpent* (Plate 48) and *The Death of the Virgin* (Plate 49)] were rejected by the clergy of the churches for which they were commissioned. The phenomenon becomes easier to comprehend, however, when we realize that the reasons for rejection probably had much more to do with the supposedly 'impure' nature of the depictions than with their lack of idealization or use of peasant types. The proximity of St. Matthew to the androgynous angel was replaced by a decorous distance in the second version (Plate 26), while a document shows that the *Madonna of the Serpent*, although doctrinally irreproachable, was almost immediately removed from its altar in St. Peter's to the church of the Palafrenieri and then sold after only two months to Cardinal Borghese, who housed it away from the public gaze in his private collection, thus tending to confirm Bellori's explanation that the Virgin and the

fig. 7 Francesco PARMIGIANINO
Madonna with the Long Neck
Florence, Galleria degli Uffizi. 1535. Canvas
216 × 132 cm.

The fashionable and worldly appearance of
the Madonna is typically Mannerist in its
flamboyant disregard of appropriate
characterization.

and it is inappropriate to read back into the situation later, seventeenth-century idealist prejudices against the radical naturalism of Caravaggio and his followers or to deduce that the popular nature of his imagery was anything other than congenial to the vast majority of churchmen. It has to be admitted, however, that the apparent rejection of the *Madonna of the Rosary* is difficult to account for without postulating some dissatisfaction with its 'vulgarity', but the circumstances are too hazy to draw any conclusions. At all events, the intrusion of sensuality into a number of Caravaggio's works seems to have been the prime, if not the sole, motive for their rejection, and it even appears possible to me that another picture, the first, Odescalchi, version of *The Conversion of Saul* (Plate 27), was found unsatisfactory by Monsignor Tiberio Cerasi not so much because of its *retardataire* Mannerist features, as because of the somewhat gratuitous nudity of Saul himself.

Caravaggio's attitude to the religious themes which he depicted is a matter for conjecture, yet his obvious feeling for the existential dilemmas which underlie many of them suggests that he was in some degree genuinely concerned with their ethos as well as their drama. There are also signs that as his life wore on and he became more and more the victim of his own impetuosity, finding himself constantly at odds with society and its restrictions, he developed a concomitant sense of pessimism and tragedy which found expression in his late religious works. But it is arguable that his response to the human condition is not especially indicative of a religious view of life, and there is demonstrably much that is personal and idiosyncratic about his treatment of religious iconography. It is, perhaps, more accurate to characterize him, as Dempsey has done, as an embattled Stoic or Cynic philosopher and to stress that his insights into personality and behaviour enabled him not only to revitalize but also to complicate the imagery of Christian commitment.

It is evident from the information we have concerning Caravaggio's violent temperament, bohemian way of life and satirical cast of mind, all amply documented in contemporary police records, that he could in no way have shared the straightforward faith of the humble worshippers whom he depicted in some of his canvases. Indeed, he may well have made a show of being irreligious. In his *Lives of the Painters of Messina* of 1724 Susinno recounted an amusing and probably apocryphal anecdote which none the less seems consistent with what we know of Caravaggio's character from more reliable sources. It is about an incident which is meant to have occurred during the artist's stay in Messina in 1609. 'When he had entered one day with certain gentlemen into the Church of the Madonna del Pilero, the most polite among them came forward to offer him the holy water, and Caravaggio asked him what it was for; to cancel out venial sins he was told: "I don't need it", was the reply, "because mine are all mortal."'

nude Christ Child were considered indecent by the authorities. It also seems reasonable to attach some weight to Mancini's statement that the clergy had *The Death of the Virgin* removed from the Church of Santa Maria della Scala because Caravaggio had used a prostitute as the model for the Madonna, although the work was probably also thought unacceptable on iconographical grounds. Such vigilance with regard to 'indecency' and nudity in religious pictures stemmed directly from the injunctions of the Council of Trent and was a common aspect of Counter-Reformation censorship. Michelangelo himself had been censured for comparable indiscretions, and it should not be thought that Caravaggio was being singled out for any special condemnation on aesthetic grounds. On the contrary, the issue was a relatively straightforward one of morality,

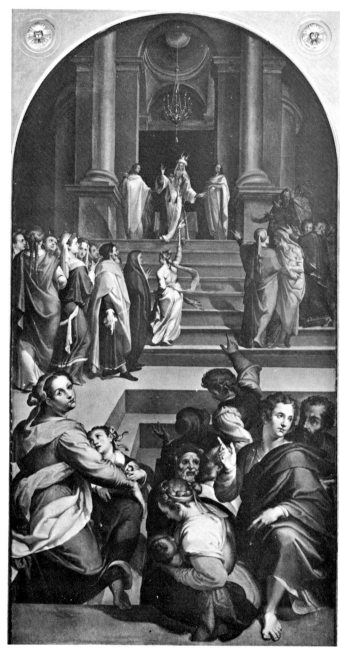

(*above left*)
fig. 8 Agnolo BRONZINO
The Martyrdom of St. Lawrence
Florence, Church of San Lorenzo. 1569. Fresco.

(*above right*)
fig. 9 Bartolommeo PASSEROTTI
The Presentation at the Temple
Bologna, Pinacoteca Nazionale. 1583/4. Canvas 390 × 198 cm.

The crowded compositions and emphasis on a variety of incident and action at the expense of the main religious episode in these two pictures exemplify certain features of Mannerist religious art which church reformers like Paleotti found distasteful.

Whether he actually possessed this degree of self-awareness, several contemporary documents and early biographies testify that he was no stranger to such sins: he is revealed as someone who, in addition to a taste for boys and prostitutes, gratuitously sought out violence and eschewed all family loyalty. Floris Claesz van Dijk, in his reliable and graphic account of Caravaggio in 1601, recorded in Van Mander's *Het Schilder-Boeck* of 1604, told how 'he does not pursue his studies steadfastly, so that after a fortnight's work he will swagger about for a month or two with a sword at his side and with a servant following him, from one ball-court to the next, ever ready to engage in a fight or an argument, with the result that it is most awkward to get along with him.' Mancini (1619/25) recounted a strange story to the effect that Caravaggio told Cardinal del Monte that he had no living relatives and refused to recognize his own brother, a cleric, who had come to the cardinal's palace to see him. 'It cannot be denied', concluded Mancini, 'that Caravaggio was very capricious ['stravagantissimo'] and that his extravagances shortened his life by at least ten years and diminished somewhat the glory which he had won through his profession.'

This verdict was possibly even retailed to Mancini by Cardinal del Monte, since the cardinal had made a remarkably similar assessment of Caravaggio's character on a previous occasion. In a letter of 24 August 1605 from Fabio Masetti to the Conte Giovanni Battista Laderchi, Masetti told how 'del Monte says that Caravaggio is an extremely capricious sort of man' ['un cervello stravagantissimo']. Furthermore, the particular incident concerning Caravaggio's brother is made more plausible by the information we now possess that his younger brother, who was actually a cleric, was in Rome in 1596. Anecdote, fact and opinion tend to reinforce each other from independent sources. It is especially interesting to note that one of Caravaggio's Sicilian patrons, the Messinese Niccolò di Giacomo, used a phrase comparable to that attributed by Masetti to del Monte. In a private memorandum written in the summer of 1609 he recorded how he commissioned four pictures of the Passion from Caravaggio, to be painted 'a capriccio del pittore' ['as the painter's fancy takes him'], that one of them, *Christ Carrying the Cross*, had already been completed and that he had insisted on receiving the other three in August, agreeing to pay for them 'whatever suited this painter with a highly disturbed brain' ['cervello stravolto']. It was this 'cervello stravolto' or 'stravagantissimo' which led Caravaggio into countless quarrels and fights, many of which ended up in the law courts, and ultimately to the murder of Ranuccio Tommasoni on 29 May 1606 as a result of the painter's heated reaction to a dispute over a ball game. The reasons for his imprisonment in Malta in 1608 are not known, but it must have been a serious offence for him to have been put in the dungeon of the Castel Sant' Angelo, Vittoriosa, and one is inclined to accept Bellori's

statement that he had insulted a senior member of the Order of the Knights of St. John. The uncontrollable side of Caravaggio's personality, clearly no myth, is perhaps most vividly revealed when one consults the transcript of the Baglione libel trial of 1603 and observes how, having categorically denied all connection with the charge of writing satirical verses about the painter Baglione, Caravaggio suddenly embarked on an emotional and damning attack upon his art.

Such intense and volatile feelings certainly nourished his own art which, for all its logic, is full of emotion. Indeed, it has already been suggested above that it is possible to discern a certain connection between the quickening tempo of his life, as he became progressively more involved in violent activities and, after 1606, an exile and a wanderer, and the increasingly authentic and moving quality of his paintings. Such a progression can be glimpsed by comparing the powerful yet somewhat virtuoso rhetoric of *The Conversion of Saul* (Plate IV) and the National Gallery *Supper at Emmaus* (Plate 29) with the more spiritual mood of the Brera *Supper at Emmaus* (Plate V) and the Messina *Adoration* (Plate 62) or the psychological subtlety and tragic, poetic resignation of the Madrid *Salome* (Plate 64) and the Borghese *David with the Head of Goliath* (Plate 67).

Caravaggio's involvement in the drama of his pictures can be further charted, in a very literal sense, through the self-portraits which he incorporated in some of them. Although it is possible to see too many of these in his œuvre, it is generally agreed that the figure of King Hirtacus of Ethiopia in the background of *The Martyrdom of St. Matthew* (Plate III), extremely close to the portrait drawing of Caravaggio by Ottavio Leoni (*frontispiece*), and the severed head of Goliath in *David with the Head of Goliath* (Plate 67), on the basis of a statement by Manilli in his 1650 guide to the Villa Borghese, are genuine self-portraits. The right-hand figure of *The Taking of Christ* (Plate 33) may also be one, as suggested by Longhi. We could interpret these facts in a neutral sense and deduce that Caravaggio merely used himself as a model because it was convenient. But to do so is to ignore the peculiar and distinctly haunting psychology of these figures. Goliath displays such anguish and exhaustion that one is tempted to advance this as an additional reason for placing the picture at the end of Caravaggio's ill-fated life. In the earlier *Martyrdom of St. Matthew*, Caravaggio as King Hirtacus, his mouth turned down, his eyes immeasurably sad, raises his arm in hesitant, impotent consternation at the spectacle of the murder which he has authorized. Even if Caravaggio was just striking an attitude, his ability to imagine himself into the dramatic situations which he painted was a remarkable one and enabled him to embellish their significance by introducing nuances of characterization which are possible and convincing, though by no means obligatory, responses to the religious

iconography. It is noteworthy that while artists had often included themselves as bystanders in religious pictures, there are no known examples prior to Pontormo's 1523–24 fresco of *The Road to Calvary* in the Certosa di Val d'Ema of an artist depicting himself as a protagonist, and no previous examples, apart from Michelangelo's famous flayed skin in the Sistine Chapel *Last Judgment*, of the tragic attitudinizing which we see in Caravaggio's *David with the Head of Goliath*. Caravaggio's ability to identify with the subjects of his pictures is also apparent in the signature which he scrawled enigmatically in the Baptist's blood in the Valletta *Beheading of John the Baptist* (Plate VIII).

Feeding on life as much as the tradition of art, Caravaggio was able to invest his religious images with something of his own deeply felt involvement in the violence and fervour of a turbulent society. One aspect of that society which stands out is the passion with which people hurled themselves into religious experience and affirmation and while it would probably be inaccurate to say that Caravaggio was directly and personally concerned with such things, there would appear to be a strong affinity between his art and the passionate language and experiences of the Counter-Reformation mystics. His exploration of that dominant theme of Counter-Reformation mysticism, the conflict of good and evil, both in external situations and in men's minds and his ability to harness it to the traditional iconography of the Bible and *The Lives of the Saints*, is a fascinating phenomenon. Like the Jesuit novice who, during the course of his spiritual exercises, attempted, with all the resources of his imagination, to visualize evil in its various manifestations, so Caravaggio depicted it in all its ferocity: 'no wild animal on earth can be more fierce than the enemy of our human nature' according to St. Ignatius Loyola's *Spiritual Exercises*. And Caravaggio's depictions can be all the more effective for the way in which he sometimes contrived to convey aspects of mental struggle, so familiar to the mystics, within the very stereotypes of saint and executioner. Such works as the Prato *Crowning with Thorns* (Plate 31) or the Naples *Flagellation* (Plate 51) are psychologically relatively straightforward because character is made conterminous with behaviour. But in other cases Caravaggio was at pains to indicate a certain ambivalence or regret on the face of a death-dealer [King Hirtacus in *The Martyrdom of St. Matthew* (Plate III), David in *David with the Head of Goliath* (Plate 67), the executioner in the National Gallery *Salome with the Head of John the Baptist* (Plate 53)] or to show turmoil on that of a saint, as in the Kansas City *St. John* (Plate 41). At the very least such anatomizing of the psyche can be said to parallel the painstaking recording of states of mind indulged in by the mystics.

Another, perhaps more obvious, point of contact can be seen in Caravaggio's portrayals of mystical surrender. Caravaggio was the first artist to create truly vivid pictorial equivalents for those magnificent but distinctly erotic descriptions of spiritual ecstasy which occur in the writings of such mystics as St. Teresa (1515–1582) and St. John of the Cross (1542–1591). His *Stigmatization of St. Francis* (Plate 6) and, more especially, his *Magdalen in Ecstasy* (Plate 50), with its enraptured, open-mouthed protagonist, anticipate by many years their currently better known High Baroque counterparts, Lanfranco's *Ecstasy of St. Margaret of Cortona* (Florence, Palazzo Pitti) and Bernini's *Ecstasy of St. Teresa* (Rome, Church of Santa Maria della Vittoria, Cornaro Chapel). It is unlikely that Caravaggio actually read St. Teresa's writings, although an Italian edition did appear in 1603, and St. John's had not even been published during his lifetime. But one should not underestimate the extent to which their kind of imagery, not altogether new and rooted in a long tradition of mystical writing, had become part of the standard religious currency of the late sixteenth century. St. Filippo Neri, whose followers, the Oratorians, were extremely influential in the Rome of Caravaggio's day, is, for example, known to have undergone many ecstatic religious experiences, the details of which were distributed through sermons and by word of mouth. But, whatever the immediate source of inspiration, Caravaggio's pictures reveal a great sensitivity to the emotional and physical, the passionate side of such experiences. St. Teresa, in her *Vida*, described her encounter with an angel who lay at her side in bodily form:

... in his hands I saw a long golden spear and at the end of the iron tip I seemed to see a point of fire. With this he seemed to pierce my heart several times so that it penetrated to my entrails. When he drew it out, I thought he was drawing them out with it and he left me completely afire with a great love of God. The pain was so sharp that it made me utter several moans; and so excessive was the sweetness caused me by this intense pain that one can never wish to lose it, nor will one's soul be content with anything less than God. It is not a bodily pain, but a spiritual, although the body has a share in it —indeed, a great share[1].

In the two pictures referred to, and also in the Cerasi Chapel *Conversion of Saul* (Plate IV), Caravaggio showed himself acutely aware of this physical dimension, of the mystical union as something passionately experienced rather than symbolically appropriate.

It might also be felt that Caravaggio's decision to employ strong contrasts of light and dark as a regular and psychologically crucial feature in his pictures from the late 1590s onwards owes something to the religious imagery in writings of the period, whether by mystics or theologians. For although the dramatic potential of powerful light combined with varying degrees of darkness had already been recognized by several sixteenth-century painters, its effectiveness as a metaphor for spiritual revelation was deeply ingrained in the language of religious experience, in which the light of faith and 'illumination' were frequently contrasted with the darkness and desolation of unbelief. A good example is St. John of the Cross's poem 'Although by Night—Song of the Soul that delights in Knowing God by Faith'.

How well I know the spring that brims and flows,
 Although by night . . .
Its radiance is never clouded and in this
I know that all light has its genesis,
 Although by night[2].

Another, which may even have been known to Caravaggio, is a verse about the conversion of Mary Magdalen, written between 1597 and 1599 by Pope Clement VIII's theologian Cardinal Robert Bellarmine. It is highly evocative of Caravaggio's picture of the same date (Plate 16), in that they both employ the image of a shaft of light as a symbol of the divine love which floods the Magdalen's soul and brings about her conversion.

Father of lights one glance of Thine
Whose eyes the universe control
Fills Magdalen with holy love,
And melts the ice within her soul[3].

The many similarities of tone and detail between Caravaggio's pictures and this language of spiritual affirmation suggest that the artist was positively inspired by the fervent religious climate of the late sixteenth century, rather than simply responding to official stipulations about the need to produce realistic images for popular worship.

The main agency through which Caravaggio was made aware of the mystical radicalism in the Church may well have been St. Filippo Neri's Oratorians. Filippo Neri, who died in May 1595, was one of the great religious figures in Rome at the end of the sixteenth century and the founder of the Oratory, originally a group of laymen who gathered together for informal discussions and lectures about religion but soon transformed into a highly organized congregation of secular priests and clerics. The Oratorians, or Filippini, who were also active in Milan during Caravaggio's youth, formed, as Friedlaender aptly put it, a kind of low Church, distinguished by its lack of ritual, encouragement of the congregation's participation in services (including the singing of hymns and 'oratorios'), and concentration on charitable works and recurrent emphasis in sermons and prayers on the need for poverty and humility. Indeed, the Oratorians, closely in touch with the laity, were the most broadbased and least doctrinaire of the religious Orders. They believed in the importance of personal religious experiences, one's 'inner voices', and were keen to remind their audiences that the Apostles were ordinary men like themselves. It seems likely that Caravaggio would have responded to their tolerant, flexible and largely exploratory approach to personal religious faith.

Yet it would be misleading to talk of one exclusive source of religious inspiration, since the ardent ideals of the Counter Reformation, whether mystical, evangelical or austerely penitential, had penetrated most levels of lay and ecclesiastical society. The new Orders, such as the Oratorians, the Jesuits, the Theatines and the Barnabites, may have been in the vanguard of this spiritual reawakening, but older Orders, including the Franciscans, the Dominicans and the Augustinians, were quick to respond to the challenge, some of them, the Carmelites for instance, establishing such reformed branches as the Discalced Carmelites (founded by St. Teresa) for whose Church of Santa Maria della Scala in Rome Caravaggio produced *The Death of the Virgin* (Plate 49). Indeed, Caravaggio did not, so far as we know, paint any pictures for the Jesuits, although it seems as if he would have liked to (see Biography under 1603), and executed only one for the Oratorians (Plate 36). He was, however, involved in at least two commissions connected with the Dominicans, *The Flagellation of Christ* (Plate 51), which was in the Church of San Domenico Maggiore, Naples, and the *Madonna of the Rosary* (Plate VII), which was almost certainly intended for a Dominican church. He also painted a number of pictures of St. Francis and was patronized by the Capuchins, who have been described by Leopold Willaert as by far the most important of the three branches of the Franciscan Order in their contribution to the Roman Catholic reform. In addition to the Messina *Adoration* (Plate 62), painted for the Capuchin Church of Santa Maria degli Angeli, he was commissioned to paint a picture for the high altar of the Capuchin church in Tolentino in January 1604, while a good version of his *St. Francis Praying* (Plate 37) is to be found in the Capuchin church in Rome. Although in origin a contemplative Order, the Capuchins became increasingly involved in preaching during the last years of the sixteenth century and took a prominent part in some of the more exacting charitable tasks, such as working in hospitals. Their honest crusading zeal and general lack of pretensions made them one of the most popular and influential of the Orders with the mass of the people.

The relationship between Caravaggio and the religious Orders, as well as such lay charitable confraternities as that of the Pio Monte della Misericordia in Naples, still needs to be investigated in more detail if we are to establish which of them were particularly attracted by his art as an expression of their own ideals. In the present state of our knowledge it is difficult to make any generalization beyond the one that his pictures clearly appealed to a wide range of reformed religious opinion. But even here there are some notable qualifications, such as the surprising rejection of *The Death of the Virgin* (Plate 49) by the Discalced Carmelites. Indeed, it is especially difficult to define Caravaggio's relationship to the religious Orders in that, although many of his commissions were executed for their churches, the immediate commissioner in most of these cases was an individual member of the upper classes—lay or ecclesiastical—who had acquired a chapel in one of these churches. And although such a person

would usually have had a particular sympathy for the Order with which he was thus associated, it is possible that some of the difficulties which Caravaggio encountered when certain of his works were found unsuitable may have been due to a conflict of priorities between church authorities and individual patrons.

In fact, it would seem that while the response of the religious community as a whole to Caravaggio's work was broadly sympathetic, that of his upper-class patrons was far less equivocally so. And the rôle which such patrons played in facilitating the development of his talent was a crucial one. Such powerful supporters as Cardinal del Monte, the Marchese Vincenzo Giustiniani and Ottavio Costa sustained Caravaggio through many a hard time and perilous situation, and acted as a protective barrier against some of the more inflexible attitudes of the morally, religiously or aesthetically conservative. Without their intense interest in his artistic experiments, which probably fascinated them far more than his distillation of Counter-Reformation sentiment, Caravaggio might well have succumbed at certain moments in his career to the pressures of public indifference and official intransigence. Cardinal del Monte took him into his palace and gave him commissions and all the backing of his considerable position as prefect of the Fabbrica of St. Peter's, protector of the Accademia di San Luca and representative in Rome of the Grand Duke of Tuscany, at a time when the artist was struggling to sell his pictures on the open market. Del Monte was probably also responsible for securing Caravaggio his first public commission in 1599 in the Contarelli Chapel of the Church of San Luigi dei Francesi. Another important patron of Caravaggio's Roman period, the Genoese noble and financier Vincenzo Giustiniani, whose inventory of 1638 refers to fifteen works by Caravaggio, carried patronage to the level of friendship by purchasing the artist's first version of *St. Matthew and the Angel* (Plate 25) after it had been rejected by the Congregation of San Luigi.

Most fascinating of all is the way in which some of Caravaggio's wealthy patrons continued to deal with him and even to champion his cause when he was forced to flee from Rome after killing Ranuccio Tommasoni in 1606. Although this period of activity is only poorly documented, one senses the existence of an elaborate network of aristocratic and commercial supporters which facilitated his movements and ensured a continuing flow of patronage. His first refuge during his exile was in the hills just south of Rome on the estates of the Principe Marzio Colonna, brother-in-law of the Marchese di Caravaggio (see Plates V and 50). In Naples, too, the artist seems to have been in contact both with prospective new buyers from other parts of Italy, such as Frans Pourbus, the agent of the Duke of Mantua, and with old Roman clients, such as Ottavio Costa (see Plates 6, 16, 17 and 41). We are told by Mancini that Costa bought a picture entitled *Christ on the*

Road to Emmaus which Caravaggio is supposed to have painted during his period of residence with Marzio Colonna, and it has recently been suggested by Spezzaferro that Costa and Caravaggio were close personal friends and that it was probably at Costa's Genoese palace that Caravaggio stayed when he fled from Rome for a brief spell in August 1605. We also know that Ippolito Malaspina, Prior of the Order of St. John in Naples and thought to be the man who introduced Caravaggio to Malta in 1607, was Costa's relative by marriage. For whatever motives, possibly ties of affection or desire for Caravaggio's pictures, such sponsorship continued from a variety of sources right up until the very end of his life, the last recorded instance being the part apparently played by Cardinal Ferdinando Gonzaga in obtaining a papal pardon for Caravaggio on the eve of the artist's death. Although we only have Bellori's statement as evidence, the likelihood of such intervention is strengthened by the fact that the Gonzaga family were confirmed admirers of Caravaggio's art. Vincenzo I Gonzaga, Duke of Mantua, Cardinal Ferdinando's brother, had bought the rejected *Death of the Virgin* (Plate 49) in 1607, while the Nancy *Annunciation* (Plate 65), presented to the primatial church at Nancy sometimes after 1608, was almost certainly acquired through the Gonzaga connection, since Henry II, Duke of Lorraine, was married to Margherita Gonzaga, Cardinal Ferdinando's sister. Even the site of Caravaggio's death, Port'Ercole on the Tuscan coast, suggests that he was continuing to rely on the support of powerful admirers. As Port'Ercole is north of Rome, Caravaggio, who cannot have heard of the papal pardon which had only just been granted, may have been sailing to Genoa to seek refuge with the Costa or Giustiniani families.

Much harder to assess than any such saga of patronal loyalty is the degree to which Caravaggio was influenced by his patrons in his ideas and manner of painting. The problem is posed acutely by the early works, which hover in status between straightforward genre painting and poetic allegory. It was fashionable for a long time to view these works as examples of Caravaggio's revolutionary naturalism, in which he concentrated on the realistic mode of representation rather than the content of the picture; or else, not in fact completely neglecting content, sought to evoke mood rather than attempt to crystallize the details of a specific iconography. Thus, it has been argued, some of his youthful paintings exist primarily on the level of homosexual pin-ups (Plates I, 1, 2, 3, 4, and 8) others as picturesque incidents (Plates 9, 10 and 11). And given what we know about the artist's sexual proclivities, as well as his aesthetic boldness, it is tempting to subscribe to such interpretations. But more recent research has also revealed the extent to which sixteenth-century artists and connoisseurs envisaged most, if not all, genre painting as inherently symbolic. Of course, artistic intention is impossible to determine with any finality, and in Caravaggio's case it is doubly

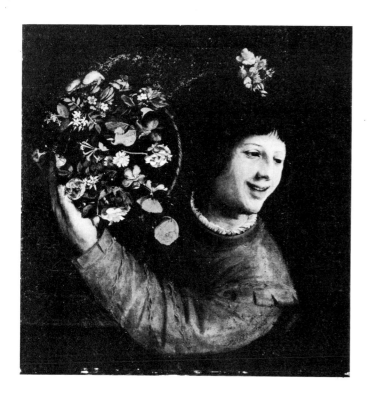

fig. 10 Dosso DOSSI
Laughing Youth with a Basket of Flowers
Florence, Fondazione di Studi di Storia dell'
Arte 'Roberto Longhi'. Early 1520s. Canvas
67 × 65 cm.

difficult because he came to be so wholeheartedly associated during the seventeenth century with the emphatically unintellectual scenes of low life produced by many of his followers. But if interpretation is to involve anything more than subjective response, the views held by contemporaries about the meanings of works of art are especially important, for even when they differ from or contradict each other, they help to place a picture in a context of critical opinion which is likely to have also played some part in its creation. In fact, it seems possible, through comparisons with similar but more verifiably symbolic pictures from the sixteenth century and by examining the ideas about poetic and artistic expression held by many intellectuals and patrons of the time, to reconstruct some of the symbolic associations of Caravaggio's pictures and to observe how, by and large, he interpreted rather than ignored the requirements of iconography.

Some of Caravaggio's early works would appear to derive from a tradition of depictions of the five senses. *The Boy with a Vase of Roses*, known only through a copy (fig. 14), and *The Boy with a Basket of Fruit* (Plate 1) could be associated with the conventional symbols of smell and taste, while *The Boy Bitten by a Lizard* (Plate 2) might represent the sense of touch, which was not usually rendered by any fixed attribute. Yet the multiple implications of many such symbols is indicated by the fact that a basket of fruit or flowers was traditionally also employed in personifications of the seasons. Dosso

Dossi's *Laughing Youth with a Basket of Flowers* (fig. 10) and Vincenzo Campi's *Fruit Vendor* (Milan, Pinacoteca di Brera) have been convincingly identified with the seasons of Spring and Autumn respectively, and there is but a short visual step from Dosso's aristocratic youth with spring flowers to Caravaggio's more plebeian *Boy with a Basket of Fruit*, proffering the ripe, not to say decaying, autumnal produce to the viewer. Caravaggio's picture can, therefore, be assumed to contain references either to the season of Autumn or to the sense of taste, and quite possibly to both. Indeed, the way in which Caravaggio gave his youth an equivocal expression which combines sensuality with melancholy suggests that he was perfectly aware of both these symbolic associations and intent on fusing them together to express the transience of love. Without the allegorical glosses the image would remain psychologically potent, yet it would lack those precise points of reference which help to give it a definable core of meaning. Such pictures were in all probability intended to be both direct and referential, and by trying to force them into a single mould, either as descriptive genre, interested only in still-life details and obvious, visually apparent sentiment, or as straight-forward allegories, we ignore the period's preference for multiple meanings in works of art, as expressed, for example, in the writings of the late sixteenth-century Milanese art theorist, Gregorio Commanini, or by the poet Torquato Tasso in his *Dialogues*.

The existence in a work of art of different levels of allegorical meaning does not imply that the artist consciously intended to stress all of them or that his learned audience would have interpreted them in a standard way. But it does suggest that the image he produced is the product of a mode of thought conditioned by allegorical principles, and it cannot, therefore, be isolated from that context without a certain loss of focus. So susceptible, in fact, are Caravaggio's early works to symbolic interpretations that one is compelled to recognize the influence on him from a very early date of ideas which we know to have been circulating among some of his colleagues and patrons. Even the very early *Boy Peeling Fruit* (fig. 11) would appear to be symbolic. The recently discovered original of this painting makes it clear that he is peeling a small citrous fruit such as the *bergamotto*, which has a bitter taste. The work could therefore be construed as an ironic commentary 'on the disillusioning surprises which life has in store for inexperienced youth'.[4]

Much work still needs to be done on the intellectual and aesthetic attitudes of Caravaggio's patrons, but it is already apparent that some of them were exponents of those emblematic habits of thought which were so favoured by the sixteenth-century academies and which stressed, in marked contrast to the Counter-Reformation Church, the importance of hidden meanings in poems and pictures. Mere description, whether in words or paint, was felt to enshrine the contingent

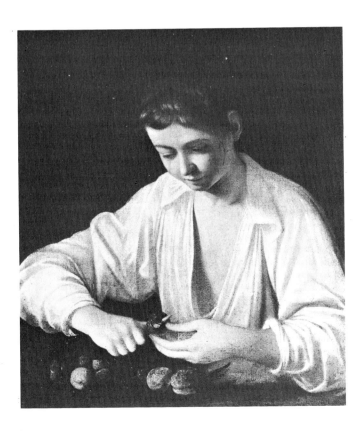

fig. 11 Copy after CARAVAGGIO
Boy Peeling Fruit
Florence, Fondazione di Studi di Storia dell'
Arte 'Roberto Longhi'. Canvas 68 × 67·5 cm.

and the accidental, whereas ideas, concepts and statements of belief required more elusive and suggestive images which challenged their audience to struggle with the puzzle of meaning and arrive thereby at a sounder understanding of the poem's or painting's essential nature. Such exercises were also regarded as entertaining riddles which might help to while away a few idle hours and were explicitly presented as such by one of the originators of the emblematic form, Andrea Alciati, in his *Emblemata* (1531). Emblem books such as the *Emblemata*, which consisted of brief descriptions, often in verse, of a great variety of symbols, usually accompanied by small engravings based upon the words, affected the development of the visual arts in two important ways. For not only did they provide a major source of arcane symbolism, but they also encouraged intellectuals and artists of all kinds to vie with each other in the creation of ingenious variations on common emblematic themes. While most earlier emblem books usually gave only one meaning for each emblem, men of learning were particularly fond of creating variations on them, utilizing their own knowledge of classical and esoteric literature. The shift towards multiplicity of symbolic meaning is discernible in Cesare Ripa's *Iconologia*, first published in 1593, in which one frequently finds several different meanings listed under each heading.

Although the source of a good deal of relatively light-

hearted improvisation, the emblematic form had a philosophically serious side, for the belief that things were not what they appeared to be on the surface was partly inspired by Neo-Platonism, that hybrid product of Renaissance culture which had attempted to reconcile paganism with Christianity by determining the spiritual significance of antique literature and mythology. And while Neo-Platonism went into a relative decline during the course of the sixteenth century, it enjoyed a revival towards its end. In fact, three of Caravaggio's contacts during the 1590s, the Cavaliere d'Arpino, his early employer, Aurelio Orsi, the brother of Caravaggio's good friend, Prospero, and Maffeo Barberini, one of the artist's patrons, were members of the Neo-Platonic Accademia degli Insensati, or 'Non-Sensual Academy', which had spread from Perugia to Rome in the late sixteenth century, and whose devotees, fascinated by emblems, 'boasted', according to Salerno (1974), 'of succeeding in raising themselves "to the contemplation of the celestial and the divine . . . notwithstanding the heavy weight of the senses which invest all earthly things with desire" '.

This Neo-Platonism was in part a sign of spiritual aspirations and may therefore be seen as an attempt to adapt classical myth and poetry to the needs of the Counter Reformation. But it was also a trapping of élitist culture, used by men of learning to reinforce their sense of separateness and refinement. As a consequence of this one sometimes finds that the self-conscious cleverness of concealed and multiple meanings detracts from, or at any rate diverts attention from, the high moral purpose implicit in the emblematic approach to symbolism. Certain numbers of Caravaggio's youthful works reflect this paradox in that their symbolic meaning often seems linked to a disillusionment with the world of the senses, while their overt appearance is provocatively and even wittily sensual. This is especially true of the precious youth in *The Boy Bitten by a Lizard* (Plate 2) and of the somewhat later painting of *St. John the Baptist* (Plate 23), which, despite its religious subject, is symbolically rather than literally conceived.

The Capitolina *St. John*, in fact, epitomizes certain cross-currents in Caravaggio's career and also helps to explain the element of apparent paradox in his earlier, non-religious works. Since the *St. John* was a private commission rather than a painting executed for public display in a church, Caravaggio clearly felt free enough of the demands of Counter-Reformation protocol to indulge his iconoclastic and hedonistic preferences. He was enabled to do so by means of an allusive and symbolic rather than a literal approach to the subject. The contrast between the smiling, erotically suggestive youth and the sacrificial ram which he embraces is to be understood as signifying the sacrifice of youth to the encroachments of time and age, and only more indirectly as pointing to Christ's own sacrifice, which

depictions of St. John traditionally indicated by the inclusion of the motif of the *lamb*. As such the painting is closer to the conceptual pattern of the earlier, non-religious works than to those religious commissions in the Contarelli and Cerasi Chapels with which it is contemporary in date. One senses the guiding hand of a cultivated patron, probably Ciriaco Mattei, who was as attached to the refinements of emblematic thought as he was to Caravaggio's mastery of realistic detail, while equally apparent is Caravaggio's own continued fascination with that oblique and intellectual approach to-subject-matter which he had probably been first introduced to, soon after his arrival in Rome, by his earliest mentors and patrons. Furthermore, the apparent contradiction of the ebullient sexuality of the saint himself is resolved by the symbolic framework within which it is cast. By accepting this framework we can see how the evocation of sensuality may be viewed as part and parcel of the 'moral' of this and earlier pictures—the transience of youth and beauty and the vanity of the senses. It was necessary to show the sin in order to point the moral. It might also be added that the depiction of beauty in its bodily aspect had always been considered permissible by Neo-Platonists in as far as they considered physical beauty as an imperfect but useful aid in directing the soul to the contemplation of divine beauty. A picture such as *The Lute Player* (Plate 4), with its androgynous ephebe singing the words 'You know that I love you', may well have pandered to Cardinal del Monte's homo-sexual tastes, but there can be little doubt that the cardinal had envisaged it first and foremost as an image of Platonic love.

The various symbolic conventions were in some ways designed to paper over paradox and contradiction and to facilitate the incorporation of diverse elements within a single work of art. But they also paid implicit recognition to the notion of poetic ambiguity, which seeks to probe the secret of ultimate paradoxes through the suggestive power of certain images. And it is on this last level that Caravaggio's early works are best confronted. Yet it was undoubtedly the stimulus provided by the need to conform to certain symbolic conventions, and especially the demand to weave evocative images round a central idea or concept, which prompted his poetic sense, and as such the rôle of his first patrons was crucial to the development of his talent. Indeed, it could be argued that by introducing him to an allusive but flexible way of presenting subject-matter they provided him with an alternative approach to the more direct imagery favoured by the official Counter-Reformation Church and thereby encouraged in him a sensitivity to the non-literal aspects of expression. The complex psychological overlays which one encounters in certain of Caravaggio's later religious paintings are in some sense a development from these poetic and symbolic pre-occupations, and they suggest that the artist was very much the product of two traditions, that of Renaissance

symbolism embellishing and poeticizing the balder aesthetic of the Tridentine decrees.

It should finally be said that those who favoured symbolic forms of art did not usually feel any contradiction between symbolism and the use by a painter of realistic detail. Such poets as Murtola and Caravaggio's friend, Marino, who wrote verses about certain of his pictures, were almost keener to emphasize the painter's unrivalled mastery of realistic representation than they were to indicate his imaginative deployment of symbolism, although, in fact, they did both. By thus regarding Caravaggio's achievement as both imaginative and representational they drew attention in their eulogies to the importance in his work of both ideas and observation of nature and paid homage to the fact that he created poetic symbols which were a response to experience rather than signs from an allegorical dictionary.

Caravaggio's friend and patron, the Marchese Vincenzo Giustiniani, viewed his art as just such a synthesis of imitation and imagination, and his verdict seems more relevant than the formulations of seventeenth-century classical theorists such as Bellori, who argued that Caravaggio 'merely copied bodies as they appear to the eye'. In a letter written, probably before 1620, to Dirk Ameyden, a Flemish agent of Philip III, King of Spain, Giustiniani set out, in a critical list of twelve categories of painting, the fruits of his experience as a connoisseur. The lower categories, or methods, include copying, sketching, still-life painting, portraiture, perspective and 'grotesque' painting, but the interest of Giustiniani's categorization lies especially in the top three methods.

The tenth method is what is called *di maniera*. In other words, the painter with long experience in drawing and painting from his imagination, without any model, creates in a painting what he has in his imagination: heads, full-length figures, as well as complete historical scenes or any sort of thing with pleasing design and colour . . . The eleventh method is to paint directly from natural objects before one's eyes. Be warned, however, that it is not enough to make a mere reproduction. Rather it is necessary that the work be well designed, with fine well-proportioned contours. It must have pleasing and appropriate colouring, which comes from the experience of how to handle colours and almost from instinct, and is a gift granted to few . . . The twelfth method is the most perfect of all since it is the rarest and most difficult. It is the union of the tenth with the eleventh, that is to say, to paint *di maniera* and also directly from life. In our time, this is the way that Caravaggio, the Carracci, Guido Reni, and other world-famous painters of the highest rank painted. Some of them were inclined more toward nature than the *maniera* and some more toward the *maniera* than toward nature, without however abandoning either method and emphasizing good design, true colours and appropriate realistic lighting.[5]

Giustiniani's distinctions are especially useful in that they characterize Caravaggio's achievement by means of the artistic terminology of the period in which they both lived and thereby help us to reconsider the much-vexed problem of the artist's 'realism' against a contemporary background. It should first of all be remembered that when Giustiniani used the word '*maniera*' as

a synonym for 'imagination' he was not just thinking in terms of a mental faculty, but also of a definable artistic style. *Maniera* literally means 'style', and while the word was sometimes employed in a neutral sense to denote the specific conventions employed by any one period or group of artists, it had latterly come to be associated with those qualities of invention, construction and virtuosity in a painting which were strictly separable from representation and which dominated the artistic output of Rome and Florence by the mid-sixteenth century; hence our use of the term 'Mannerism' to distinguish the prevalent artistic style of this period. *Maniera* meant to Giustiniani both a style, his tenth method, and an attribute, as in his twelfth method, the one being at its best brilliant, although short of excellent and, by implication, a little *démodé*, the other being an important part of a great painter's armoury, although not the whole of it.

This scale of values clearly reflected an historical situation and what Giustiniani considered to be Caravaggio's achievement in relation to the art of the past. Mannerism was precisely that concentration on style at the expense of realistic detail and demonstrable content which was so frowned upon by the Church reformers. Its heyday, in the works of Vasari, Salviati and Bronzino in the mid-century, was over by the time Caravaggio came to Rome, but although much modified through the introduction of more realistic detail and a closer attention to immediate subject-matter, it continued to prosper well into the 1590s and even beyond in the work of such artists as the Cavaliere d'Arpino (fig. 4) and Federico Zuccaro. Caravaggio and Annibale Carracci were, for Giustiniani as well as for the majority of subsequent writers, the two single artists most responsible for ending the predominance of the late *maniera* and inaugurating a new style more in touch with nature. But whereas seventeenth-century critics such as Agucchi and Bellori made a distinction in kind between Annibale's revolution and Caravaggio's, regarding the former as still incorporating elements of imaginative stylization, the latter as exclusively reliant on copying the model, Giustiniani only hinted at a possible difference of degree: 'Some of them were inclined more toward nature than the *maniera*' and vice versa.

Yet when one examines Caravaggio's *œuvre* in detail it quickly becomes apparent that Giustiniani's assessment is the more accurate. Indeed, Bellori's version of Caravaggio as a naïve if powerful realist is a major falsification, prompted less by a sensitive response to Caravaggio's own pictures than a deeply ingrained prejudice against any kind of art which did not, in contrast to that of Annibale Carracci and his Bolognese followers, adhere to those 'classical' principles of idealization and mimetic gesture which derive ultimately from the late works of Raphael. It might also be added that the later seventeenth-century classic-idealist objection to Cara-

fig. 12 REMBRANDT van Rijn
Lucretia
Minneapolis, Minneapolis Institute of Arts (William Hood Dunwoody fund). 1666. Canvas 111 × 95 cm.

Although Rembrandt was too profoundly original to be considered a 'follower' of Caravaggio, he was obviously inspired by the Borghese *David* (Plate 67) in this late work. There are numerous correspondences of detail between the two pictures, and Rembrandt, strangely, even portrayed Lucretia apparently holding a bed-tassel, in order to perpetuate the clenched left fist of the figure in Caravaggio's picture. He was clearly impressed by the sophisticated structure of the pose and the way in which this helps to articulate the brooding, introspective mood. Having never visited Italy Rembrandt probably knew Caravaggio's *David* through a copy.

vaggio was in part the result of a somewhat uncritical confusion between his own paintings and those of his so-called followers. Bellori regarded Caravaggio as a malign influence on subsequent painters because his method of painting direct from the model, allegedly without modification, 'enabled them to make facile copies after nature'. And it must be admitted that many of the 'Caravaggisti' were so inspired by the naturalistic quality of Caravaggio's art they they tended to gloss over its more imaginative and calculated aspects and produce pictures which were, both in subject-matter and composition, far more straightforwardly realistic than his own. The Caravaggisti rarely treated subject-matter with the same degree of poetic insight and psychological complexity and paid far less attention than Caravaggio to composition. The tavern scenes of Manfredi (fig. 1) and Honthorst, atmospheric rather than explicit, are distinguished by their random, 'slice-of-life' grouping of figures, whereas Caravaggio's own works were more compactly and 'classically' composed. Indeed, it is one of the ironies of seventeenth-century art that some of Caravaggio's immediate following distorted the significance of his message for future generations by emphasizing his more obvious qualities at the expense of his finely balanced integration of naturalism, subject-matter and style. It took Rembrandt (fig. 12) or Georges de La Tour (fig. 13) to remind later seventeenth-century viewers just how subtly contrived Caravaggio's pictures were.

This element of contrivance, which Giustiniani had noted and valued, was part of Caravaggio's Renaissance heritage. In wedding imaginative design to realistically observed detail he was not only better able to illuminate meaning, but also actually extended tradition by creating a new and immaculate balance between the two Renaissance objectives of imitating nature and perfecting style. At no stage did he seek to supplant that tradition by completely subordinating style to observation as his seventeenth-century critics claimed.

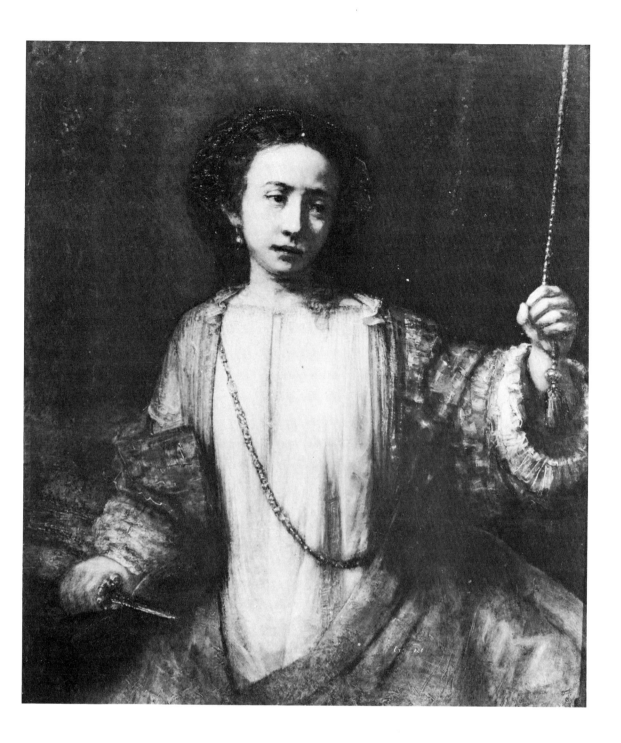

There is, nevertheless, an important distinction to be made between the way in which Caravaggio and Annibale attempted to reconcile scrutiny of nature with the requirements of art. Annibale came to rely more and more on a Raphaelesque formula of figurative idealization and short, sharp, expressive gestures to give his pictures a dramatic and formal unity (figs. 2 and 3). He consequently tended to produce frequently beautiful yet somewhat schematic images—particularly towards the end of his career—in which the fruits of direct observation co-exist uneasily with the elements of stylization. Caravaggio, by contrast, was more organic in his approach to composition, moulding his realistically studied figures into incisive, monumental groupings which are plausible and dignified without being stilted. Instead of

superimposing a formula on the raw material of nature, he counteracted and qualified the randomness of observation through an acute, intuitive feeling for pictorial structure. This is evident both in his treatment of detail where, for example, he frequently articulated the fingers of a hand in an unexpected and almost abstract way, as well as in his grasp of composition. While he did employ certain formulae in his compositions he rarely, if ever, did so in a mechanical way, but instead fashioned his figures into patterns which reflect rather than force their situation. One of his favourite and most original devices was that of an archway of figures, or a single figure in the form of an arch, which gives an additional and specific meaning to the term 'monumental' as applied to his art. Beginning with the single-figure *Narcissus* (Plate

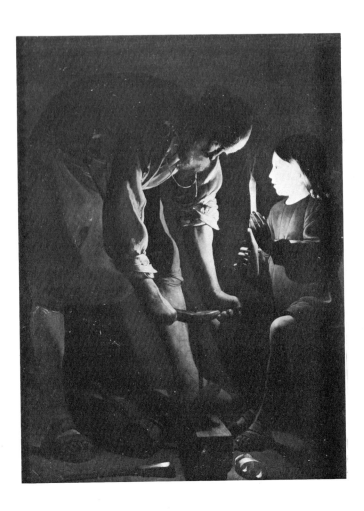

fig. 13 Georges de LA TOUR
Christ and Joseph in the Carpenter's Shop
Paris, Musée du Louvre. c. 1642. Canvas
137 × 101 cm.

La Tour may not have visited Italy, but
whether through contact with originals or
copies, he was undeniably influenced by the
powerful geometry of Caravaggio's works.
Anthony Blunt (*The Burlington Magazine*,
August 1972) has drawn attention to
compositional similarities between this picture
and the Cerasi Chapel *Conversion of Saul*
(Plate IV), but one might also detect them in
the uncertainly attributed Prado *David with the
Head of Goliath* (Plate 22).

fig. 14 Copy after CARAVAGGIO
Boy with a Vase of Roses
Atlanta, High Museum of Art (Great Painting
fund). Canvas 67·3 × 52·5 cm.

21) and developing in a number of permutations
through such works as the Cerasi Chapel *Conversion of
Saul* (Plate IV), *The Incredulity of St. Thomas* (Plate 32),
the Vatican *Entombment* (Plate 36), the Cremona *St.
Francis* (Plate 38), the Genoa *Ecce Homo* (Plate 46) and
the Rouen *Flagellation* (Plate 52), this motif reached a
peak of classical rigour in the great Valletta *Beheading of
John the Baptist* of 1608 (Plate VIII), in which the frozen
archway of figures looming over the prone body of the
saint is strategically placed in front of a much taller arch
of stone. Although such a device can be used to great
effect in characterizing the intense, bowed feelings of a
single figure like St. Francis, it is perhaps most effective
as a means of stressing the interaction, and also the
inseparability, of all the actors in a drama: the dead

Christ and his mourners; the living Christ and his
tormenters; St. John, the gaoler and his executioner,
together with the instigator of his death, Salome, and a
shocked bystander; even Narcissus and his reflection.

Caravaggio's originality and success lay in combining
such formal elements with a more direct approach to
depicting the model than anything that had gone
before. The realistic treatment of individual figures is
one of the most striking aspects of his style and is related
to the fact that he abandoned the time-honoured prac-
tice of making drawings and instead usually painted
straight onto the canvas without preparation. This gave
his renderings of the human figure a physical and
psychological immediacy lacking in the more deliberate
methods of Annibale Carracci, who arrived at his
finished compositions through several stages of drawing
and refinement. Indeed, Caravaggio's involvement
simply in studying the posed model seems to have been
so intense that one is conscious, on several occasions, of
the intrusion of the world of the studio into that of the
picture: a gesture held, and studied, for just a little too
long, as in the right-hand Apostle in the National
Gallery *Supper at Emmaus* (Plate 29); a drowsy figure
isolated on a tiny chair in a bare room and viewed, by

the artist, from above (Plate 12); a bolster protruding from underneath a drape where it supports a lounging god (Plate 8). Such signs of realistic ardour undoubtedly played a major part in freeing future generations from the tyranny of certain sixteenth-century artistic stereotypes, but realism was usually controlled and regulated in Caravaggio's own work by an overriding sense of design.

Caravaggio's bold new synthesis was, nevertheless, no mere juggling act. Design was for him a function of the method of painting direct from life, rather than a schematic imposition. Two of the most salient features of his mature art, his use of *chiaroscuro* and his close-up treatment of the figures, are best understood as developments from his passionate scrutiny of the model. The *chiaroscuro*, far from being simply atmospheric, was a formula for isolating and emphasizing the lit figures on a shallow foreground stage against a wall of darkness, while the close-up treatment aided this process by decreasing the area of surrounding space and thus forcing the figures themselves on our attention. A comparable ratio between figure and space is first evident in Italian art during the radical early phase of Mannerist experimentation in the 1520s, when Pontormo in particular embarked on a similarly concentrated analysis of interacting figures. Indeed, for all his greater degree of stylization, Portormo was perhaps Caravaggio's most brilliant precursor as a religious painter in the sixteenth century, and the structural similarity between their work seems more than accidental. It is, in fact, a consequence of a parallel approach to visible reality and artistic form, both artists assimilating the one to the other with the vigour of intense, unmediated perception rather than via a framework of assumptions and procedures. That Caravaggio opted for a far greater degree of realistic detail does not make him any less an heir to the Renaissance tradition, which had always granted genius a great degree of latitude to experiment in finding an expressive tension between the imitation of human action and its ordering through art.

Caravaggio's undoubted influence on future generations of often more prosaic painters has tended to conceal this indebtedness to the more universal ideals of the Renaissance. The directness and intensity of his vision certainly appealed to many artists who were more interested in copying the world than they were in interpreting it, but his own gift was poetic and dramatic as well as representational. His pictures, almost without exception, appeal to us today as profound meditations on human existence and their incisive grasp of timeless situations stands as much outside the history of stylistic development as his break with the habit of idealization forms a part of it.

FOOTNOTES

1. *Works*, 1, 192–3. Quoted in R. T. Petersson, *The Art of Ecstasy*, 1970, p. 40.
2. G. Brenan, *St. John of the Cross, his Life and Poetry*, 1973, p. 165.
3. F. Cummings, 'The Meaning of Caravaggio's "Conversion of the Magdalen" ', *The Burlington Magazine*, Oct. 1974, p. 577.
4. B. Nicolson, *The International Caravaggesque Movement*, 1979, p. 34. Illustrated, pl. 1.
5. G. Bottari, *Raccolta di lettere sulla pittura, sculptura ed architettura*, Rome, 1768, vol. VI, pp. 247–53. Trans. in R. Engass and J. Brown, *Sources and Documents in the History of Art Series, Italy and Spain, 1600–1750*, 1970, pp. 16–20.

BIOGRAPHY

Late 1571 Date of Caravaggio's birth. Although no baptismal certificate has been found, we know from numerous subsequent references that he was called Michelangelo Merisi or Amerigi. Caravaggio's birth was previously thought, on the basis of Milesi's epitaph of 1610, to have occurred in 1573 and presumed to have taken place in the small Milanese town of Caravaggio after which the artist was later called and where his family owned some land. But newly discovered documents show that Caravaggio's younger brother, Giovanni Battista, was baptised in Milan in November 1572. Indeed, Caravaggio's father is documented as living in Milan at the time of his first marriage in 1563. The new date of birth has been calculated on the basis of a document of sale of 25 September 1589, in which Caravaggio declared himself to be eighteen years old. His father, Fermo Merisi, was professionally qualified, was described as 'magister' in various documents and may have been, as Mancini related (c. 1620), the *maestro di casa* and architect of the Marchese di Caravaggio. He married Caravaggio's mother, Lucia Aratori, after the death of his first wife (c. 1569?), in the Church of Santi Pietro e Paolo at Caravaggio on 14 January 1571. Caravaggio was, therefore, probably born in the latter part of that year, either in Caravaggio itself or in Milan.

4 November 1572 Baptism of Caravaggio's younger brother, Giovanni Battista, in the Church of Santa Maria in Passerella, Milan.

18 February 1578 The guardianship of Michelangelo da Caravaggio and his brothers and sister was invested in their mother, their father having died intestate. By 1578 there were four children, listed, in order, as Michelangelo, Giovanni Battista, Giovanni Pietro and Caterina. The family later moved back to Caravaggio.

6 April 1584 Caravaggio was apprenticed for a period of four years to Simone Peterzano, a leading Milanese artist who styled himself a pupil of Titian, but was also strongly influenced by the ideas of late Mannerism and was a close friend of the art theorist Lomazzo.

25 September 1589 Caravaggio sold half of a piece of land in Caravaggio for 350 Imperial lire with the option of buying it back after five years for the same sum. This possibly suggests that he was thinking of opening a studio, his apprenticeship having been completed over a year beforehand, or of travelling: Bellori (1672) reported that he went to Venice at some time prior to his arrival in Rome. If he did travel, he was again in Caravaggio in June and July 1590 and March 1591, when further sales of land, made jointly with his younger brother, Giovanni Battista, were recorded. It seems from these documents that the family was in some financial difficulties.

1590/92 Death of Caravaggio's mother.

11 May 1592 Michelangelo, Giovanni Battista and Caterina had the family property divided between them, which suggests the death at some earlier date of the youngest brother, Giovanni Pietro. Despite his seniority, Caravaggio received only a modest part of the estate, mostly in cash, as distinct from his brother who came into possession of the greater part of the land and the family house at Porta Folceria in Caravaggio. This cash settlement possibly indicates that Caravaggio was intent on leaving his home town and tallies with Mancini's later statement that he left for Rome at about the age of twenty.

Late 1592 Caravaggio probably arrived in Rome where, according to the document of 11 May 1592, he had an uncle, Ludovico, who was a priest.

1592–1596 The first few years in Rome have left no trace in contemporary documents. Caravaggio's later biographers, however, allow us to reconstruct a tentative picture of his movements from one studio to another in search of employment and fame, although it is not possible to link extant pictures with all of these phases or always to place the phases in a precise sequence. The artist seems to have worked first of all for Lorenzo Siciliano, a Sicilian who specialized in manufacturing crudely painted heads for the open market, and for whom, according to Bellori's marginal notes to Baglione's *Vite*, 'being very poor indeed, and virtually naked, he [Caravaggio] painted heads for a groat apiece and produced three a day.' It was probably here that he met the Sicilian painter, Mario Minniti, who, many years later in 1608, was, according to Susinno, responsible for

gaining Caravaggio the commission to paint *The Burial of St. Lucy* (Plate 60) in Syracuse. He also spent some time in the house of a priest named Pandolfo Pucci of Recanati, but this seems to have been a lodging in exchange for certain domestic duties rather than a place of work. Caravaggio reputedly left after a few months because of Pucci's meanness and failure to feed him properly. According to Mancini, Caravaggio, in what is the earliest recorded instance of his satirical sense of humour, nicknamed Pucci 'Monsignor Insalata'. He may also have worked for a while at some stage with the Sienese painter, Antiveduto Gramatica, and it was probably also fairly early on that he was admitted to the Hospital of the Consolazione for the treatment of an injury he had sustained as the result of a horse-kick, painting a number of pictures during his convalescence for the prior of the hospital who, according to Mancini, took them with him to his homeland, which was probably Seville (see Plate 5). But no pictures have yet been linked precisely with any of these phases in Caravaggio's life, and they have generally been regarded as artistically relatively unimportant. By contrast, the period, mentioned only in passing by Mancini but given great emphasis by Bellori, which Caravaggio spent in the house of the Cavaliere d'Arpino, one of the leading painters of his day, has been considered crucial and formative. It may either have preceded or followed his stay at the hospital. This emphasis is partly due to the fact that two pictures by Caravaggio later confiscated from d'Arpino's studio (Plates I and 1) have been logically assumed to date from this period, partly because Bellori recounted that 'he was employed by him to paint flowers and fruits, which he imitated so well that from here on they began to attain the high degree of beauty so fully appreciated today' (and indeed, a number of Caravaggio's early pictures do at least *contain* flowers or fruit) and partly because d'Arpino's circle was renowned for just that sophisticated symbolism which we encounter in certain of Caravaggio's early works. Caravaggio did not stay very long with d'Arpino, however, and, to judge from a number of later references, developed a personal hostility towards him. He then seems to have set up on his own and to have attempted, with the aid of a well-known and well-connected painter of 'grotesques', Prospero Orsi, to sell his pictures to a more discerning class of patron than in his days with Lorenzo Siciliano. It was probably at this point that he spent some time in the house of Monsignor Petrignani, who had arrived in Rome in 1595, but Caravaggio was apparently working for himself rather than for Petrignani as a patron. It is, however, not clear how long he stayed with Petrignani or whether he stayed there after he had established links with Cardinal Francesco del Monte, to whose palace he moved at some stage. Caravaggio sold some pictures, including *The Cardsharpers* (Plate 9), to Cardinal del Monte and was henceforth well-patronized by this discerning and influential patron, a leading member of the papal Curia.

1596/97 Caravaggio was given rooms in del Monte's palace, where he stayed until at least November 1600. His friend Mario Minniti was also lodged in the palace. Bellori implied that Caravaggio was brought to del Monte's attention through the efforts of Prospero Orsi, while Baglione stated that the cardinal saw some of his pictures in the shop of an art dealer named Valentino, near the Church of San Luigi dei Francesi. These two accounts are not necessarily mutually exclusive.

26 October 1596 A document recording the sale of some of the artist's land in Caravaggio attests to the presence in Rome of Caravaggio's younger brother, the cleric Giovanni Battista, a fact which gives additional weight to Mancini's anecdote about Caravaggio's refusal to recognize his brother during an encounter in Cardinal del Monte's palace.

23 July 1599 Caravaggio received the commission for the two lateral paintings in the Contarelli Chapel of the Church of San Luigi dei Francesi (Plates III and 24). It was his first public commission and he undertook to complete the work within one year for a fee of 400 scudi.

4 July 1600 Caravaggio received a final payment of fifty scudi for the completed pictures of *The Calling of St. Matthew* (Plate 24) and *The Martyrdom of St. Matthew* (Plate III) in the Contarelli Chapel.

24 September 1600 Caravaggio was commissioned to paint two paintings of *The Conversion of St. Paul* (Plate 27) and *The Crucifixion of St. Peter* (see Plate 28) for a chapel acquired by Monsignor Tiberio Cerasi in the Church of Santa Maria del Popolo for the fee of 400 scudi, to be completed within eight months.

25 October 1600 Caravaggio was referred to in a court testimony made by his friend Onorio Longhi, the architect, who was accused of insulting and assaulting a painter called Marco Tullio. Longhi said that Caravaggio, who was at the time recovering from an illness and had a boy carrying his sword for him, separated Longhi and Tullio without, however, unsheathing his sword: 'It was Marco Tullio who seized the scabbard and flung it at me. Michelangelo could hardly stand; so he could not draw the sword.'

19 November 1600 The first recorded complaint against Caravaggio in the Roman police records concerned an accusation by one Girolamo Stampa of Montepulciano of unprovoked assault.

7 February 1601 There is a record of settlement out of court of another case of armed assault brought against Caravaggio by Flavio Canonico, a former sergeant of the guards at the Castel Sant' Angelo.

10 November 1601 Caravaggio received the final payment for the finished, second-version Cerasi Chapel pictures (Plates IV and 28).

9 January 1602 A document refers to the fact that a *Deposition* for the 'Chiesa Nuova' was already commissioned from Caravaggio (Plate 36).

7 February 1602 Caravaggio was commissioned to paint an altarpiece of St. Matthew writing the Gospel, with an angel dictating to him, to replace Cobaert's sculpture group which was disliked by the new Rector of the Congregation of San Luigi dei Francesi, Francesco Contarelli. Caravaggio undertook to paint it (Plate 25) by 23 May 1602 for 150 scudi. He probably completed this work on time, but it was considered unsatisfactory and he was asked to paint a second version (Plate 26).

22 September 1602 Final payment for the second *St. Matthew and the Angel*.

28 August 1603 The first day of a lengthy libel action brought against Caravaggio, Onorio Longhi, Orazio Gentileschi and Filippo Trisegni by the painter Giovanni Baglione, an artistic rival and future biographer of Caravaggio, for writing and disseminating scurrilous verses about him and his works. These were prompted, according to Baglione, by Caravaggio's annoyance at the fact that Baglione had been chosen instead of him to paint a picture of the Resurrection in the Church of the Gesù. Caravaggio denied writing the verses, but at the same time admitted that he did not think Baglione was a good painter. In a revealing statement he defined a good painter as one who 'knows how to paint well and to imitate well natural things', yet included in this category artists as stylistically different as Annibale Carracci, the Cavaliere d'Arpino, Federico Zuccari, Il Pomarancio and Antonio Tempesta, which suggests that his taste was fairly catholic. What he seemed to value above all was competence; Baglione's *Resurrection* was unsatisfactory because it was 'clumsy'.

14 September 1603 As part of his evidence in the same trial, Orazio Gentileschi said that 'it must be six to eight months since I last spoke to Caravaggio, although he sent to my house for a Capuchin's frock, which I lent him, and for a pair of wings which he sent back to me about ten days ago.' It is difficult to connect the wings with known pictures, *Victorious Love* (Plate 34), according to Gentileschi's own testimony, having been done some time before, and the first *St. Matthew and the Angel* (Plate 25) having certainly been finished in 1602. The Capuchin's frock, however, may have been connected with the picture of St. Francis at Carpineto Romano (see Plate 37). The trial seems to have petered out, with Caravaggio still held prisoner, until he was released on 25 September on surety from the French ambassador.

2 January 1604 A letter from Lancellotto Mauruzi sent from Rome to the priors of his native city, Tolentino, informs us that Caravaggio had arrived in Tolentino to paint an unnamed picture for the high altar of the church of the Capuchins, Santa Maria di Constantinopoli. The picture has not been identified.

24/25 April 1604 A waiter from the Albergo del Moro brought a complaint against Caravaggio for throwing a plate of artichokes at him and threatening him with a sword; the former was confirmed, the latter denied by another witness.

20 October 1604 and 18 November 1604 Caravaggio was arrested on two separate occasions for further disturbances.

16 February 1605 Caravaggio brought a petition concerning a rug which a certain Alessandro Ricci had allegedly stolen from him.

28 May 1605 Caravaggio was arrested again, in the early hours of the morning, for carrying a sword and dagger without a licence.

20 July 1605 The artist was again in prison for insulting a certain Laura and her daughter Isabella.

29 July 1605 Mariano Pasqualone of Accumulo, a notary, testified that he was wounded in the back of the head by Caravaggio while walking in the Piazza Navona, in consequence, Pasqualone guessed, of a quarrel they had had a few days earlier concerning a girl called Lena who frequented the Piazza Navona: 'She is Michelangelo's girl.'

Early August 1605 Caravaggio fled to Genoa to escape arrest.

26 August 1605 Caravaggio was back in Rome, the affair having been settled out of court.

August 1605—July 1606 Letters from Fabio Masetti to Giovanni Battista Laderchi concerning a picture which Caravaggio was meant to be painting for Cesare d'Este, Duke of Modena. Though the picture may have been

begun before Caravaggio left Rome in June 1606, it was certainly unfinished. Friedlaender has tried to link the work with the *Madonna of the Rosary* (Plate VII), but his theory is at best unproven.

1 September 1605 Another complaint was lodged against Caravaggio, this time by Prudenzia Bruna, for throwing stones at the window of her house in the Campo Marzio. He apparently owed her six months' rent for a house which he had rented from her; this not being paid, she obtained a warrant to take possession of certain of his belongings left in the house at the time he was arrested in connection with the wounding of Pasqualone: 'That's why, I believe, he broke my Venetian blind—to annoy me.'

24 October 1605 Caravaggio was wounded in the throat and left ear by an unknown assailant. He claimed that he fell on his own sword.

8 April 1606 Caravaggio's only surviving signature, apart from the partial one on *The Beheading of St. John the Baptist* (Plate VIII), is on a document of this date recording the final payment to him by the Confraternity of Sant' Anna dei Palafrenieri for the *Madonna of the Serpent* (Plate 48).

29 May 1606 Caravaggio killed Ranuccio Tommasoni of Terni in a dispute arising from a game of tennis which they had been playing in the Campo Marzio. He then fled from Rome and spent some time in hiding on the estates of the Principe Marzio Colonna at Paliano, Zagarolo and Palestrina, in the hills south of Rome.

Late September/early October 1606 Caravaggio moved to Naples.

6 October 1606 Document recording a commission from Nicolò Radolovich of Bari to Caravaggio for a picture of thirteen and two-thirds *palmi* high by eight and one-half *palmi* wide, to be completed by December and priced at 200 ducats. It was to contain figures of the Madonna and Child surrounded by choirs of angels in the top half and underneath St. Dominic and St. Francis embracing in between St. Nicholas on the right and St. Vitus on the left. The work is not known.

9 January 1607 Caravaggio received the final payment for the *Madonna of Mercy* (Plate VI), painted for the Governors of the Confraternity of Pio Monte della Misericordia in Naples.

11 May 1607 and 29 May 1607 Payments made by Tommaso de Franchis to Caravaggio, probably for the Naples *Flagellation* (Plate 51).

14 July 1607 A newly discovered document of the Inquisitor's court at Vittoriosa shows that Caravaggio was already in Malta by 14 July 1607, enjoying the company of several Knights. He gave evidence on 26 July concerning a charge of bigamy brought against an unnamed painter of Greek origin. Caravaggio denied that he had heard anything that would confirm the accusation during time spent with the accused and others at the house of Fra Giacomo Marchese on 14 July.

September 1607 The *Madonna of the Rosary* (Plate VII) and a *Judith and Holofernes* by Caravaggio were for sale on the Naples art market. Both works were later bought by the Flemish painter Finson.

14 July 1608 Caravaggio was made a Knight of Obedience of the Order of the Knights of St. John of Jersualem (the Knights of Malta).

6 October 1608 A commission was appointed to organize a search for Caravaggio, who had, meanwhile, made a daring night-time escape from prison in the Castel Sant' Angelo, Vittoriosa. We are not certain why he was put there in the first place, but Bellori said that 'all of a sudden his turbulent nature brought his prosperity to an end and caused him to lose the favour of the Grand Master; because of a very inopportune quarrel with a most noble Knight he was thrown into prison and subjected to misery, fear and maltreatment.' It may be that the knights helped him to escape from this impregnable fortress in order to avoid the embarrassment of having to punish, and perhaps even to execute, so famous a painter.

October 1608 Caravaggio fled to Syracuse, on the east coast of Sicily.

1 December 1608 Caravaggio was expelled, *in absentia*, from the Order of the Knights of St. John: 'thrust forth like a rotten and fetid limb from our Order and Community'.

Late 1608/early 1609 Caravaggio moved up the Sicilian coast to Messina.

10 June 1609 Note recording the delivery of Caravaggio's picture of *The Raising of Lazarus* (Plate 61) to Giovanni Battista de' Lazzari's chapel in the Church of the 'Padri Crociferi', Messina. He was referred to as 'Knight of Jerusalem', so his expulsion from the Order cannot have been heard of.

Before August 1609 A memorandum by the Messinese Niccolò di Giacomo records that he had commissioned four scenes of the Passion from Caravaggio, was already in possession of one of them, *Christ Carrying the Cross*, and had insisted on receiving the others by the end of August.

August/September 1609 Caravaggio spent a brief spell in Palermo. He possibly kept on the move in order to elude the agents of the Knights of Malta, who may or may not have been pursuing him, but whom he must have feared anyway, although Susinno related a more salacious story about how the artist had to leave Messina in a hurry because he had wounded a schoolteacher who had objected to the undue interest which Caravaggio seemed to be showing in some of his boys.

September/October 1609 Caravaggio was back in Naples.

24 October 1609 Message to Francesco Maria della Rovere, Duke of Urbino, from his informers in Rome that 'word has been received from Naples that the famous painter Caravaggio has been killed, and others say disfigured'. In fact, the artist was badly wounded in the face. Whether one considers this to have been the work of the Knights of Malta, as Bellori stated, depends to some extent on whether one accepts the view that Caravaggio could have escaped from the dungeon of the Castel Sant' Angelo only with their connivance, although the attack could, of course, have been carried out unofficially by a group of knights pursuing their own vendetta. It is probable that Caravaggio took a long time to convalesce, and this may in part account for the fact that we find it so difficult to link more than a handful of surviving works, and these hesitantly, with his second stay in Naples.

Late July 1610 Death of Caravaggio at Port' Ercole 'while he was on his way back from Naples to Rome because he had been granted pardon by His Holiness from the sentence of banishment which he was under for capital crime' (contemporary newspaper notice). The fact that Port' Ercole is north of Rome, however, suggests that Caravaggio had not yet heard of the papal pardon and, perhaps, was sailing instead for Genoa, the home town of Ottavio Costa and Vincenzo Giustiniani.

BIBLIOGRAPHY

The Caravaggio literature is vast and growing all the time. Full bibliographies up to the early 1970's can be found in Spear, Cinotti and Marini (see below). Anyone interested in the artist would be well advised to delve regularly into *The Burlington Magazine*, which frequently publishes news of the latest research, exhibitions and discoveries concerning Caravaggio.

All the significant early biographies—those by Van Mander, Mancini, Baglione, Bellori and Sandrart—with the exception of Susinno, are translated in Friedlaender's *Caravaggio Studies*; but, for Guilio Mancini, see also the modern edition of his *Considerazioni sulla pittura*, ed. Marucchi and Salerno, Rome, 1956-57. For Susinno, see Susinno F.: *Le Vite de' Pittori Messinesi*, 1724, ed. V. Martinelli, Florence, 1960.

Some of the more important twentieth-century studies dealing with Caravaggio or other aspects of his period are listed below. This is followed by a fuller list of recent literature.

Askew, P., 'The Angelic Consolation of St. Francis of Assisi in Post-Tridentine Italian Painting', *Journal of the Warburg & Courtauld Institutes*, XXXII, 1969, 280–306.

Baumgart, F., *Caravaggio, Kunst und Wirklichkeit*, Berlin, 1955.

Borea, E., ed., *Caravaggio e Caravaggeschi nelle Gallerie di Firenze*, (exhibition catalogue), Palazzo Pitti, Florence, 1970.

Borla, S., 'L'Ultimo Percorso del Caravaggio', *Antichità Viva*, VI, 1967, no. 4, 3–14.

Boschloo, A. W. A., *Annibale Carracci in Bologna. Visible Reality in Art after the Council of Trent*, 2 vols., Staatsdrukkerij/'s-Gravenhage, 1974.

Brenan, G., *St. John of the Cross, his Life and Poetry*, Cambridge, 1973.

Causa, R., *Opere d'arte nel Pio Monte della Misericordia a Napoli*, Cava dei Tirreni/Naples, 1970.

Cinotti, M., ed., *Immagine del Caravaggio*, catalogue of an exhibition held in Bergamo, Caravaggio and Brescia, 1973. (Contains good, up-to-date compilation of documents, although the information in the catalogue is not always accurate).

Engass, R., '*La virtù di un vero nobile*. L'Amore Giustiniani del Caravaggio', *Palatino*, XI, 1967, 13–20.

Engass, R. & Brown, J. (eds), *Sources and Documents in the History of Art series, Italy and Spain, 1600–1750*, New Jersey, 1970.

Freedberg, S. J., *Painting in Italy, 1500–1600*, revised ed., Harmondsworth, 1975.

Friedlaender, W., *Caravaggio Studies*, Princeton, 1955.

Frommel, C., 'Caravaggios Frühwerk und der Kardinal Francesco Maria del Monte', *Storia dell'Arte*, 1971, n. 9–10, 5–52.

Haskell, F., *Patrons and Painters*, London, 1963.

Hess, J., 'The Chronology of the Contarelli Chapel', *The Burlington Magazine*, XCIII, 1951, 186–201. (see also Rottgen).

Hess, J., 'Modelle e modelli del Caravaggio', *Commentari*, V, 1954, 271–89.

Hinks, R., *Michelangelo da Caravaggio*, London, 1953.

Hinks, R., *Caravaggio's 'Death of the Virgin'*, Charlton Lecture, Newcastle upon Tyne; Oxford Univ. Press, 1953.

Hirst, M., Letter on Rembrandt and Caravaggio's *David*, *The Burlington Magazine*, April 1968, 221.

Jullian, R., *Caravage*, Lyon–Paris, 1961.

Kitson, M., *The Complete Paintings of Caravaggio*, London, 1969.

Longhi, R., *Il Caravaggio*, Milan, 1952. Reprinted with a few revisions, Rome/Dresden, 1968. (See also the volumes of his *Opere Complete* (Complete Works), which are in the process of being brought out by *Sansoni*. Among those which have already appeared, especially vols. I, II & IV).

Macrae, D., 'Observations on the Sword in Caravaggio', *The Burlington Magazine*, CVI, Sept. 1964, 412–16.

Mahon, D., *Studies in Seicento Art and Theory*, London, 1947.

Mahon, D., 'Egregius in Urbe Pictor: Caravaggio Revised', *The Burlington Magazine*, XCIII, 1951, 223–34.
Mahon, D., 'Addenda to Caravaggio', *The Burlington Magazine*, XCIV, 1952, 3–23.
Mahon, D., 'On Some Aspects of Caravaggio and His Times', *The Metropolitan Museum of Art Bulletin*, XII, 1953, 33–45.
Mahon, D., Entry on the Capitoline *St. John* in *Artists in 17th century Rome*, Wildenstein exhibition catalogue, London 1955.
Mahon, D., 'A Late Caravaggio Rediscovered', *The Burlington Magazine*, XCVIII, 1956, 225–8.
Mâle, E., *L'Art Religieux de la fin du XVIe siècle, du XVIIe siècle, et du XVIIIe siècle*, Paris, 1972.
Marangoni, M., *Il Caravaggio*, Florence, 1922.
Marini, M., *Io Michelangelo da Caravaggio*, Rome, 1974. (The most comprehensive monograph, with excellent illustrations and much comparative material. It is, nevertheless, to be used with caution since it contains a number of bizarre attributions and factual errors).
Moir, A., *The Italian Followers of Caravaggio*, Cambridge, Mass., 1967.
Pérez-Sánchez, A. E., ed., *Caravaggio y el Naturalismo español*, catalogue of an exhibition held in Seville, 1973.
Posner, D., 'Caravaggio's Homo-Erotic Early Works', *The Art Quarterly*, XXXIV, 1971, 301–24.
Posner, D., *Annibale Carracci*, 2 vols., London, 1971.
Röttgen, H., 'Die Stellung der Contarelli-Kapelle in Caravaggios Werk', *Zeitschrift für Kunstgeschichte*, XXVIII, 1965, 47 ff. (Redates the Contarelli Chapel pictures on documentary evidence).
Röttgen, H., 'Caravaggio—probleme', *Münchner Jahrbuch der Bildenden Kunst*, XX, 1969, 143–70.
Röttgen, H., *Il Cavalier d'Arpino*, catalogue of an exhibition held in Rome, 1973.
Salerno, L., 'Caravaggio e il Priore della Consolazione', *Commentari*, VI, 1955, 258–60.
Salerno, L., 'The Picture Gallery of Vincenzo Giustiniani', *The Burlington Magazine*, C11, 1960; Jan., 21–7; March, 93–104; April, 135–48.
Salerno, L., Kinkead, D., & Wilson, W., 'Poesia e Simboli nel Caravaggio', *Palatino*, X, 1966, 106–17.
Sammut, E., *Caravaggio in Malta*, Malta, 1951.
Spear, R., *Caravaggio and his Followers* (exemplary catalogue of the 1971 Cleveland exhibition), revised ed., N.Y., 1975.
Venturi, L., *Studi radiografici sul Caravaggio* (Atti della Accademia Nazionale dei Lincei, Memorie, V, no. 2), Rome, 1952.
Waterhouse, E., *Italian Baroque Painting*, London, 1962.
Willaert, L., *Après le Concile de Trente, La Restauration Catholique (1563–1648)*, Brussels, 1960. Vol. 18 of *Histoire de L'Eglise*, ed. Fliche and Martin.
Wittkower, R., *Art and Architecture in Italy, 1600–1750*, 3rd revised ed., Harmondsworth, 1973.

More recent literature—in chronological order
Lavin, I., 'Divine Inspiration in Caravaggio's Two St. Matthews', *Art Bulletin*, Mar. 1974, vol. LVI, 101, 59–81.
Special issue of *The Burlington Magazine* devoted to Caravaggio and the Caravaggesques, CXVI, no. 859, Oct. 1974. This contains the following useful articles:—
Greaves, J. L. & Johnson, M., 'New findings on Caravaggio's technique in the Detroit "Magdalen" ', 564–72.
Cummings, F., 'The meaning of Caravaggio's "Conversion of the Magdalen" ', 572–78.
Spezzaferro, L., 'The Documentary Findings: Ottavio Costa as a Patron of Caravaggio', 579–86.
Salerno, L., 'The Art-Historical Implications of the Detroit "Magdalen" ', 586–93.
Gregori, M., 'A New painting and some Observations on Caravaggio's Journey to Malta', 594–603.
Nicolson, B., 'Caravaggio & the Caravaggesques: Some Recent Research', 603–16.
Nicolson, B., 'Review of Marini's book', 624–5.
Röttgen, H., *Il Caravaggio, Ricerche e Interpretazioni*, Rome, 1974.
Colloquio sul tema Caravaggio e i Caravaggeschi, Rome, 1974. (Contributions by Argan, Bologna, Brandi, de Salas, Pérez-Sánchez, Reznicek, Salmi etc.).
Bologna, F., *Il Caravaggio nella cultura e nella società del suo tempo*, Rome, 1974.
Vsevolozhskaya, S. and Linnik, I., *Caravaggio and his Followers—Paintings in Soviet Museums*, Leningrad, 1975.
Potterton, H., *The Supper at Emmaus by Caravaggio*. Pamphlet. *Painting in Focus no. 3*, The National Gallery, London, 1975.
Wind, B., 'Genre as Season: Dosso, Campi, Caravaggio', *Arte Lombarda*, 42/43, 1975, 70–3.
Cinotti, M. (ed.), *Novità sul Caravaggio*, Regione Lombardia, 1975.
Moir, A., *Caravaggio and his Copyists*. New York, 1976.
Dempsey, C., Review of Boschloo's *Annibale Carracci in Bologna*, *Art Bulletin*, March 1976, 129–31.

Gregori, M., 'Addendum to Caravaggio: The Cecconi *Crowning with Thorns* reconsidered', *The Burlington Magazine*, CXVIII, no. 883, Oct. 1976, 671–80.

Lurie, A. T. and Mahon, D., 'Caravaggio's Crucifixion of Saint Andrew from Valladolid', *The Bulletin of the Cleveland Museum of Art*, Jan. 1977, 3–24.

Cuzin, J.-P., *La Diseuse de bonne aventure de Caravage* (Les dossiers du départment des peintures, 13), Musée du Louvre, Paris, 1977.

Scribner, Charles III, '*In Alia Effigie*: Caravaggio's London *Supper at Emmaus*', *Art Bulletin*, September, 1977, Vol. LIX, no.3, 375–82.

Pacelli, V., 'New Documents concerning Caravaggio in Naples', *The Burlington Magazine*, CXIX, no. 897, Dec. 1977, 819–29.

Azzopardi, J. (ed.), *The Church of St. John in Valletta, 1578–1978*. Exhibition catalogue, Malta, June 1978.

Bardon, F., *Caravage ou l'expérience de la matière*, Paris, 1978.

Nicolson, B., *The International Caravaggesque Movement*, Oxford, 1979.

Note on the Plates

I have included all surviving pictures which I consider to be by Caravaggio, three originals which were destroyed in the 1939–45 War (Plates 14, 25 and 43), two which are lost (Plates 9 and 63) and one or two which may be either originals or faithful copies. It has been impossible, for reasons of space, to include a number of other copies of lost originals or illustrations of disputed works which I do not regard as autograph—for example *David and the Head of Goliath* in the Kunsthistorisches Museum, Vienna. Very few of Caravaggio's paintings can be dated precisely, so I have adopted the device of a vertical stroke to indicate that a work was probably produced *at some time* between the enclosing dates, the whole preceded by a small 'c' when even this seems too specific. All Caravaggio's paintings are in oil, although the results of some recent laboratory analyses suggest that the artist may have combined this on occasion with egg tempera. This *would appear to be* the case with the Detroit *Conversion of the Magdalen* (Plate 16), and the National Gallery *Supper at Emmaus* (Plate 29) and *Salome* (Plate 53). Tests carried out at the National Gallery, London, however, have not fully confirmed Meryl Johnson's belief that Caravaggio deliberately applied tempera onto a *wet* surface of oil in order to achieve an additional translucence in the white highlights. I am grateful to Joyce Plesters for detailed information regarding the technical condition of the two National Gallery pictures.

I *The Boy with a Garland of Ivy*, called the *Bacchino Malato*
ROME, Galleria Borghese. 1593/94. Canvas 67 × 53 cm.

Among the pictures sequestered from the house of the Cavaliere d'Arpino in 1607, this picture is described, without attribution, in the inventory of confiscated works as a 'small picture of a youth with a garland of ivy, and a bunch of grapes in his hand'. It was then given by Pope Paul V to his nephew, Cardinal Scipione Borghese, and has remained in the Borghese collection ever since. First referred to as a *Bacchus* by Caravaggio in the Borghese inventory of 1693, it is now widely accepted as an original. Although the pose, and our information on Caravaggio's practice at the time he was working in d'Arpino's studio (c. 1593/94), would suggest that he used himself as a model, the iconography still presents certain problems. In the first place it is difficult to reconcile the traditional designation as *Bacchus* with the fact that the youth is wearing an ivy-wreath: ivy was certainly a plant sacred to Bacchus, but his own wreath is normally of vine leaves, or vine leaves intertwined with ivy. Indeed, it may be that early attempts to catalogue the picture as *A Satyr*, for example in the Borghese inventory of 1790, were not so misguided, since the ivy-wreath was one of the attributes of these bacchic followers. This might also account for the figure's peculiar colouring, which Roberto Longhi ingeniously assumed to be an indication of sickness, arguing that the picture was a self-portrait painted by Caravaggio while he was recovering from a hypothetical bout of malaria in the Hospital of the Consolazione—hence the *Bacchino Malato*. We now know, from Mancini's account, that Caravaggio was, in fact, the victim of a horse-kick. Any explanation of the subject which is too straightforward, however, ignores not only Caravaggio's powerful originality but also the sophisticated, allusive and sometimes complex symbolism popular during the 1590s in the circle around d'Arpino. As the work was probably painted while Caravaggio was working in d'Arpino's studio, it is possible to see in the painting a reference to the elegiac poet, described in Alciati's popular *Emblemata* (1546 edition, p. 21v.) as a pale youth garlanded with ivy.

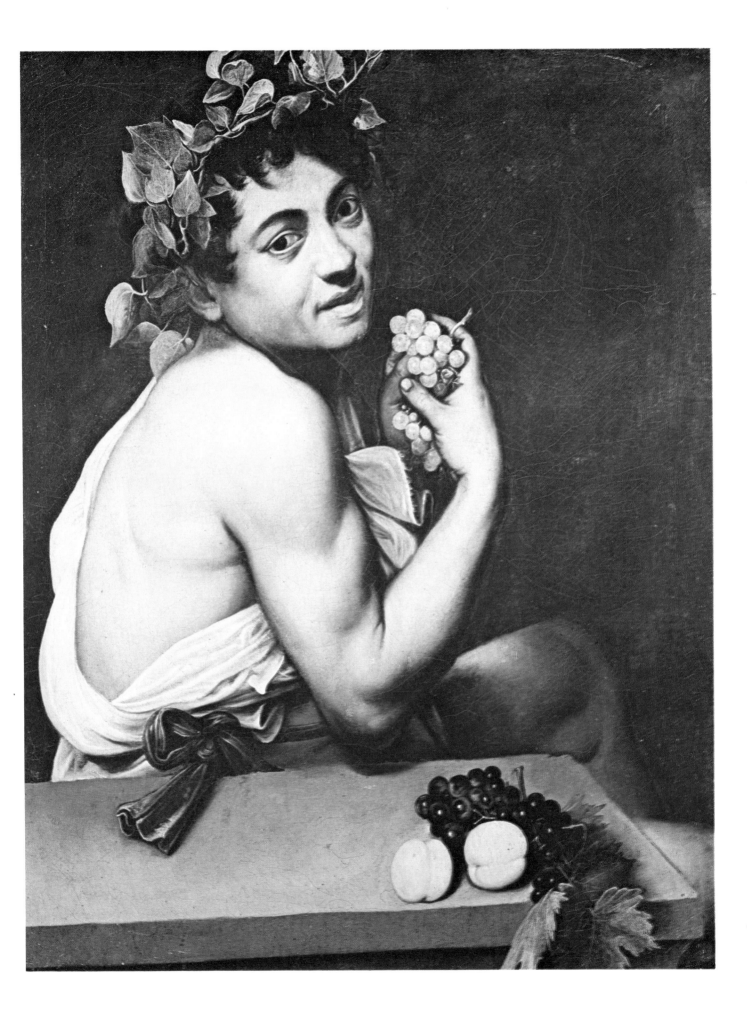

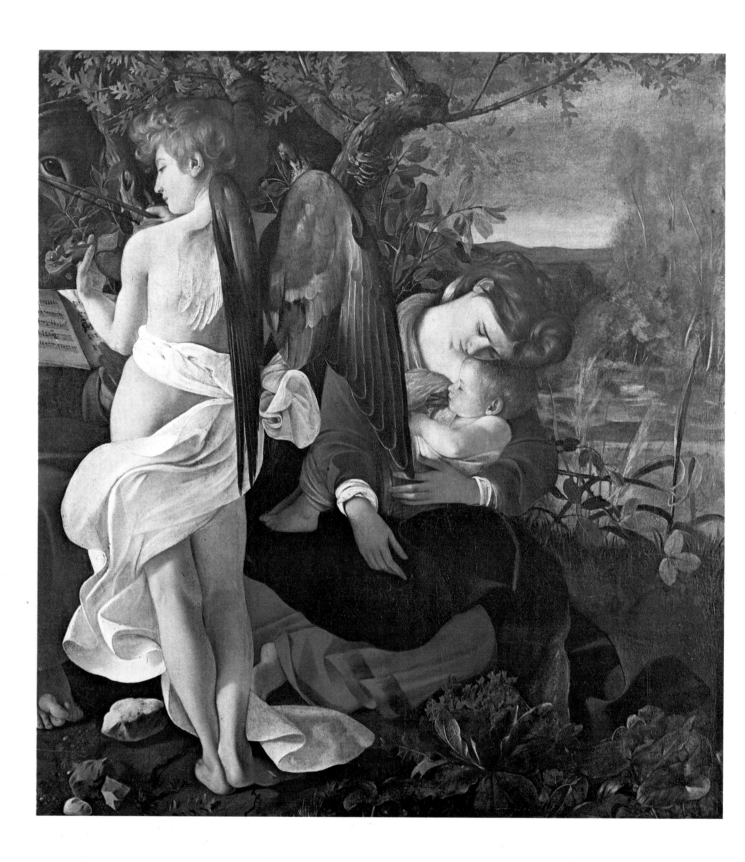

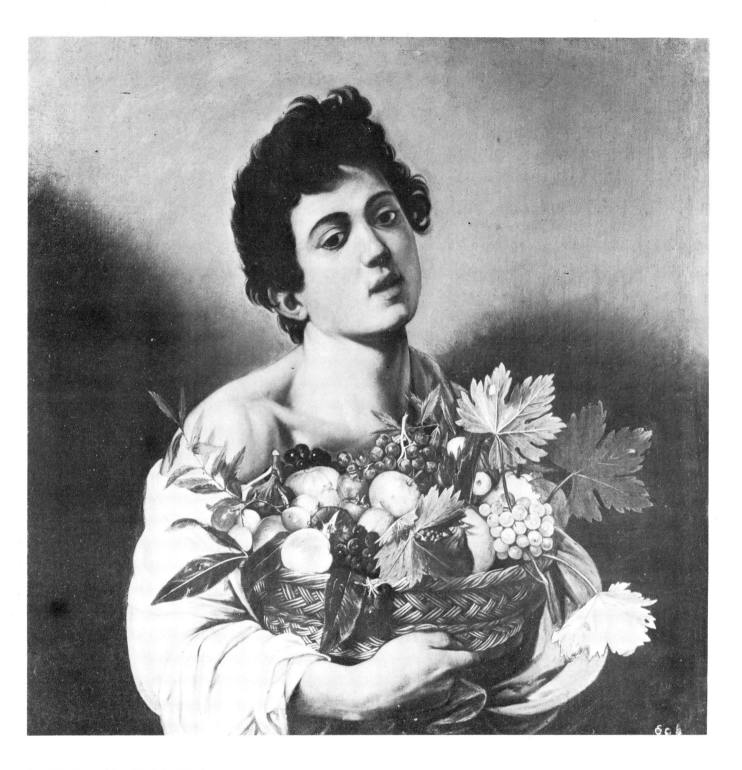

1 *The Boy with a Basket of Fruit*
ROME, Galleria Borghese. 1593/94. Canvas 70 × 67 cm.

The Boy with a Basket of Fruit has a similar history to *The Boy with a Garland of Ivy* (Plate I) and was also part of the d'Arpino confiscation of 1607. Described, without attribution, in the inventory of confiscated works, it was first referred to as by Caravaggio ['Garavagna'] in the Borghese inventory of 1693 and is now almost universally accepted. The image is a powerful yet ambiguous one as the youth simultaneously proffers and clings to his basket of fruit. Baskets of fruit were attributes of the satyrs, and it may be that we have here, as in *The Boy with a Garland of Ivy*, a humanized and idealized representation of one of Bacchus's entourage. But the theme of love (physical love, as indicated by the bare right shoulder) seems intended additionally and, indeed, the sexual suggestiveness so typical of several of Caravaggio's early works is here such a prominent feature that it diverts attention from more specific iconographical references. Yet baskets of fruit were used to symbolize both the sense of taste and the season of autumn, and it seems likely that Caravaggio deliberately linked these two symbolic allusions with the erotic characterization in order to convey the transience of love.

II *The Rest on the Flight into Egypt*, detail
ROME, Galleria Doria-Pamphili

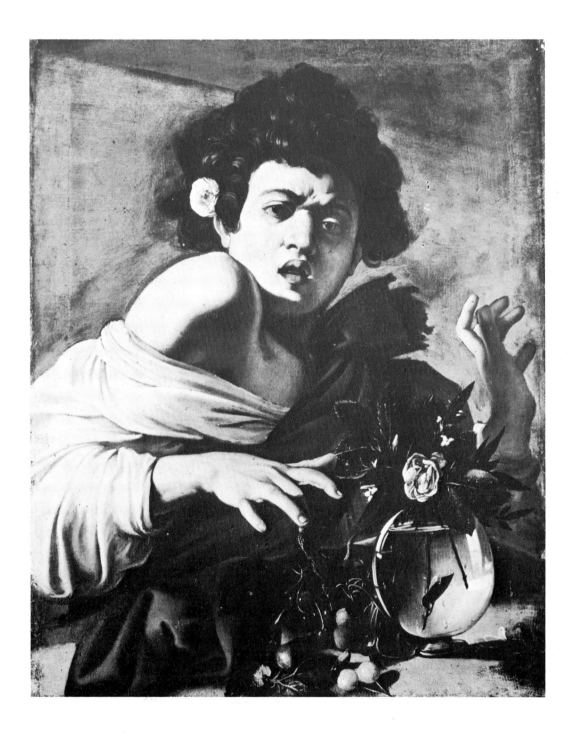

2 *The Boy Bitten by a Lizard* copy?
FLORENCE, Fondazione di Studi di Storia dell' Arte 'Roberto Longhi'. c. 1594/96. Canvas
65·8 × 39·5 cm.

The image tallies with Baglione's description of a picture executed sometime after Caravaggio's period with d'Arpino: '. . . a boy bitten by a lizard which emerged from flowers and fruit; and it was painted with such diligence that the boy really appeared to scream.' Its symbolic meaning has provoked much debate, and hypotheses have included the sense of touch, the choleric temperament, sensual indulgence leading to death and premature death itself. Marini has drawn attention to references in Ripa's *Iconologia* which explain the sixteen-year-old youth with roses in his hair as a symbol of pleasure, roses as a symbol of love and curly, scented hair as indicative of delicacy, lust and effeminacy. It is worth adding that the bared shoulder, as in the Borghese *Boy* (Plate 1), can be seen as a sign of *voluptas*, and that the lizard was, according to Alciati, a symbol of deceit. Indeed, Alciati's emblem *In fraudulentos* may have provided some inspiration for this convincing portrayal of luckless love. It describes the treachery perpetrated by jealous wives who poison their rivals with the small lizard (*stellio*) which 'lurks in secret places and hollow tombs' and 'displays the signs of envy and of crooked guile'. 'Anyone who drinks wine into which the *stellio* has been plunged finds his face covered with ugly spots. In this way a woman often takes revenge on her rival; she deceives her with the wine, and when her beauty is gone her lover abandons her.' Another version of this picture in the Vincent Korda Collection, London, may be the original.

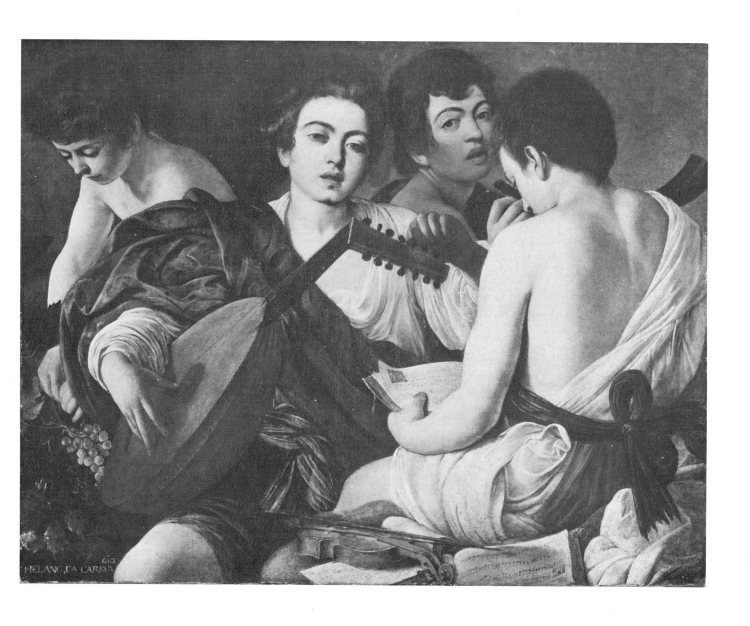

3 *Concert of Youths*
NEW YORK, Metropolitan Museum of Art (Rogers fund). 1595/96. Canvas 92 × 118·4 cm.
Inscribed lower left: . . . CHELANG. DA CARAVAGIO.

The inscription is not original, and the picture has obviously been cut down, at least on the
left-hand side. But it is, none the less, probably the picture mentioned by Baglione as having been
painted for Cardinal Francesco del Monte, one of Caravaggio's first and most enthusiastic patrons.
Its style and mood reflect the artist's earliest methods and preoccupations: half-length figures of
androgynous youths, clad in pseudo-classical garb, are posed in a manner which is sexually
suggestive yet also hints strongly at an allegorical meaning. As usual this meaning remains elusive,
although it probably has something to do with music either as an antidote for love or an
accompaniment to it. The figure in the centre has tears in his eyes, and the one on the left, plucking
a bunch of grapes, originally had wings, like a cupid. The fact that, according to the restorer, Isepp,
these wings were subsequently painted out by the artist himself is, if correct, comparable to
Caravaggio's supposed over-painting of the wound on St. Francis's hand in the Hartford picture
(Plate 6). Such an action suggests a calculated tendency towards understatement and possibly also
a desire to do away with some of the artifice of allegorical language in order to universalize the
picture's impact. The realistic qualities of the *Concert of Youths* (Plate 3a) contribute to this process, and
in fact it even seems possible that Caravaggio constructed the picture out of portraits of himself, as the
horn player looking over his shoulder, and his friends, the lutenist possibly being based on his close
friend the Syracusan painter Mario Minniti. But it is also noteworthy that the rather abstract
arrangement of limbs and masses and the stylized treatment of such features as the lutenist's right
hand reveal an interest in pattern and structure which equally takes us away from the finicky
detailing of attributes so favoured by a certain kind of allegorical painter.

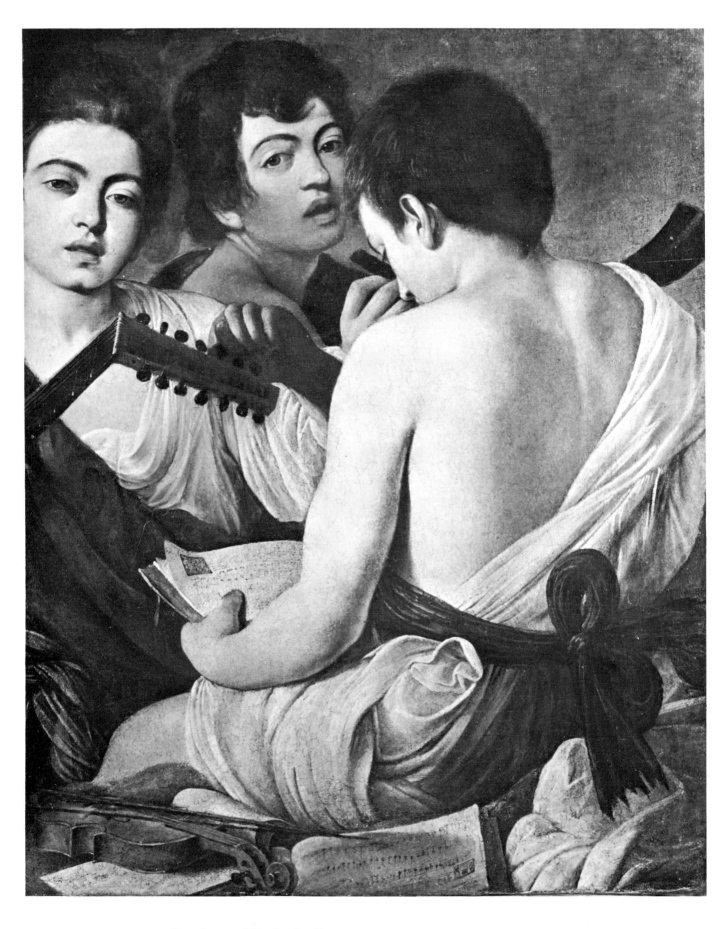

3a *Concert of Youths*, detail

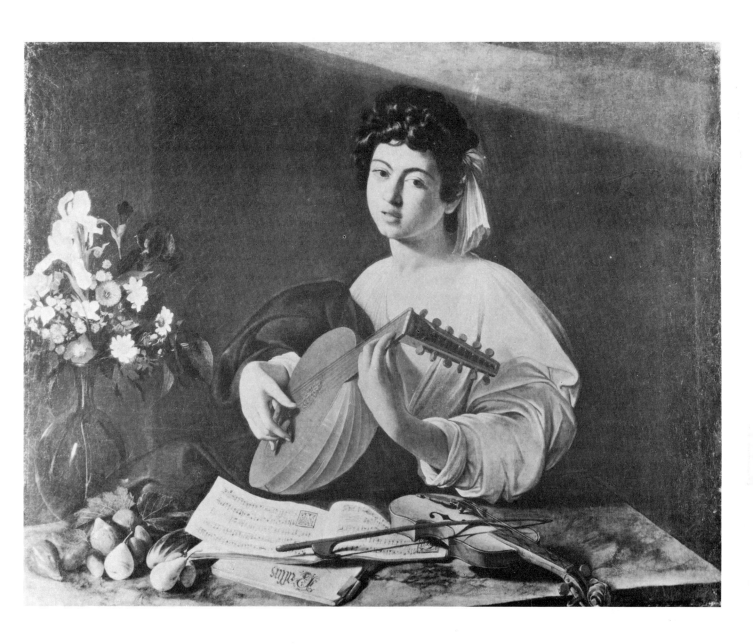

4 *The Lute Player*

LENINGRAD, Hermitage Museum. 1595/97. Canvas 94 × 119 cm.

The Lute Player was painted for Cardinal del Monte and probably reflects the patron's homosexual tastes as well as those of the artist. Caravaggio was said by Baglione to have considered it the most beautiful work he ever painted, while Bellori mistook it for a picture of a girl. Whether or not it was originally intended to be hung over a door, its size was such as to be ideally suited for that purpose, and it was listed as 'un quadro sopraporto' in the Giustiniani inventory of 1638. Giustiniani had obviously bought it at the del Monte sale in 1628; it was subsequently purchased by Baron Denon for the Hermitage in 1808. Details worth noticing are the reflections in the vase of flowers, comparable to a similar but more obvious reflection of a window in the slightly later *Conversion of the Magdalen* (Plate 16), the stronger contrast between light and shadows which signals the beginning of Caravaggio's interest in *chiaroscuro* and the strategically placed Cremona violin, proffered to the viewer and inviting his participation. The music (Plate 4a) shows the beginning of a madrigal, 'Voi sapete ch'io v'amo . . .' ('You know that I love you . . .') by the popular Netherlandish composer Jacob Arcadelt (c. 1514–1568). The closed score underneath has the name 'Gallus' written on it and could refer to any of three sixteenth-century composers known by that name.

5 *St. John the Baptist*
TOLEDO, Toledo Cathedral. c. 1594/97. Canvas 169 × 112 cm.

Although at one time this picture was thought to be by the Viterbese painter, Bartolomeo
Cavarozzi, who spent some time in Spain (1617–c. 1619), several scholars have recently supported
the old attribution to Caravaggio. A. E. Perez Sánchez argues that, while the figure of the youthful
St. John has certain affinities with Cavarozzi's style, the rest of the picture does not, and the
extremely high quality of certain passages, especially the beautifully depicted vine leaves, so strongly
reminiscent of the Ambrosiana *Basket of Fruit* (Plate 7), is much more characteristic of Caravaggio.
The delicate treatment of features and contours is also close to that of early paintings by
Caravaggio, [the *Concert of Youths* (Plate 3) and *The Stigmatization of St. Francis* (Plate 6)] as is
the gentle *chiaroscuro*. Such a dating on stylistic grounds, together with the work's Spanish
provenance, leads one to speculate whether this, in fact, may not have been one of those pictures
which, according to Mancini, Caravaggio painted for the Prior of the Hospital of the Consolazione,
where he had been undergoing treatment sometime in the early or mid-1590s: 'He soon fell ill with
a serious illness and; being without money, he was forced to go to the Hospital of the Consolazione,
where, during his convalescence, he made many pictures for the Prior, who afterwards took them
with him to his homeland, Seville.' The problem is somewhat complicated by the fact that one
manuscript version of Mancini's *Considerazioni sulla pittura* reads 'Siviglia' ['Seville'], another **'Cicilia'**
['Sicily']. It has been demonstrated by Luigi Salerno (1955) that there was in 1593 a Spanish prior
of the hospital, Camillo Contreras, and that he may have remained prior until June 1595, when a
new prior is referred to in a document. Frommel has found evidence which casts doubt on Salerno's
finding, but does not, to my mind, invalidate it. The presence of paintings by Caravaggio in Seville
at an early date is an important issue in that such works may have influenced the young Velázquez
in his early *bodegones* painted in the late part of the second decade of the seventeenth century. The
word *bodegones* has come to refer to still-lifes, or genre scenes including still-lifes, but Velázquez's
were usually religious scenes presented in a genre idiom with still-life details.

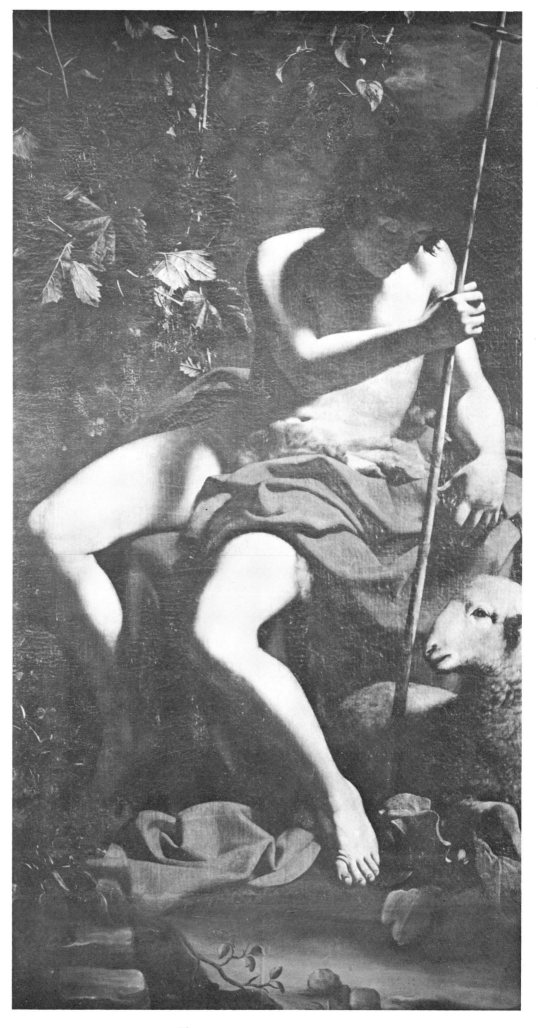

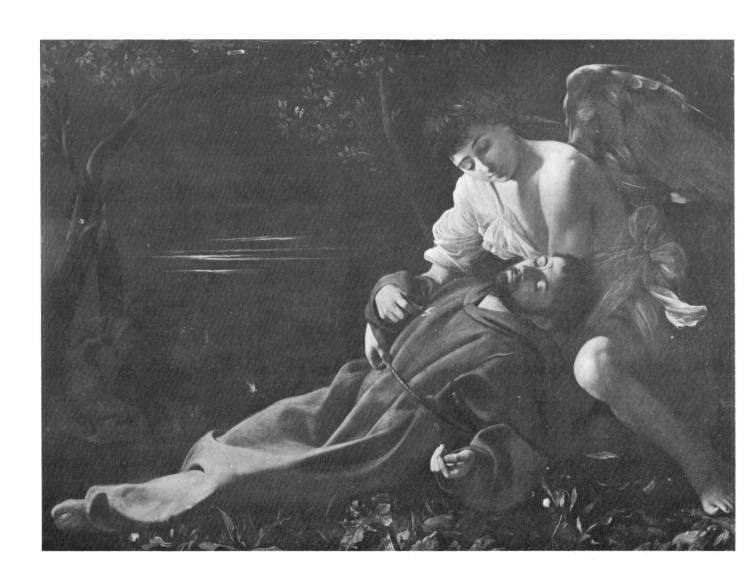

6 *The Stigmatization of St. Francis*
HARTFORD, Wadsworth Atheneum (Ella Gallup Sumner and Mary Catlin Sumner collection).
c. 1595/97. Canvas 92·5 × 127·8 cm.

This compelling rendering of St. Francis receiving the stigmata on Mount Alverna has been
identified with a picture given by Ottavio Costa to Abbot Ruggero Tritonio of Udine in c. 1606/07
and was probably subsequently acquired from Tritonio's nephew by Cardinal del Monte, in whose
collection it was listed in the inventory of 1627. The treatment of the angel and the delicate,
diffused *chiaroscuro*, reminiscent of Savoldo, place the picture unmistakably in Caravaggio's early
phase, despite the obvious anticipation of his later 'black' paintings. The Hartford painting is, in
fact, the earliest undisputed surviving example in which Caravaggio employed that dark manner
which was to become a hallmark of his style, and although it is here explicable narratively, since
the event is meant to have occurred at night, it seems possible that this accident of subject-matter
alerted Caravaggio to the effectiveness of strong contrasts of light and shade as a metaphor for
spiritual experience, or, at any rate, prompted him to experiment for himself with an idiom with
which he was already familiar through the Milanese works of earlier north Italian exponents of
chiaroscuro. The rendering of the subject is, furthermore, highly original, since Caravaggio dispensed
with the traditional seraph in the sky and stressed instead the personal nature of the saint's vision
as, insensate to this world, he imitates the dead Christ in his pose and is sustained, Christ-like
again, by an angel. Another interesting detail is the fact that the wound on St. Francis's right hand
has been painted over, possibly by Caravaggio himself, with the effect of transferring the drama
further from outward forms and symbols to 'inner' and only partially articulated feeling. Francis's
companion, Brother Leo, is discernible in the left middle distance of the picture, as are the
shepherds in the background who watch the miraculous illumination of the night sky.

7 *Basket of Fruit*
MILAN, Pinacoteca Ambrosiana. c. 1596. Canvas 31 × 47 cm.

The Ambrosiana *Basket of Fruit* is the only independent still-life by Caravaggio to have survived. It was probably given by Cardinal del Monte, along with other works, as a present to Federico Borromeo, Archbishop of Milan, in 1596, and Borromeo later donated it to his own Ambrosiana picture gallery, founded in 1618. Although Bellori recounted that Caravaggio was employed by d'Arpino to paint flowers and fruit, and despite the fact that there are several impressive still-life insets in his early pictures, the Ambrosiana still-life stands in a class of its own. Its abstract clarity of design, its silhouetting of forms against the light, oatmeal background and its almost oriental refinement, recalling the Uffizi *Bacchus* (Plate 8), are rare qualities in a still-life and go some way towards corroborating a revealing remark made by Caravaggio to his friend and patron Vincenzo Giustiniani to the effect that 'it required as much craftsmanship to paint a good picture of flowers as one of figures.' The result is so much more than painstaking copying: Caravaggio had obviously been applying the same principles of selection, patterning and restraint as in his figure compositions. Indeed, it seems incredible that certain writers at one time felt that the *Basket of Fruit* was a fragment because the branch of vine leaves at the right was cut by the frame. X-rays taken in 1966 demonstrate, on the contrary, that Caravaggio painted the *Basket of Fruit* onto an already completed canvas of 'grotesques', of the kind associated with his friend Prospero Orsi.

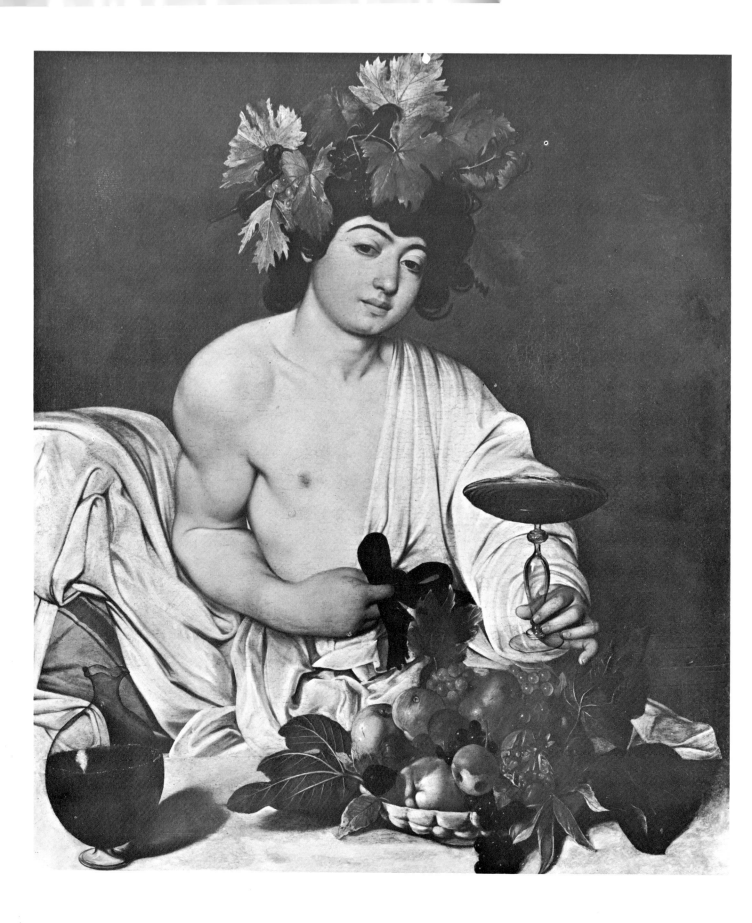

8 *Bacchus*

FLORENCE, Galleria degli Uffizi. 1595/97. Canvas 95 × 85 cm.

The view expressed by some scholars that the Uffizi *Bacchus* is the self-portrait referred to by
Baglione as 'a Bacchus with some bunches of different kinds of grapes', which Caravaggio is
supposed to have painted while working in d'Arpino's studio, seems suspect on two grounds. The
facial likeness is not very close to the drawing of Caravaggio by Ottavio Leoni (*frontispiece*) or to the
fairly definite self-portrait in the background of *The Martyrdom of St. Matthew* (Plate III); indeed,
The Boy with a Garland of Ivy (Plate I), despite its uncertain subject, seems to be closer to Baglione's
description. Secondly, the quality of handling and colour support a date sometime after
Caravaggio had left d'Arpino's studio. For although this *Bacchus* displays signs of weakness in
the drawing, in, for instance the relation of the stem to the foot of the glass (Plate 8a), and in
the relation of the decanter to its base, its colours are more richly and sensitively orchestrated than
in the very early works. It seems more reasonable to accept this technical evidence of increased
mastery of tone and colour than the formal evidence which might suggest an analogy between
Bacchus's pose and that of *The Boy with a Basket of Fruit* (Plate 1). We know, in fact, from later
works that Caravaggio was quite capable of re-using or adapting his own earlier poses even after
lengthy intervals and also that his skill at drawing was always less than perfect. The colours range
(Plate 8b) impressively from the strong, warm treatment of leaves and fruit, through the polished
and oily skin of the left hand, to the bright black velvet bow and the subtly original grey stripe on the
ill-concealed buff pillow. Although less atmospheric, Caravaggio's colours in this instance recall the
work of Titian, such details as the hands, as well as the overall conception, suggesting parallels with
Titian's *Flora* in the Uffizi—an equally restrained yet subtly erotic evocation of a mythological deity.

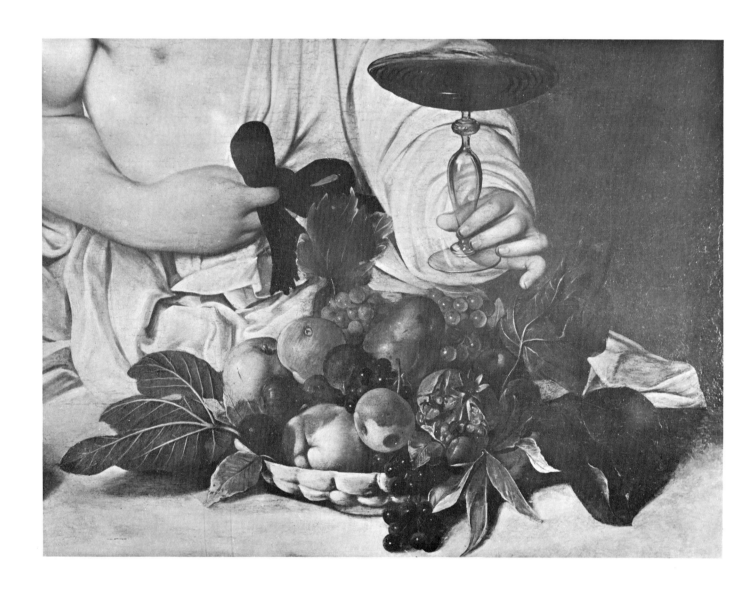

8b *Bacchus*, detail

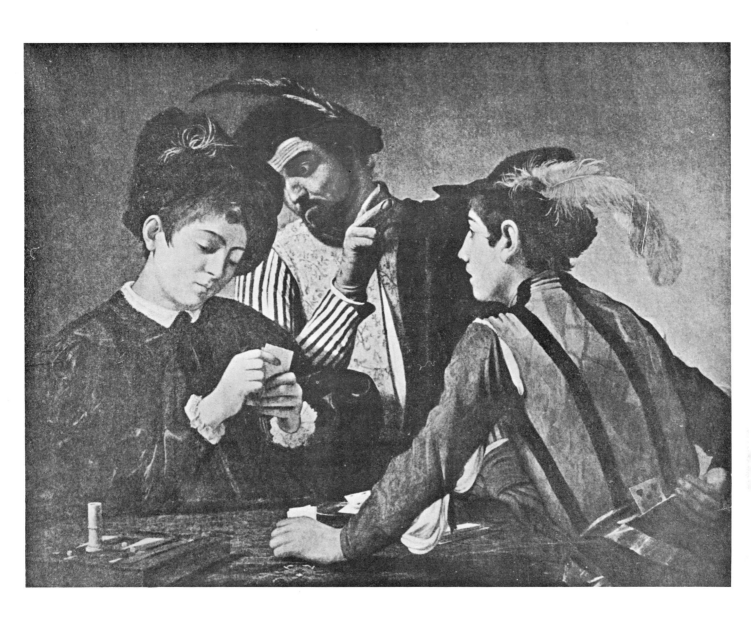

9 *The Cardsharpers*
formerly ROME, Sciarra collection. 1595/97.

Listed in Cardinal del Monte's inventory of 1627 and, according to Bellori, subsequently acquired
by Cardinal Antonio Barberini, *The Cardsharpers* is reproduced here from a nineteenth-century
photograph. Innumerable copies exist, one of which, by Carlo Magnone, was commissioned by the
Barberini themselves in 1642. The original entered the Colonna di Sciarra collection in 1812 and
remained there until c. 1896; it was sold in 1899 to a member of the Rothschild family. Its
subsequent history has proved a mystery, with several paintings being proposed as the lost original.
The most plausible of these is in a New York private collection, but even this painting is more likely
to be a good copy. The image proved almost disproportionately influential and, along with
Caravaggio's *Fortunetellers* (Plates 10 and 11), helped to encourage a vogue for gipsy, bohemian and
gaming scenes among some of his most gifted admirers, including Manfredi, Honthorst, Valentin
and even La Tour. The fact that such subjects came, in the seventeenth century, to be considered
almost the hallmark of the Caravaggio style is a reflection not simply of the distorting hand of time,
but also of the spontaneous, almost Giorgionesque, appeal of Caravaggio's few renderings in this
vein. *The Cardsharpers* was, according to Bellori, *bought* rather than commissioned by del Monte.
But it probably appealed to the cardinal as an emblem of deceit, albeit a less cultivated one than
The Boy Bitten by a Lizard (Plate 2), and he seems to have subsequently commissioned another
'moralistic' genre picture, the Capitolina *Fortuneteller* (Plate 11), as a pendant to it.

10 *The Fortune-teller*
PARIS, Musée du Louvre. 1595/97. Canvas 99 × 131 cm.

One of two pictures of this subject associated with Caravaggio, the Louvre *Fortune-teller* was given to Louis XIV by Don Camillo Pamphili in 1665 on the occasion of Bernini's visit to Parts. Since it has such a convincing provenance it has always been recognized as an original work, but its very high quality only recently became apparent as a result of the cleaning and restoration carried out at the Laboratoire de Recherches des Musées Nationaux de France prior to the exhibition held in 1977 at the Pavillon de Flore of the Louvre. Technical analysis has revealed that a horizontal band approximately 10 cm. wide has been added along the top, and that the picture surface was also stretched by 2 to 4 cm. all the way round when the canvas was at some stage relined. It also seems that the whole of the white plume was added later, over the varnish of the original picture, and presumably by another hand. The addition of the strip of canvas and the white plume may well have occurred after the picture's arrival in France, especially since it does not seem to have been very much admired by the classically minded French intelligentsia, committed as most of them were to the Poussinesque principles of the newly founded Académie Royale. Chantelou described the picture as a poor one, 'sans esprit, ni invention'. Indeed, the enlargement of the canvas may be seen as a symptom of the disapproval with which later seventeenth-century idealist painters and critics viewed the close-up and directly dramatic approach of Caravaggio and his followers and as an attempt to invest the work with a little more of that aesthetic distance and self-contained action which appealed to them in the paintings of Raphael and Poussin. The theme of fortune-telling, treated sometimes as part of a larger picture, had a long history in Netherlandish art (for example in the work of Bosch, Bruegel and Jacques de Gheyn II) but tended to be presented in a grotesque or comic manner. Caravaggio, by contrast, was more lyrical and successfully conveyed both the charm of the gipsy and the excitement of the young gallant as she engagingly strokes his palm. On closer inspection, however, it can be seen that the girl is slipping a ring off the boy's finger, and as such the work should be understood as a parable of deceit, similar to but more subtle than most earlier depictions of the subject.

11 *The Fortune-teller* original?
ROME, Pinacoteca Capitolina. Canvas 116 × 151·2 cm.

The recent exhibition of this picture alongside the Louvre version (Plate 10) in the Pavillon de Flore has prompted a fresh appraisal of the relative merits of the two canvases. Pierre Cuzin and Benedict Nicolson came down forcefully in favour of the Louvre version, arguing that the generally poor quality of the Capitolina painting is indicative of its non-autograph status or that, at most, it was begun by Caravaggio and finished by another hand. A major difficulty in dismissing the work from the Caravaggio canon is the fact that its provenence is every bit as good as that of the Louvre picture. Frommel has indicated the similarity of size between the Capitolina *Fortune-teller* and a picture of the subject listed as by Caravaggio in the 1627 inventory of Cardinal del Monte's collection, and this picture was also sold to Pope Benedict XIV in 1749/40 as an original work by Caravaggio. It might, however, be argued that the inventory of the cardinal's works was drawn up after his death and the attribution to Caravaggio may, therefore, have been a mistake which has been perpetuated, on and off, ever since. The qualitative superiority of the Louvre picture suggests that this may well have been the case. But we should perhaps withhold a final judgment on the problem until the Capitolina canvas has been subjected to the same careful technical analysis as its Parisian counterpart, and there is, indeed, still an outside chance that we shall then discern more evidence of Caravaggio's technique and style than currently meets the eye. Cuzin has rightly indicated the high quality of the painting of the gipsy's face and turban and the similarity in the treatment of the lights and darks in this passage to the corresponding part of the Louvre version. The handling of the face also seems to me close to that of *The Penitent Magdalen* (Plate 12) in the nearby Galleria Doria-Pamphili. The fact that most of the rest of the surface is so relatively poor may be due to extensive reworking, perhaps of an incomplete sketch, by another artist. It is worth noting that X-rays, which reveal that *The Fortune-teller* was painted on top of another picture, or fragment of a picture, of a Virgin praying, in a style close to that of the Cavaliere d'Arpino, also show several changes between the original painting of the figures of the *The Fortune-teller* and what we see today. The young man's face, in particular, was originally rather different, especially in the shape of the nose, and was closer, in fact, to that of the Louvre boy than to the standardized visage on the final paint surface. This may, of course, be an indication that an 'imitator' was trying to make his debt to the Louvre picture a little less obvious. Whether or not painted by Caravaggio himself, the work was probably commissioned by Cardinal del Monte as a pendant to *The Cardsharpers* (Plate 9), which he owned. Both scenes were intended as parables of deceit, and it seems highly probable that the cardinal, unable to acquire the Louvre picture from its owner, commissioned a version to complement the thematically related composition which he already possessed.

The Martyrdom of St. Matthew, X-ray reconstruction in diagram form from the Istituto Centrale del Restauro, Rome.

III *The Martyrdom of St. Matthew*
ROME, Church of San Luigi dei Francesi, Contarelli Chapel. 23 July 1599/4 July 1600. Canvas 323 × 343 cm.

X-rays of *The Martyrdom* reveal that Caravaggio had more difficulty with it than he had with *The Calling of St. Matthew* (Plate 24). Yet it has proved virtually impossible to establish an accurate sequence for the execution of the several figures and groups of figures underneath the final paint surface. Some scholars have attempted to relate the X-ray findings to Bellori's statement that Caravaggio repeated the picture twice by proposing that there were two stages prior to the final one. But their deductions are based primarily on the scale of figures and are not, unfortunately, confirmed by any other logic. Easier to assess are the variety of Caravaggio's sources which range from the standard 'hand-on-hip' Mannerism of the large figure in the centre foreground of the reconstruction, which also recalls the angel in *The Rest on the Flight into Egypt* (Plate 13), to more obvious derivations from battle pictures of the High Renaissance period. Friedlaender has indicated the closeness of the charging swordsman seen in profile on the left of the reconstruction to one in

Raphael's fresco of *The Battle of Ostia*, but the motif of the fallen figure in the front centre, in *contrapposto* and straddled by the large soldier, was derived almost as obviously from Michelangelo's famous cartoon of *The Battle of Cascina*. The rationale behind such references probably had less to do with Caravaggio's need to find appropriate poses for a scene of strife than with his desire to give his picture a quality of monumental grandeur akin to that of the High Renaissance. The great effort expended on working out the composition on the canvas, however, makes it clear that Caravaggio failed to follow the well-established Renaissance practice of making detailed preparatory drawings, and we, in fact, have no surviving drawings by Caravaggio to make us modify this assumption. In placing *The Martyrdom* anachronistically before *The Calling* I have followed Mahon's reasoning that since the figure scale of the finished version is the same as that in *The Calling*, while that of the earlier attempts is, for the most part, considerably smaller, *The Calling*, X-rays of which reveal very few alterations and no changes of scale, must have been painted after Caravaggio had already worked out his proportions in the other picture. The picture depicts the death of the saint at the hands of the soldiers of the King of Ethiopia, whom Matthew had first converted to Christianity and then condemned for taking more than one wife. The king himself is shown as the bearded figure who stretches out his hand in the background (Plate IIIa), revealing perhaps a certain amount of regret at the slaughter which he has instigated, and it is interesting that this same figure is the most convincing of a handful of more or less definite self-portraits in Caravaggio's œuvre, since it closely resembles a portrait drawing of the artist by Ottavio Leoni (*frontispiece*). Speculation on Caravaggio's attitude to the religious stories which he portrayed so vividly can only be increased by such information, but it is naturally all but impossible to arrive at any definite conclusions from such ambiguous internal evidence. In the pursuit of the dramatic and the monumental Caravaggio borrowed, to the extent of almost 'quoting' directly, the figures of the saint and the gesticulating boy on the right from Titian's famous altarpiece of *The Martyrdom of St. Peter Martyr* (see fig. 5), formerly in the Church of San Zanipolo, Venice, but destroyed by fire in 1867.

IIIa *The Martyrdom of St. Matthew*, detail

IV *The Conversion of Saul (The Conversion of St. Paul)*
ROME, Church of Santa Maria del Popolo, Cerasi Chapel. 1601 (before 10 November). Canvas 230 × 175 cm.

As one enters the Cerasi Chapel, *The Conversion of Saul* is on the right, *The Crucifixion of St. Peter* (Plate 28) on the left, and both compositions are arranged round a diagonal axis which leads the eye into each picture. Whether or not under the explicit guidance of his patron, Caravaggio here produced a much more concentrated version of the image. Whereas in the Odescalchi panel (Plate 27) one is inevitably concerned with 'reading' the picture as a story and registering the various reactions of the different figures to the miracle, here one is shocked into a more direct and, indeed emotional response as Saul almost slides out of the picture on top of one. Even the horse and the elderly groom seem passively to recognize their own insignificance in a drama which, symbolized by the powerful *chiaroscuro*, is taking place behind Saul's closed eyelids. The somewhat melodramatic use of gesture and the insistent three-dimensionality of the composition mark a shift in Caravaggio's style from more mannered multi-figure designs like the Odescalchi picture and *The Martyrdom of St. Matthew* (Plate III) towards the realistic rhetoric of the National Gallery *Supper at Emmaus* (Plate 29).

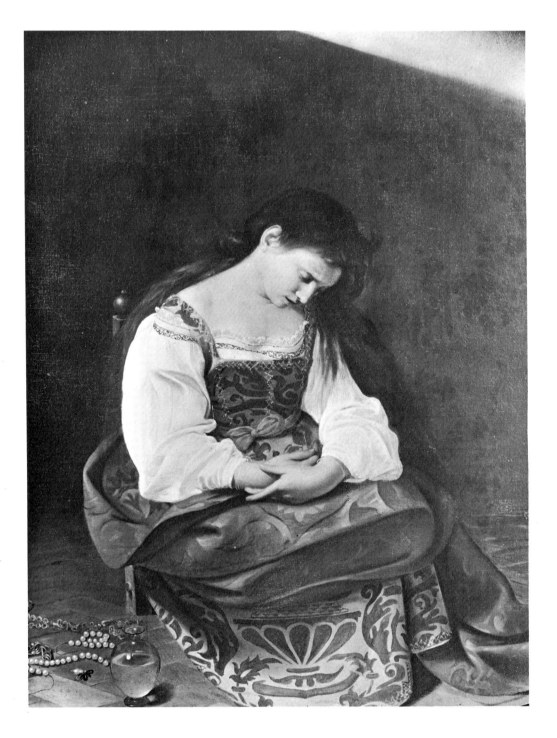

12 *The Penitent Magdalen*
ROME, Galleria Doria-Pamphili. 1596/98. Canvas 106 × 97 cm.

According to Mancini, *The Penitent Magdalen* was painted, with *The Rest on the Flight into Egypt* (Plate 13), *The Fortune-teller* (Plate 10) and an unidentified *Saint John the Evangelist*, while Caravaggio was staying with Monsignor Fantino Petrignani, shortly after the artist had left d'Arpino's studio. Petrignani was an Umbrian churchman who, among his many distinctions, was Chierico of the Apostolic Chamber, papal Vice-Legate in Viterbo, Governor of the Marches and Archbishop of Cosenza; but, since none of the pictures mentioned was listed in Petrignani's inventory of 18 March 1600, it is possible that Caravaggio merely painted them at his house, rather than for its owner. *The Penitent Magdalen* and *The Rest on the Flight into Egypt* were in the Pamphili collection by the mid-seventeenth century. Almost misleadingly realistic for a religious work, the picture lacks any rhetoric beyond the tear which trickles down the Magdalen's nose. This detail, however, and the cast-off jewellery and perfume jar, help to distinguish her as the penitent Magdalen, but the skull, the emblem with which she was often provided for contemplation, is scarcely implied by the void between her arms, and the eloquent cradling gesture seems to evoke an ambiguous mood. Indeed Bellori described the figure as a girl drying her hair, and it is true that the whole setting recalls the studio. The model, painted from above without adjustment, seems to be the same one used by Caravaggio for the Virgin in *The Rest on the Flight into Egypt*.

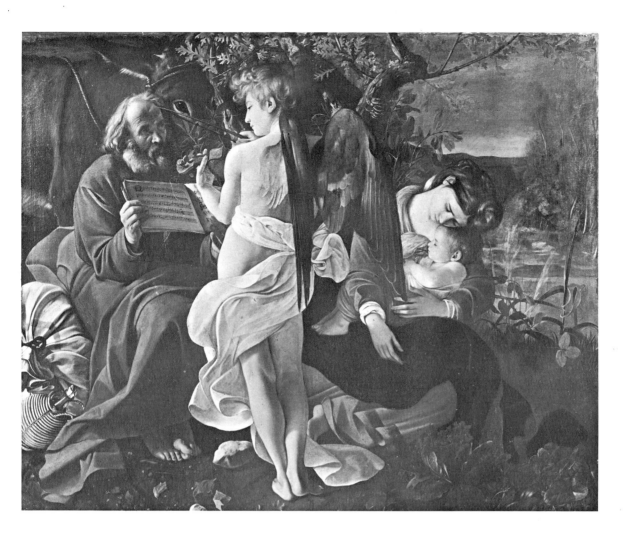

13 *The Rest on the Flight into Egypt*
ROME, Galleria Doria-Pamphili. 1596/98. Canvas 135·5 × 166·5 cm.

The history of this picture is identical with that of *The Penitent Magdalen* (Plate 12). Its colours, however, which are brighter and more varied than in any of Caravaggio's pictures either before or after (see Plate II), strike an unusual note which owes something to the Venetian tradition and to Lotto in particular. The composition also echoes certain details of a picture of the same subject in the Pinacoteca Ambrosiana, Milan, by another Venetian painter, Jacopo Bassano. But the most obvious and direct compositional source, which also perhaps even provides a clue to the light colour scheme in Caravaggio's picture, is Annibale Carracci's *Judgment of Hercules* (Naples, Museo Nazionale di Capodimonte), which Carracci must have begun work on soon after his arrival in Rome in November 1595 and completed sometime the following year. Annibale's picture, painted originally for the ceiling of the Camerino Farnese, was widely admired, and its powerful blend of naturalism and formalism seems to have prompted Caravaggio to a strange feat of emulation. The composition in both works is centred by a tree and includes the main figures arranged harmoniously across the picture surface—although in Caravaggio's painting the sequence of standing, sitting, standing has been reversed—while the landscape in both pictures is divided into a verdant and a desolate half. Furthermore, Caravaggio has based the pose of his standing angel very closely on Annibale's figure of 'Vice' in *The Judgement*, perpetuating the sensual element but investing it in a male figure. There are, nevertheless, two significant differences, and Caravaggio's changes of emphasis point clearly forwards to his own mature style. There is less space in *The Rest on the Flight into Egypt*, the figures filling up most of the picture surface and pressing themselves on our attention in the narrow foreground plane, whereas Annibale's figures are well integrated by means of perspective into an illusory space. And while Annibale's figure-types are idealized, Caravaggio's St. Joseph, with his brown skin, wrinkled brow and bare feet was culled straight from life, as was the sad Madonna (see Plate 12). The grey-green stripe on Joseph's sack is reminiscent of the stripe on Bacchus's pillow in the Uffizi *Bacchus* (Plate 8) and once again highlights the phenomenon of Caravaggio's rather literal use of studio props. The ears of corn (Plate 13a) just behind the Madonna are an important part of the iconographical scheme. According to legend, the fleeing Holy Family passed by a husbandman sowing seed, and Mary instructed him to tell any inquirers that they had passed at the time of sowing—after which the corn miraculously grew overnight, putting Herod's men off the scent when they heard the husbandman's (truthful) story and saw the ripened corn.

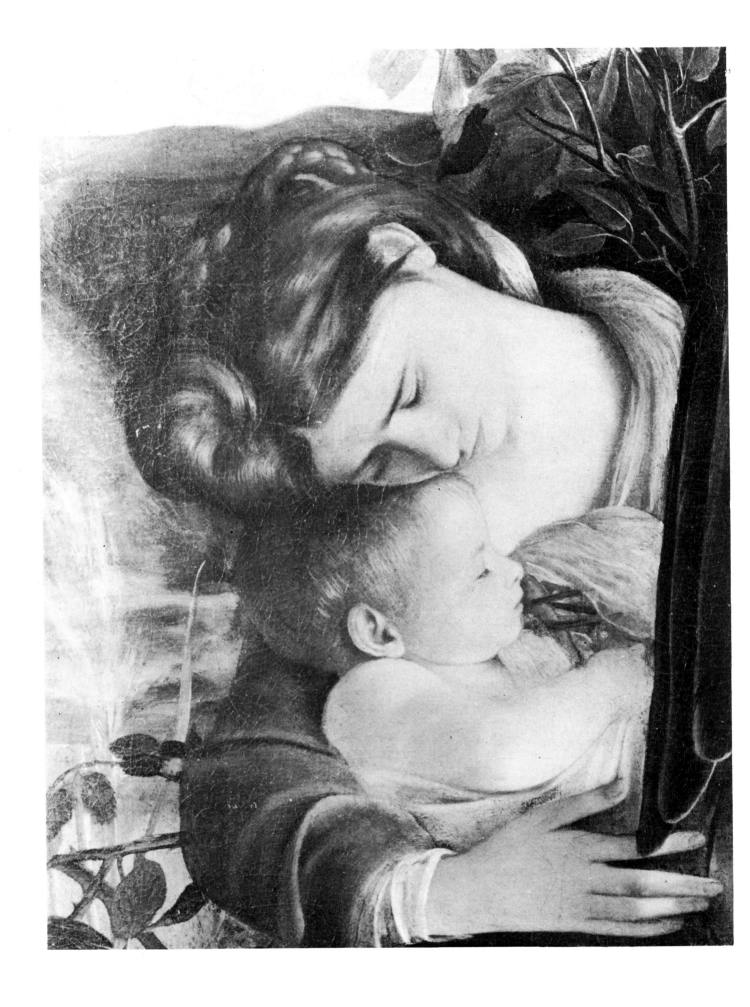

13a *The Rest on the Flight into Egypt*, detail

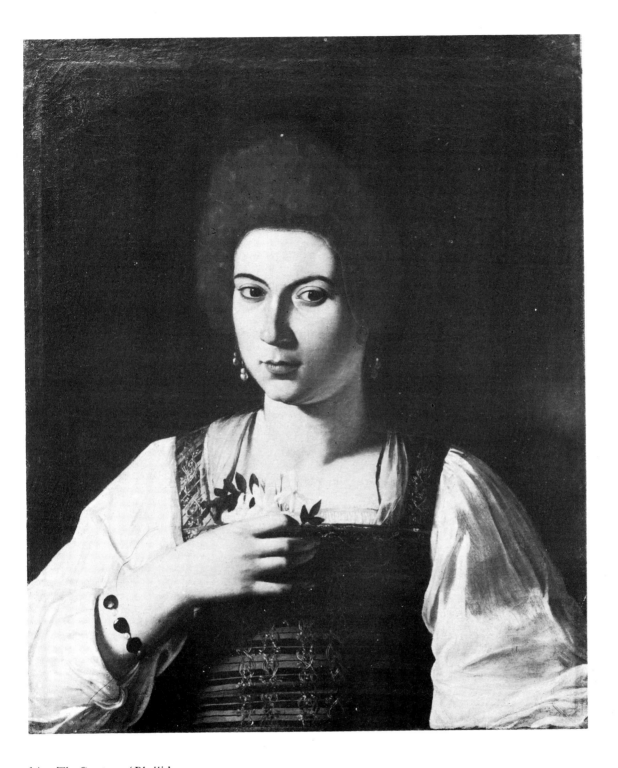

14 *The Courtesan 'Phyllis'*
formerly BERLIN, Kaiser-Friedrich-Museum (destroyed in the bombardments of 1945). c. 1598/99.
Canvas 66 × 53 cm.

This was probably the portrait of the courtesan 'Fillide' ['Phyllis'] listed in the Giustiniani
inventory of 1638. If it was actually commissioned by the Marchese Vincenzo Giustiniani it would
have been the earliest fruit of contact between Caravaggio and one of his most important patrons,
for the work can be dated no later than 1598/99 on stylistic grounds. The strong, yet not extremely
dark shadows, the treatment of the sleeves and the challenging expression of the face remind one of
such works as *St. Catherine* (Plate 15), *The Conversion of the Magdalen* (Plate 16) and *Judith and
Holofernes* (Plate 17). But the 'Phyllis' was probably painted earlier than any of these: it is worth
noting that the pose of her hand resembles that of the Virgin in *The Rest on the Flight into Egypt*
(Plates II and 13). The flowers which she holds so elegantly at her breast are definitely
jasmine, symbol of erotic love, and certainly not orange blossom, symbol of 'pure' love, as Voss and
others have claimed. Voss's suggestion that the picture represented Caterina Campani, wife of
Caravaggio's friend, the architect Onorio Longhi, is, therefore, unacceptable, while the old
description in the Giustiniani inventory would seem to make sense of the posy of jasmine.

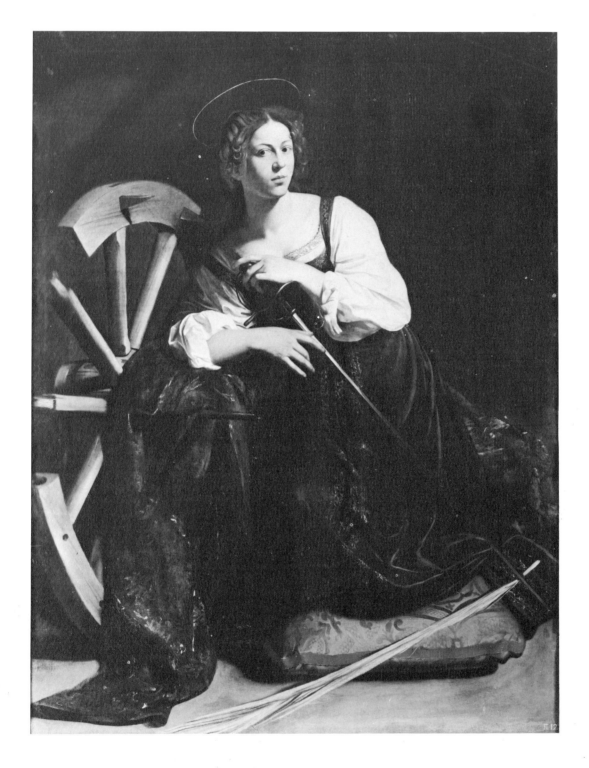

15 *St. Catherine of Alexandria*
LUGANO, Thyssen-Bornemisza Collection. c. 1598/99. Canvas 173 × 133 cm.

St. Catherine of Alexandria, virgin martyr of the fourth century, was unsuccessfully tortured on a wheel which was broken by a heavenly thunderbolt and, like many martyrs, was subsequently beheaded with a sword. In this picture painted for Cardinal del Monte and, after 1628, belonging to the Barberini family, Caravaggio depicted this popular female saint, surrounded by her attributes, in a forthright and uncompromising manner which doubtless reflects her commitment to Christ but also suggests more than a little of the worldliness of *The Courtesan 'Phyllis'* (Plate 14). This was perhaps due to Caravaggio's procedure of working directly from the model in the studio and, while obviously spending a considerable amount of effort in posing the figure, rendering the detail with surprisingly few modifications. Indeed it has been suggested that not only did he use the same model for this picture as for *The Conversion of the Magdalen* (Plate 16), but that the third finger of her left hand, hanging down limply here and propped up in an unusual way in *The Conversion*, was a natural deformity which Caravaggio chose not to alter. If that were the case it would help us in defining his aesthetic attitude at this time more precisely. But it seems equally possible that he merely arranged the finger in an elegant and somewhat artificial manner for visual effect.

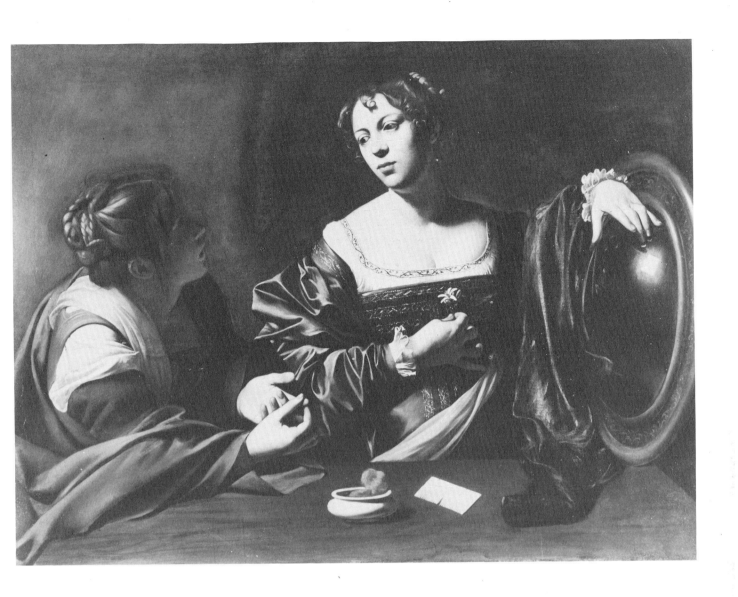

16　*The Conversion of the Magdalen*, called *The Alzaga Caravaggio*
DETROIT, Detroit Institute of Arts (gift of the Kresge Foundation and Mrs. Edsel B. Ford).
c. 1598/99. Canvas 97·8 × 132·6 cm.

The designation 'Alzaga Caravaggio' was coined as a tribute to Martin de Alzaga whose efforts, starting in 1967, led to the widespread recognition of this picture, now in Detroit, as the lost original of a work previously known through copies. *The Conversion* belonged to Ottavio Costa, who also owned *The Ecstasy of St. Francis* (Plate 6) and it seems to have been given by him c. 1606/07 to to his friend and business associate Giovanni Enriquez de Herrera, better known to posterity for his patronage of Annibale Carracci. In this picture Caravaggio followed the convention of identifying the Magdalen with Mary of Bethany, and gave a new implication to the traditional theme of the two sisters by portraying their relationship dramatically and, more especially, in terms of light and shade. Instead of the usual symbolic contrast between Martha, as indicative of the active life, and Mary, of the contemplative, he has chosen to depict the precise moment of the Magdalen's conversion when, rejecting her former life of sensuality and vanity, symbolized by the mirror, she succumbs, no doubt partially in response to her sister's words, to the meaning of Christian love and is both literally and metaphorically illuminated. *The Conversion* is one of the earliest instances of Caravaggio employing strong contrasts of light and shade, (*chiaroscuro*) to give a visual dimension to spiritual experience. The psychological drama is further enhanced by depicting Martha's mouth dropping open in wonder at her sister's sudden conversion, in a manner which recalls the right-hand figure in *The Cardsharpers* (Plate 9). The picture is also notable for Caravaggio's *apparent* use, in certain passages, of an unusual 'wet-on-wet' application of tempera on oil.

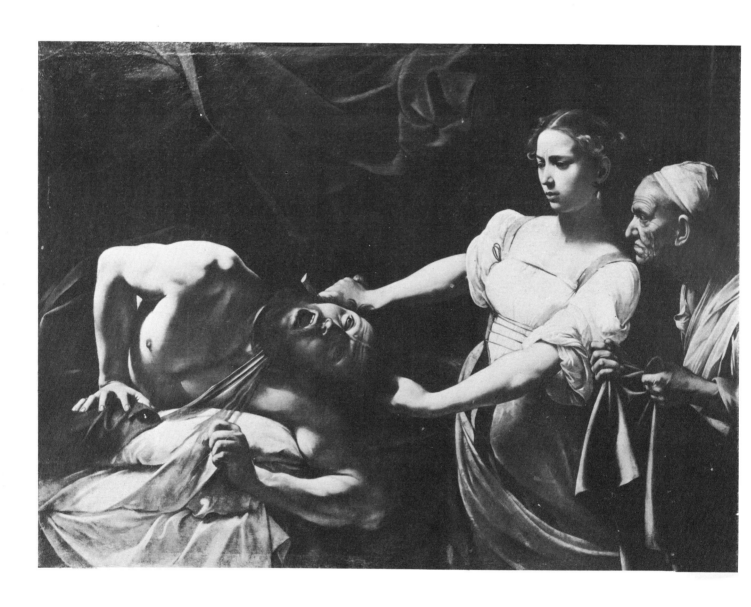

17 *Judith and Holofernes*
ROME, Galleria Nazionale d'Arte Antica, Palazzo Barberini. c. 1598/99. Canvas 145 × 195 cm.

Presumably the *Judith and Holofernes* owned by Ottavio Costa, this picture was only rediscovered in the collection of Vincenzo Coppi in 1951 and was subsequently acquired by the Italian state in 1971. The theme of the rich Israelite widow who saved her country by first enticing and then slaying the Assyrian commander Holofernes was a popular one, but it was less usual to depict the precise moment of decapitation. Caravaggio obviously relished the dramatic and psychological possibilities of the episode, and his Judith (Plate 17a), dressed to kill and frowning with concentration as she performs her clinical operation, is no straightforward heroine. Indeed, on one level, Caravaggio adopted the interpretation, fairly common by the late sixteenth century, that the story was a parable of female calculation and deceit, but, moving beyond mere misogyny, transformed it into a memorable sado-erotic image. This treatment of the episode differed from the more popular Counter-Reformation view that the story of Judith's triumph symbolized the victory over sin and the senses. It was, in fact, this novel psychological aspect which was most obviously stressed by disciples of Caravaggio such as Artemisia Gentileschi and Valentin in their paintings on the theme. The picture is normally assigned to the mid- to late 1590s on stylistic grounds and also because of facial similarities between Judith and the Thyssen *St. Catherine* (Plate 15), but its smooth, luminous handling, the use of the draped curtain and the rather stylized curving of the figure of Judith herself seem to anticipate Caravaggio's later works of c. 1605–07.

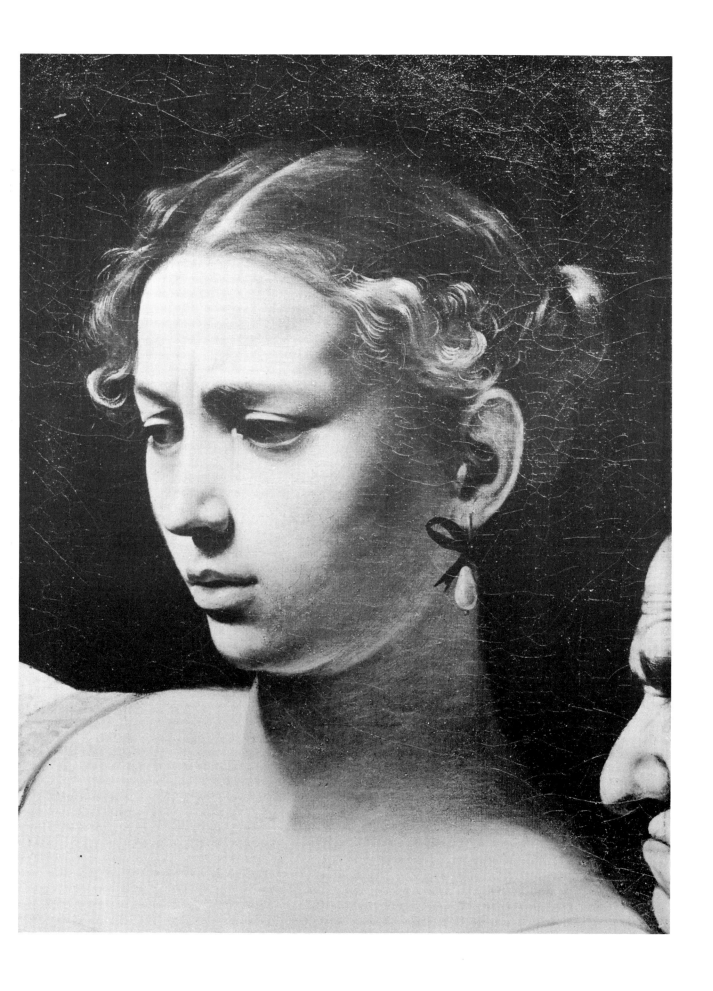

17a *Judith and Holofernes*, detail

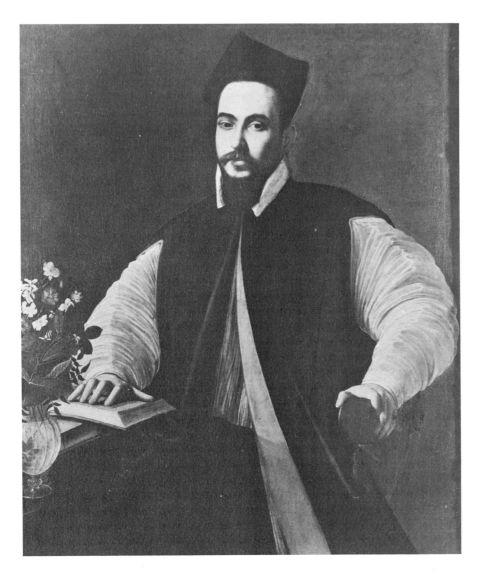

18 *Portrait of Monsignor Maffeo Barberini*, by Nicodemo Ferrucci?
FLORENCE, Galleria Corsini. ?1604. Canvas 121 × 95 cm.

19 *Portrait of Monsignor Maffeo Barberini*, original?
FLORENCE, private collection. ?1598/99. Canvas 124 × 90 cm.

Maffeo Barberini, born in 1568 and pope from 1623 to 1644 as Urban VIII, came from a
well-established Florentine family and was, during the 1590s, in the process of building his career
at the papal Curia in Rome, becoming Protonotaro Apostolico in 1593 and Chierico di Camera in
1598. Mancini (1619–25) referred to portraits painted for him by Caravaggio, and Bellori (1672)
to a single portrait of him by the artist. Yet it is impossible to identify the work, or works, in
question with certainty. The Corsini picture, with its vase of flowers and clear colouring, does have
certain affinities with Caravaggio's early Roman style, but also seems to be rather unimaginatively
composed. Further, the picture, together with a pendant, also in the Galleria Corsini, of Maffeo's
uncle Monsignor Francesco Barberini, has been plausibly connected with a document of July 1604,
recording a payment made by Maffeo for two unspecified portraits to Nicodemo Ferrucci, a pupil
of Passignano. The portrait of Maffeo Barberini in the Florentine private collection certainly seems
a more dramatic and, indeed, revolutionary work, its powerful *contrapposto* recalling Michelangelo's
prophets, but also appropriately evoking a mood of business-like authority, with Maffeo clearly
giving orders with his right hand while he holds a memorandum in his left. This latter
characteristic is possibly an indication that the work dates from some time after his appointment to
the important administrative post of Chierico di Camera. The inexpertly foreshortened ear is a
useful identifying feature in Caravaggio's work. Although it should be noted that nothing in the
published Barberini archives refers explicitly to a portrait by Caravaggio, Maffeo later commissioned
The Sacrifice of Isaac (Plate 35) from him and also belonged, through his interest in poetry and
philosophy, to the Accademia degli Insensati, which included such figures as d'Arpino and Aurelio
Orsi and which seems to have had some influence on Caravaggio's way of thinking 'emblematically'
in his earlier works.

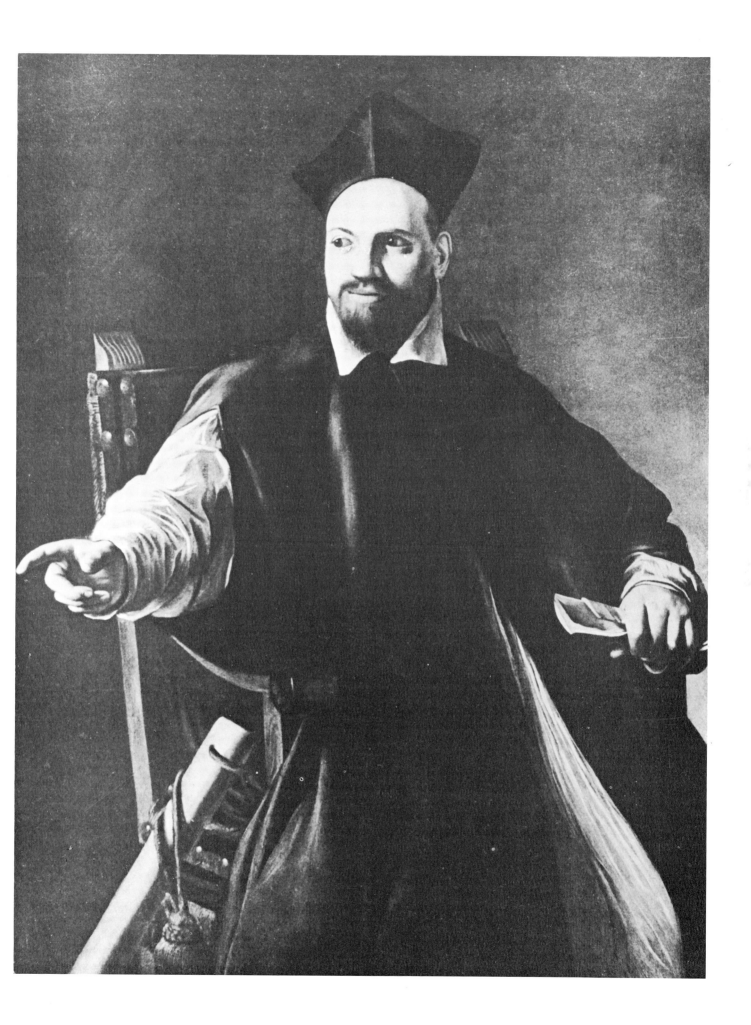

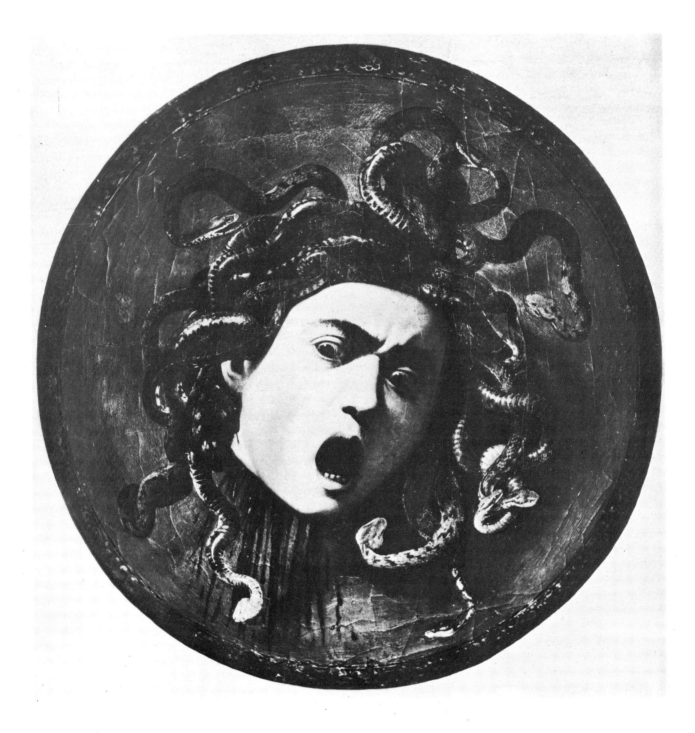

20 *Medusa*
FLORENCE, Galleria degli Uffizi. 1598/1601. Canvas on poplar wood shield 55·5 cm. diameter.

This rendering of the decapitated gorgon on a convex shield was painted for Cardinal del Monte, who gave it as a present to his protector, Ferdinand I de' Medici, Grand Duke of Tuscany. There are several precedents for depicting Medusa on a tournament or parade shield, and Leonardo da Vinci is said to have painted a horrifying monster, which resembled a gorgon, on a wooden roundel. Caravaggio nonetheless invested the head with such compelling psychological power that many have taken it to be yet another expressive self-portrait. The face is certainly more male than female, and the thought of Caravaggio working from his own likeness in a mirror gives an additional resonance to an image which is intended anyway as a mirror reflection: the only way that Perseus could kill the gorgon while avoiding her mortal stare was to use his own shield as a mirror. The theme of the decapitated Medusa was frequently invoked as a symbol of triumph over the senses, but in a poem of 1620 the celebrated poet and one-time friend of Caravaggio, Giambattista Marino, suggested that the terrifying gorgon was merely a symbol of Duke Ferdinand's own courage, sufficient to turn his enemies to marble. The image was also traditionally associated with despair, which hardens the heart so that it becomes incapable of repentance. Needless to say, any or all of these interpretations may have been associated with Medusa by Caravaggio and his learned public. The shield was recorded in the inventory of the Medici armoury in 1631 as being attached to a figure in a suit of armour.

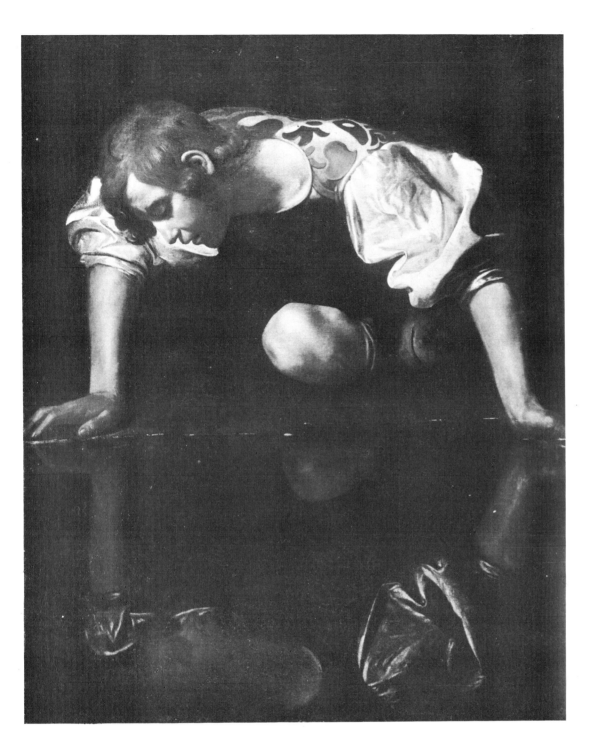

21 *Narcissus*
ROME, Galleria Nazionale d'Arte Antica, Palazzo Corsini. 1598/1601. Canvas 133·3 × 95 cm.

This undocumented picture was discovered in a Milanese private collection in 1913 by the great Italian scholar Roberto Longhi and immediately assigned to Caravaggio—surely one of the most perceptive attributions of Longhi's long and, as regards attribution, not unchequered
career. For despite considerable damage, especially on the face, and a somewhat loose handling, the picture is both in design and execution very close to what we know of Caravaggio's work in the late 1590s and early 1600s. It is comparable in colour and handling to certain passages in *The Calling of the St. Matthew* (Plate 24), *The Martyrdom of St. Matthew* (Plate III) and the Capitolina *St. John the Baptist* (Plate 23), while its clear-cut architectonic structure parallels the Potsdam *Incredulity of St. Thomas* (Plate 32). It may even be referred to in a document which records the export, in 1645, from Rome to Savona, of a picture of Narcissus by Caravaggio. The artist may possibly have conceived the subject of the picture Neo-Platonically in terms of a union between man, Narcissus, and nature, water, through love aroused by beauty; but he also invested the image with altogether more direct intimations of doomed sensuality, the fleshy lips and pouting expression recalling those in *The Boy Bitten by a Lizard* (Plate 2). The emphatic classicism of design was possibly in part prompted by study of a famous antique statue of a boy removing a thorn from his foot—*The Spinario*.

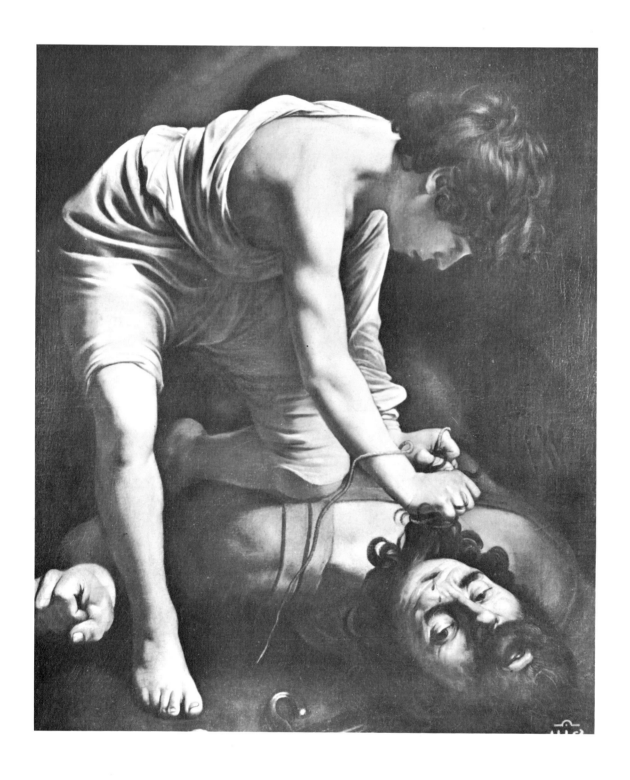

22 *David with the Head of Goliath*, original?
MADRID, Museo del Prado. ?1598/1601. Canvas 110 × 91 cm.

There is no mention of a full-length *David and Goliath* by Caravaggio in the sources, and the earliest references to this picture show that it was in the Alcázar, Madrid, in 1686 and 1700 and in the Palacio del Buen Retiro, Madrid, by 1774. Numerous comparisons can be made with known works by Caravaggio, especially *The Conversion of Saul* (Plate IV), for the composition, and *Judith and Holofernes* (Plate 17), for the similarity between the two severed heads, while there is clearly also a close correspondence with *Narcissus* (Plate 21). If any doubts remain about *David with the Head of Goliath* it is because of the somewhat stolid composition, which seems to lack Caravaggio's usual animation, rather than the quality of the handling, which compares favourably with that of accepted works.

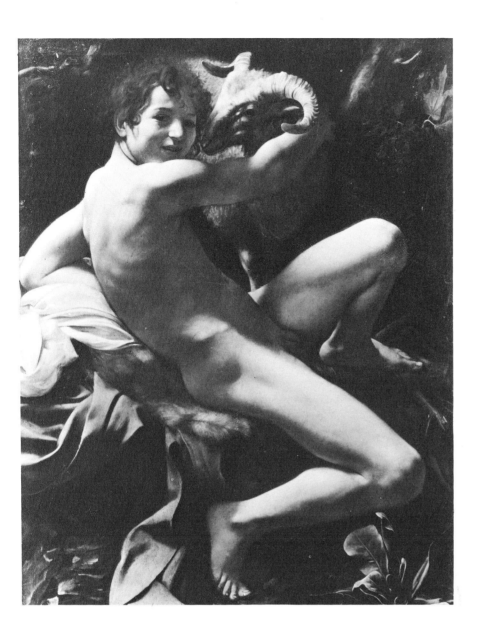

23 *St. John the Baptist*
ROME, Pinacoteca Capitolina. 1599/1601. Canvas 130·4 × 97·6 cm.

The most likely provenance for this iconographically unusual picture was first reconstructed by
Denis Mahon (1955), who argues that it was commissioned by Ciriaco Mattei, was given by him
to his son, Giovanni Battista, who, interestingly enough, bore the same name as the saint, and was
then bequeathed by the son in wills of January 1623 and June 1624 to Cardinal del Monte. The
picture was listed in the del Monte inventory of 1627 and sold at the del Monte sale of 1628,
probably with the Rome *Fortune-teller* (Plate 11), to Cardinal Pio. It was sold by the Pio family to
Pope Benedict XIV in 1749/50 to be lodged in the newly founded Capitoline museum. The fact
that the young Baptist has none of his usual identifying attributes (a bowl, reed cross and lamb)
has led to some doubt about the identity of the subject, but the fact that it is mentioned in so many
of the early sources as a Baptist should be given due emphasis. The Baptist had often been depicted
as a good-looking, semi-nude, youth during the Renaissance (for example in Raphael's picture
in the Uffizi, which also stresses *chiaroscuro*, and in Andrea del Sarto's smaller composition
in the Pitti) and Caravaggio clearly owed as much to this well-established iconographic
trend as he did, in the pose, to Michelangelo's energetic male nudes on the Sistine ceiling or his statue
of *Day* in the Medici Chapel. But the figure, lounging like the Uffizi Bacchus on a bundle of
bedding, is much more overtly sensual than any of these Renaissance works, and it is as if
Caravaggio chose to develop the subject's acquired connations at the expense of its original biblical
and Christian significance. Yet this is probably an oversimplification resulting from our inadequate
understanding of the symbols which do appear in the picture. Most mystifying of all, the ram,
instead of the customary Lamb of God, may, as Luigi Salerno (1966) has suggested, have been
intended as a symbol of sacrifice—Christ's future sacrifice, but also, on a philosophical level, the
inevitable sacrifice of St. John's smiling youth to the encroachments of time. Another version in the
Galleria Doria-Pamphili, Rome, may have been painted by Caravaggio himself, but is probably
an extremely good copy by a different artist.

ROME, San Luigi dei Francesi, Contarelli Chapel

The three scenes from the life of St. Matthew in the Contarelli Chapel of the French Church of San Luigi (St. Louis) in Rome were Caravaggio's first public commission and among his most influential creations. The chapel had been endowed in 1565 by the noble French ecclesiastic, Mathieu Cointrel, whose name was italianized as Matteo Contarelli, but despite attempts to have it decorated with scenes from the life of his patron saint, Matthew, by the Brescian painter, Muziano, work on the chapel had not even been begun by the time of Contarelli's death in 1585. Responsibility then passed to Contarelli's heirs, the Crescenzi family, who, in their turn, commissioned the Cavaliere d'Arpino, one of the leading artists working in Rome during the 1580s and 1590s. D'Arpino actually frescoed the ceiling during the early 1590s, but, for reasons which remain unclear, the rest of the chapel was not completed. The clergy became dissatisfied and began to petition the pope against the Crescenzi, whom they accused of hoarding the money of the endowment deliberately, until finally, on 12 July 1597, the money was placed under the control of the Fabbrica of St. Peter's—that part of the Vatican bureaucracy devoted to the erection and furnishing of buildings. D'Arpino was given a final opportunity to complete the decoration of the side walls of the chapel, but again prevaricated, with the result that the Fabbrica awarded the commission to Caravaggio, in all probability as a result of the good offices of his patron, Cardinal del Monte, who was himself its prefect. The commission for the two lateral paintings, *The Calling of St. Matthew* (Plate 24) and *Martyrdom of St. Matthew* (Plate III) is dated July 1599, and payment for the completed works was made in July 1600. Caravaggio was not then commissioned to paint the altarpiece of *St. Matthew and the Angel* (Plates 25 and 26) as well, since the intention was still, at this time, to have it sculpted by the Flemish sculptor, Jacob Cobaert (Cope Fiammingo), who had been working intermittently on the project since 1587!

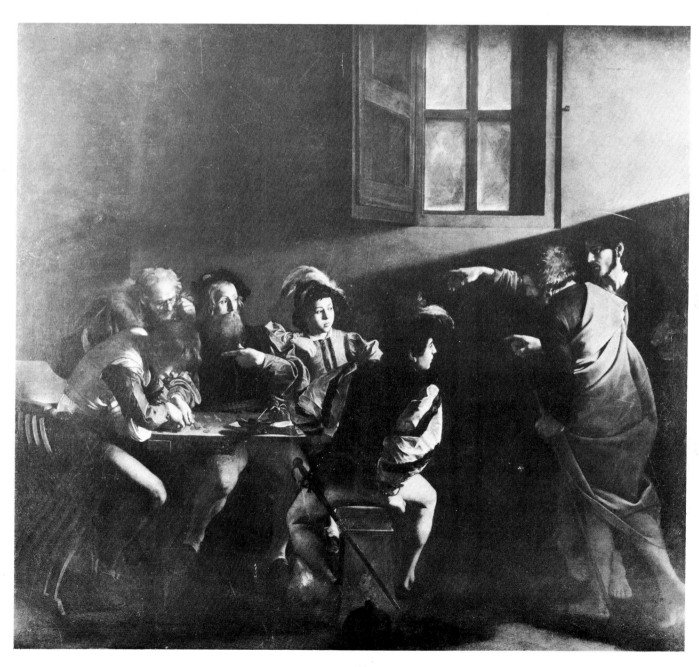

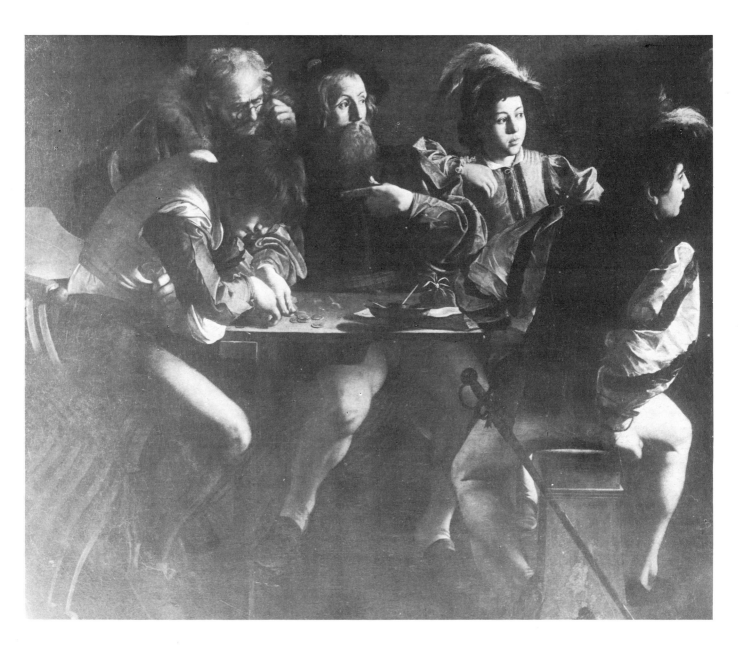

24a *The Calling of St. Matthew*, detail

24 *The Calling of St. Matthew*
ROME, Church of San Luigi dei Francesi, Contarelli Chapel. 23 July 1599/4 July 1600.
Canvas 322 × 340 cm.

The wealthy tax-collector Levi (Matthew), counting out his money at a table in front of a house, is summoned to the discipleship by Christ's gathering gesture; but if we follow the line of Christ's arm round to his left hand, deep in shadow, we can see how the gesture is amplified to suggest that Matthew should follow him into the world at large, the space of the spectator. It was to a great extent this clear legibility, so different from many Mannerist paintings, which accounted for the work's enormous popularity. For although the youths who surround Matthew are dressed in a Renaissance type of costume, or possibly as the liveried retainers of some wealthy gentleman, and the figures of Jesus and St. Peter wear timeless robes, the effect is one of a mythical religious event re-enacted in a recognizably everyday context. The quality of realism (Plate 24a) is further enhanced by the careful attention paid to the texture and lighting of the red, green, black and yellow materials of the young men's costumes: an essay in warm, sensuous tones which, like several of Caravaggio's works of the middle and late 1590s, bears comparison with that great Venetian master of natural effects, Giorgione. The typically Caravaggesque beam of light which plays such a crucial part both in the composition and in symbolizing Matthew's conversion, has a further, illusionistic function in that it enters the picture from the direction of a real window in the chapel.

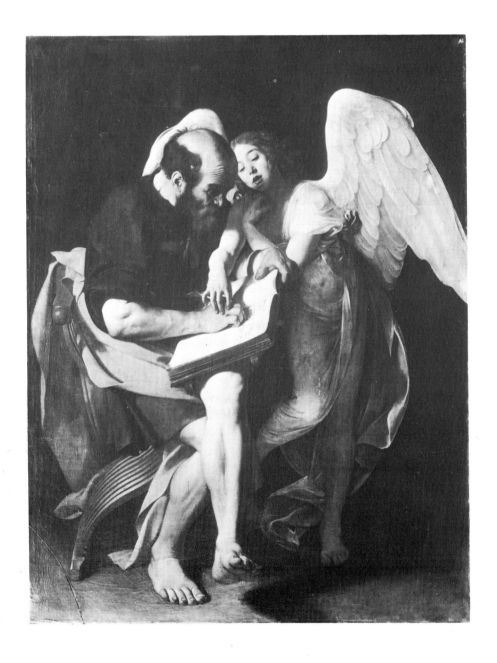

25 *St. Matthew and the Angel*, first version
formerly BERLIN, Kaiser-Friedrich-Museum (destroyed in the bombardments of 1945).
7 February/?May 1602. Canvas 223 × 183 cm.

The line at the bottom left is due to a crack in the photographic plate. At the time of Caravaggio's
commission for the two lateral paintings the commission for the altarpiece still belonged to the
mediocre and extremely old Flemish sculptor, Jacob Cobacrt (Cope Fiammingo); but apparently
his work was so poorly executed that it was rejected as soon as it was placed *in situ*, although it was
then still unfinished, and a contract made on 7 February 1602 with Caravaggio, this time by
Giacomo Crescenzi, for a painted altarpiece instead. The discovery of this document has proved
perplexing to scholars since it had previously been thought that the style of this picture, with its
three-dimensionality and solid modelling, was close to that of at least two or three years earlier.
Yet the precise chronology of Caravaggio's pictures is still a legitimate subject for debate, and the
sculptural quality and foreshortening in this work do not seem so very far from the National Gallery
Supper at Emmaus (Plate 29) which many scholars now place rather late—1602/03 according to the
National Gallery catalogue. Furthermore, it is possible, as Salerno has suggested, that Caravaggio
sought to give his picture a particularly sculptural appearance in an attempt to create a powerful
substitute for Cobaert's rejected piece. At all events, the picture, like the sculpture, was, in its turn,
rejected, although this time for moral and religious rather than aesthetic reasons. Bellori says that
the clergy considered that it lacked 'decorum', and objected to the saint's crossed legs and
prominent feet, but it almost certainly had as much to do with the erotic character of the angel,
in such close proximity to St. Matthew himself. Caravaggio's friend and patron, the Marchese
Vincenzo Giustiniani, purchased the rejected work and probably had it cut down in size to
accommodate it to his own private picture gallery. It is noteworthy that the cross-legged pose of the
saint is strongly reminiscent of that in a picture of c. 1521 of the same subject by Caravaggio's north
Italian predecessor, the Brescian artist Romanino (Brescia, Church of San Giovanni Evangelista).

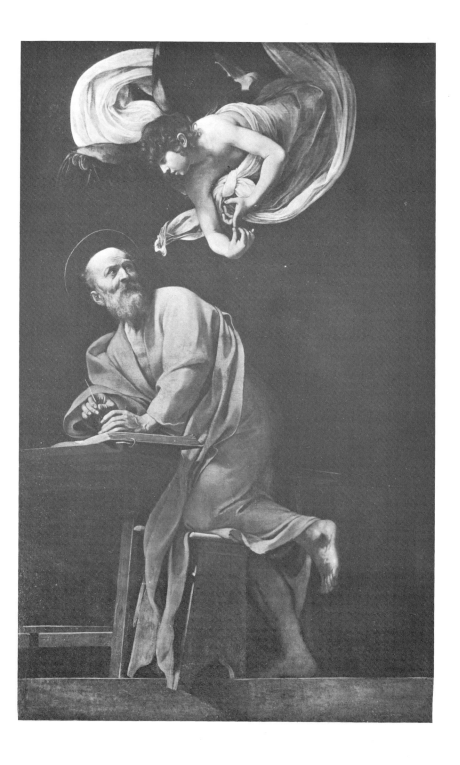

26　*St. Matthew and the Angel*, second version
ROME, Church of San Luigi dei Francesi, Contarelli Chapel. ?June/22 September 1602. Canvas 296·5 × 195 cm.

Caravaggio's failure to please the clergy of San Luigi with his first version of the picture led him to produce what some modern scholars have described as a more conservative and classical solution, with the saint and angel now respectably at arm's length. Indeed, the geometrical pattern of the angel's drapery and the way in which the top half of his body is flattened into a relief-like form combine with the spiralling *contrapposto* of the saint's body to create a composition which is both classical and mannered. The classical element is further enhanced by the fact that the picture is framed in the chapel by two columns, and it is as if Caravaggio allowed himself to be influenced by this setting in the vertical emphasis which he gave to the second version, whereas in the first he simply treated the columns as a frame rather than an aspect of the overall design. But realism was by no means completely ousted by style in the later work: the illusionism of the foreshortened stool, tilted upwards by the inspired saint, is arguably the linch-pin of the composition, completing the downward movement which originates in the angel and redirecting it into the space of the chapel. Furthermore, the emphatic gesture of the angel is as good an observation of Latin gesticulation as Christ's more expansive one in the superficially equally stylized Odescalchi *Conversion of Saul* (Plate 27).

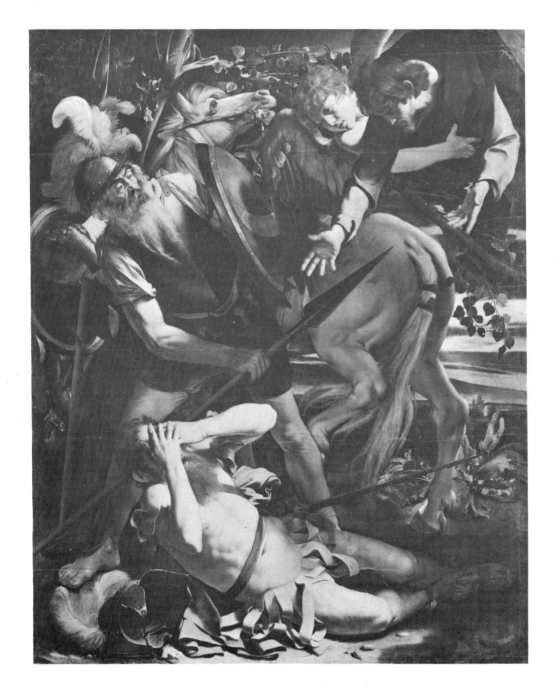

27 *The Conversion of Saul (The Conversion of St. Paul)*
ROME, collection of the Principe Guido Odescalchi. 24 Sept 1600/1601. Cypress wood panel
237 × 189 cm.

Two paintings, of the conversion of St. Paul and the martyrdom of St. Peter, to be painted on
cypress wood, were commissioned from Caravaggio on 24 September 1600, by Monsignor Tiberio
Cerasi, consistorial advocate and Clement VIII's general treasurer, to be placed in a chapel which
he had acquired in July 1600 in the Augustinian Church of Santa Maria del Popolo. Neither of the
two famous pictures now in the chapel is on wood, and this, together with a reference by Baglione,
has led people to look for earlier versions. Baglione states that 'these pictures were first painted in
another style, but because they did not please the patron, they were taken by Cardinal Sannessio,
and Caravaggio then painted the two versions one sees now.' If Baglione is to be taken literally the
two earlier versions must have been completed, and rejected, before Cerasi's death on 3 May 1601.
Although a few modern scholars have doubted the identification of the Odescalchi picture with a
first version of *The Conversion*, its very similar size, its poplar wood support and the fact that it is
demonstrably 'in another style' all point towards Caravaggio's authorship—as, indeed, do several
stylistic features such as the angel, the helmet on the ground, the figure of Christ, who echoes the
executioner in *The Martyrdom of St. Matthew* (Plate III), and even the Mannerist pose of the horse,
which parallels that of St. Matthew in the second version of *St. Matthew and the Angel* (Plate 26).
Although not mentioned in the Bible, which records Saul simply hearing a voice, the figures of the
vision were usually depicted by artists in the sixteenth century, while the lighting, strangely harsh
for Caravaggio, is probably explicable iconographically as an attempt to render the blinding light
which struck Saul to the ground.

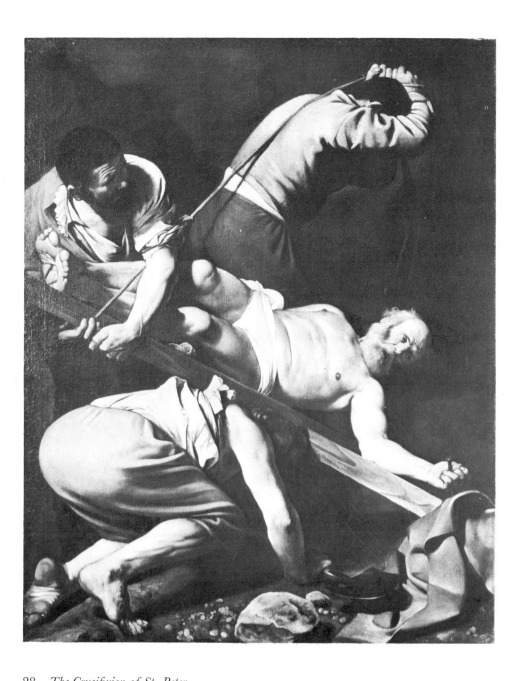

28 *The Crucifixion of St. Peter*

ROME, Church of Santa Maria del Popolo, Cerasi Chapel. 1601 (before 10 November). Canvas 230 × 175 cm.

Both of Caravaggio's paintings in the Cerasi Chapel are in marked contrast to the chapel's altarpiece by Annibale Carracci (fig. 2). This is in part due to the fact that both painters paid attention to the location of their pictures when formulating the design, so that whereas Annibale's composition is frontal, Caravaggio, whose compositions were for the lateral walls, attempted to lure the spectator's eye into the pictures along diagonal lines of recession. But it also seems probable that the two most famous painters of the younger generation in Rome treated their joint commission as something of a competition, with the result that they both chose to emphasize those aspects of their respective styles with which they wished to be associated: Annibale, with his pale precious colours and firm outlines, became more 'classical' than ever, whereas Caravaggio, eager to assert, as he did at the Baglione libel trial in 1603, that a good painter is someone 'who knows how to paint well and imitate well natural things', chose to stress details such as the executioner's dirty feet and the beautifully polished and foreshortened spade together with the powerfully expressive facial features of St. Peter (Plate 28a). It is worth noting that Caravaggio's handling in the two Cerasi pictures is subtler and more masterly than in the Contarelli works (Plates III, 24, 25 and 26), and that colour plays an important rôle in leading the eye from one picture to the other; especially significant is the harmonious contrast between the two cloths at the far end of either of Caravaggio's pictures—grey in *The Crucifixion of St. Peter*, bright pink in *The Conversion of Saul* (Plate IV). Some attempts have been made to identify the lost first version of *The Crucifixion of St. Peter*, referred to by Baglione, with a painting in the Hermitage, Leningrad (Plate 28b), but even the view that this represents a copy, or partial copy, of the lost original is not altogether convincing.

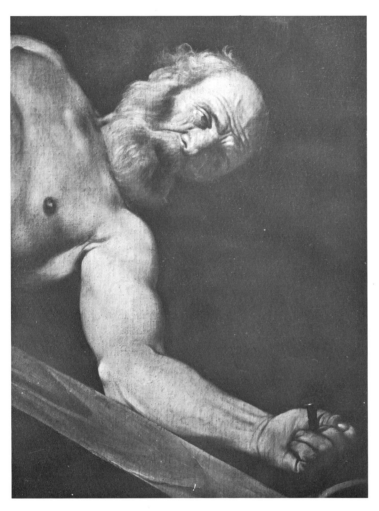

28a *The Crucifixion of St. Peter*, detail

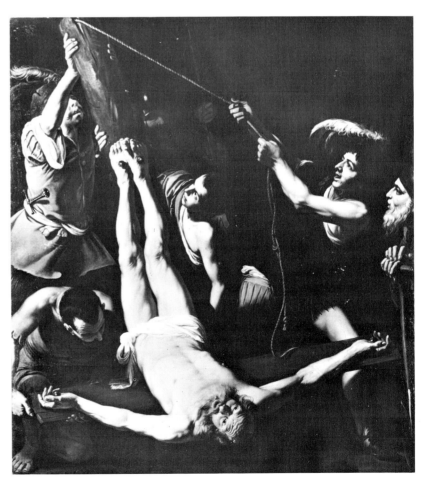

28b Scho╌l of CARAVAGGIO.
The Crucifixion of St. Peter
LENINGRAD, Hermitage Museum. Canvas

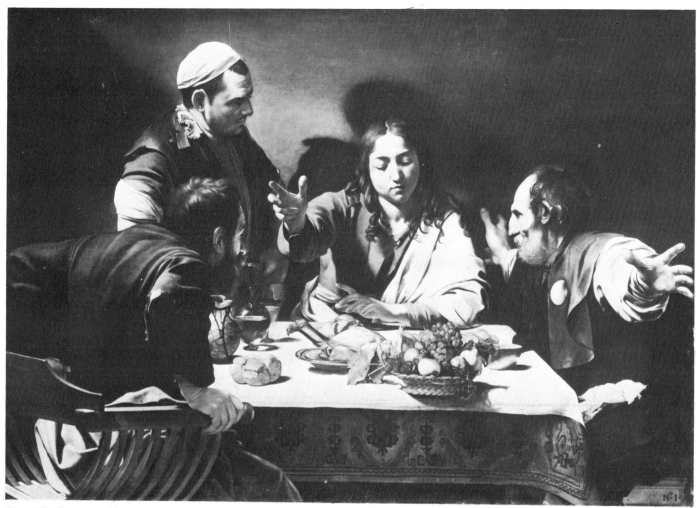

29 *The Supper at Emmaus*
LONDON, National Gallery. 1602/03. Canvas 141 × 196·2 cm.

The Supper at Emmaus can be seen as an elaborate showpiece which seeks to develop to the full the dramatic potential of a group of figures seated round a table. But, unlike those in the more modest *Cardsharpers* (Plate 9) and *The Conversion of the Magdalen* (Plate 16), the thoughts and feelings of the protagonists are conveyed through violent movement and expansive gestures. Even Jesus seems rather too conscious of the effect he is making in this flamboyant gathering of vernacular eloquence in which not even the basket of fruit can keep still. Although the grandiose gesture of Christ himself is derived from that of Michelangelo's Christ in the Sistine *Last Judgment*, one is aware of Caravaggio's dependence on the posing of models and of the way in which they are not altogether successfully integrated into the action—note for example, the Apostle on the right, whose over-large right hand (Plate 29a) adds to the feeling of an inadequate assimilation of individually observed details. This was exactly the kind of failing implied by Van Mander in *Het Schilder-Boeck* of 1604 and stated much more explicitly by Mancini in his *Considerazioni sulla pittura*. But despite these obvious faults, the picture remains a great achievement which, doubtless because of its illusionistic excesses, as well as its masterly *chiaroscuro* and succulent still-life details, was widely admired and copied during the seventeenth century. It was bought by Cardinal Scipione Borghese, the passionate collector and nephew of Pope Paul V, sometime after his arrival in Rome in the summer of 1605, possibly from Ciriaco Mattei. Tests made on cross-sections of pigment at the Detroit Institute of Arts by Meryl Johnson have been interpreted as showing that Caravaggio employed the unusual technique of applying a thin layer of tempera, 'wet-on-wet', over the oil paint in the area of the tablecloth. The effect of this is allegedly, as in the Detroit *Conversion of the Magdalen* (Plate 16), to produce an additional translucence in the white highlights. But the biological staining technique used in these tests would need to be supplemented by gas chromatographic analysis before more certain conclusions can be drawn. The National Gallery, London, now possesses the apparatus for gas chromatography but it will only be possible to take samples for analysis from damaged areas when the painting is again in need of restoration. It should be added that biological staining tests carried out at the National Gallery on a number of admittedly smaller cross-sections of pigment than those sent to Miss Johnson at Detroit have not produced any firm results. Although they indicate traces of protein, and in some instances strongly suggest the presence of egg tempera, it is not at all clear whether tempera was applied in the unusual 'wet-on-wet' manner which Miss Johnson has suggested. Apart from the more conventional mixed-media technique of applying tempera over a *dry* layer of oil paint, a number of other reasons could be advanced for the presence of protein in these samples. Miss Johnson's conclusions may be correct, but it would be well to treat them with caution for the time being.

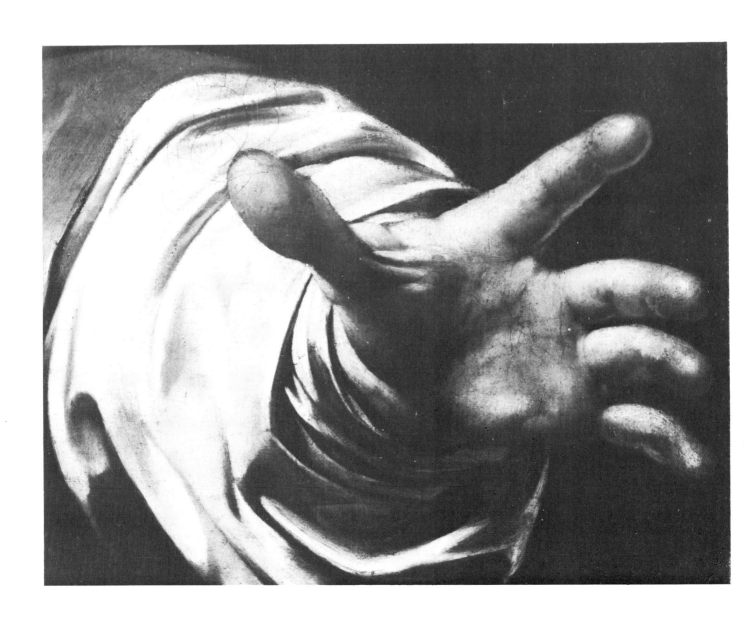

29a *The Supper at Emmaus*, detail

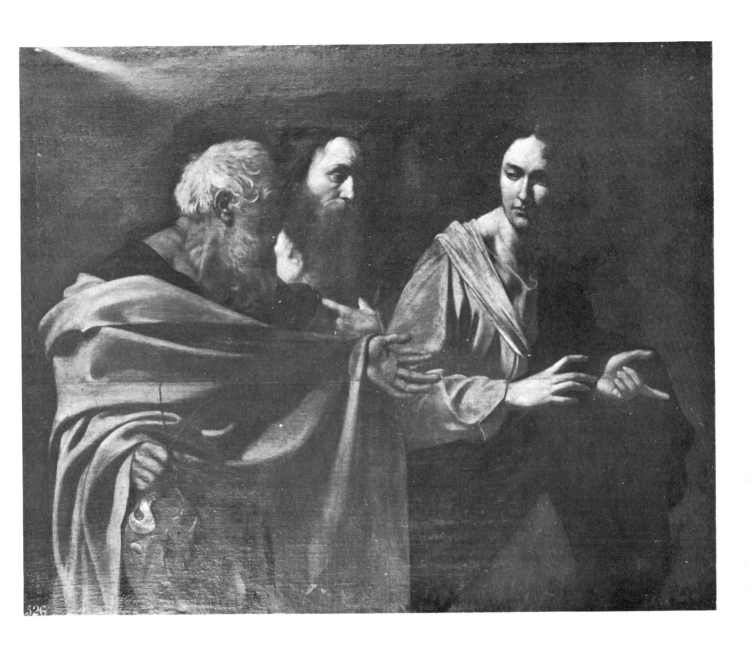

30 *The Calling of St. Peter and St. Andrew* or *The Walk to Emmaus*, copy?
HAMPTON COURT PALACE, Royal Collection (Reproduced by gracious permission of Her Majesty the Queen). Canvas 132 × 163 cm.

This picture was acquired by Charles I, King of England, in 1637 and listed, c. 1639, in Van Doort's catalogue of the collection, as the work of an imitator of Caravaggio. Other contemporary references which seem to apply to the same picture, however, mention it as an original. It is in rather bad condition, and we have to await its projected cleaning before deciding on its authenticity. It is fair to add that most modern scholars have felt it to be a copy after a lost original, but given the highly unexpected 'emergence' of a genuine work by Caravaggio from under the dirt and repainting in the case of the Prato *Crowning with Thorns* (Plate 31), it is perhaps not unreasonable to be cautiously optimistic. Whether or not original, the beardless type of Christ is strikingly reminiscent of the figure in the National Gallery *Supper at Emmaus* (Plate 29), and the Hampton Court composition is probably, at least, therefore, a copy after a lost original. The picture's subject has also presented problems, Friedlaender linking it with a reference by Baglione to a *Walk to Emmaus* commissioned by Ciriaco Mattei, Longhi arguing that, because of the presence of the fish and the questioning gesture of the central figure, it represents rather the moment when Jesus challenges Peter and Andrew to abandon their livelihood and become, instead, 'fishers of men'. Horace Walpole rather interestingly referred to it in the eighteenth century as 'one of the finest pictures the King has'.

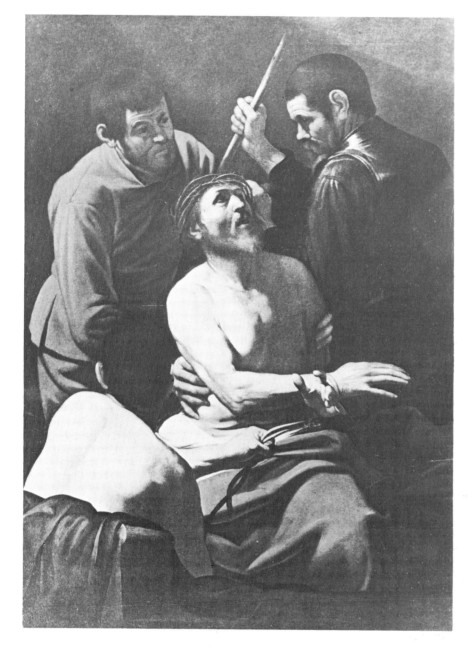

31 *The Crowning with Thorns*
PRATO, Cassa di Risparmi e Depositi di Prato. 1602/03. Canvas 178 × 125 cm.

The recent cleaning of this picture, formerly in the Cecconi collection, has revealed it as an undoubted masterpiece of Caravaggio's mature Roman phase, dating from about the same time as the National Gallery *Supper at Emmaus* (Plate 29) which it resembles, above all, in its lighting. The picture is distinguished by the skilful manner in which Caravaggio adapted an archaic composition to his own purposes and thereby successfully challenged both the archaeological classicism of the young Rubens, working in Italy from 1600 to 1608, and the evolved intellectualism of the aged Titian. There can, as Mina Gregori has shown, be little doubt that Caravaggio's Christ was influenced by the figure of Christ in Rubens's altarpiece of the *Crowning with Thorns*, completed by April 1602 for the Church of Santa Croce in Gerusalemme, Rome, and that Rubens's figure was, in turn, derived from the famous classical statue of *The Belvedere Torso*. It also seems probable that the pose of Caravaggio's soldier in armour, holding his staff in a somewhat artificial manner which symbolizes rather than facilitates his rôle as tormenter, owed something to Titian's famous depiction (Paris, Musée du Louvre) of the subject, which Caravaggio could have seen in his youth in the Church of Santa Maria delle Grazie, Milan. But Caravaggio's response to both pictures was competitive rather than deferential, and he clearly attempted to eliminate their conspicuous clutter by reverting to the compact, symmetrical kind of fifteenth-century composition employed, for example, by Hieronymous Bosch in *Christ Mocked* (London, National Gallery). The effect, altogether brilliant, is of a classicism which discerns an order in situations but does not impose one on them and makes ample use of significant rather than 'appropriate' gestures to lend both visual and psychological cohesion to the image. There is a downward spiral of very precise actions: pulling Christ's hair, a motif actually adopted from the related subject of the mocking of Christ by the Jews; squeezing his body; tightening the rope around his wrists.

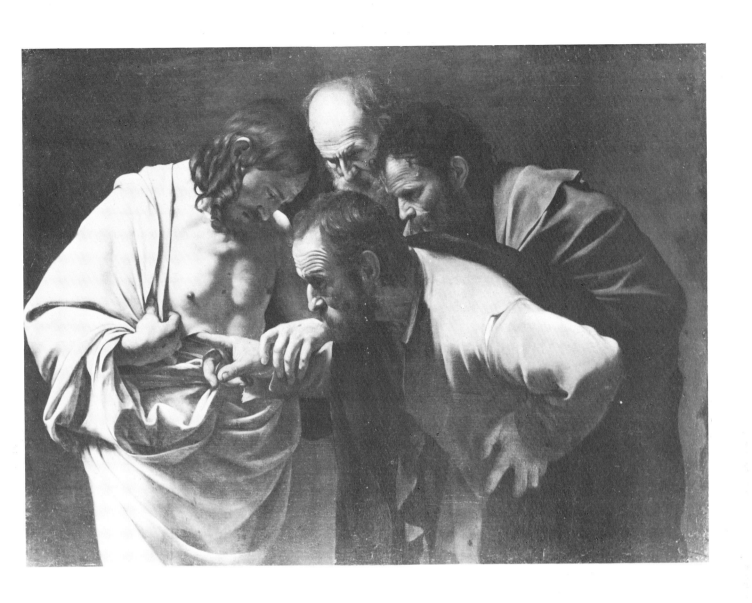

32 *The Incredulity of St. Thomas*
POTSDAM, Schloss Sanssouci (Staatliche Schlösser und Gärten). 1601/03. Canvas 107 × 146 cm.

This picture of 'Doubting Thomas' gingerly placing his finger inside Christ's wound is close to the National Gallery *Supper at·Emmaus* (Plate 29) in its figure-types as well as its iconography, being another instance of Christ appearing to his disciples after the Resurrection. Its rhetoric, however, is less overt, and the effect of immediacy and physical presence is achieved by showing the figures close up and cut off at the level of the knees, an unusual feature in earlier depictions of the subject. But, as so often with Caravaggio in his mature phase, realistic and illusionistic qualities, such as St. Thomas's diagonally foreshortened left arm, are offset by a keen attention to the interrelationship of forms, creating, in this instance, a highly abstract pictorial architecture which resembles a gateway surmounted by a pentagonal pediment. An overall classicism of design is combined with a realistic and unidealized treatment of the individual figures, although it was primarily the latter quality which accounted for the great interest which the work aroused among artists. The picture belonged to the Marchese Vincenzo Giustiniani from an early date—before 1606.

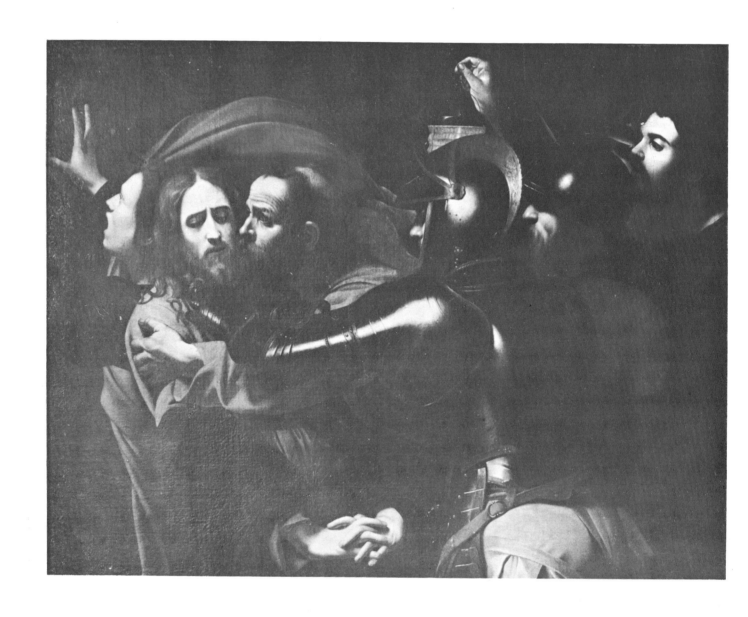

33 *The Taking of Christ*, copy?
ODESSA, State Museum of Western and Eastern Art. c. 1601/03. Canvas 133 × 171 cm.

This impassioned and tender rendering of the betrayal of Christ, which corresponds exactly with a detailed description given by Bellori, was executed for the Marchese Asdrubale Mattei, brother of Ciriaco Mattei. Since many western scholars have not actually seen the work its status hovers between that of 'possible original' and 'good copy', with a doubtless praiseworthy tendency to err on the side of caution. It is certainly far superior to any of the other surviving copies, even if, by contrast with the other versions, it is possibly slightly reduced in size. Its highly dramatic grouping of figures is symptomatic of the phase in Caravaggio's art which began in c. 1598/99 and which is represented by such works as *Judith and Holofernes* (Plate 17) and *The Martyrdom of St. Matthew* (Plate III). But the articulate and well-balanced blend of rhetoric and genuine emotion in the Odessa picture suggests that it was not one of the artist's very earliest evocations of religious drama. It is also difficult to imagine Caravaggio having painted *The Taking of Christ*, with its sense of the excitement and danger of the night, before the period of his nocturnal scuffles with the police and others, the earliest of which are documented in the police records of late 1600 and early 1601. Indeed, the figure on the far right, holding the lantern, may be a self-portrait. Once again Caravaggio managed to combine a traditional classical quality, apparent in the motif of the billowing cloak which frames the heads of Christ and Judas, with a powerful physicality (the bovine thrust of Judas's face), and a feeling of equally intense spirituality, evident in Christ's noble countenance and the way in which his intertwined fingers express both anguish and self-control.

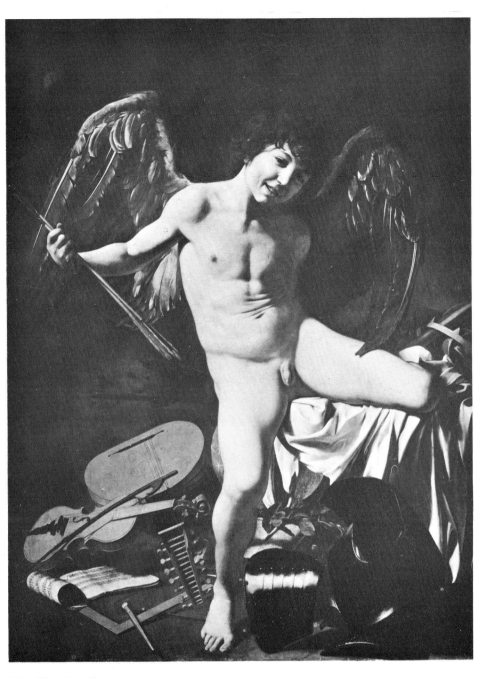

34　*Victorious Love*
BERLIN, Staatliche Museen, Gemäldegalerie. c. 1602. Canvas 154 × 110 cm.

This smiling and distinctly provocative cupid was painted for the Marchese Vincenzo Giustiniani, who considered it the masterpiece of his collection and, as a sign of esteem as much as through modesty, had it placed behind a green silk curtain in his gallery. It is referred to by the painter Orazio Gentileschi as an '*Earthly Love*' as opposed to a '*Heavenly Love*' which Caravaggio's rival, Baglione, painted for the same patron and of which versions exist in Berlin and at the Palazzo Corsini, Rome. The theme of love as a great leveller which respects neither rank, nor achievement, nor culture but irreverently subjects all and sundry to its influence ('omnia vincit amor') was a well-established one, and, in fact, forms the leitmotif of Annibale Carracci's important contemporary ceiling decoration in the Galleria Farnese, Rome. Nevertheless, R. Engass has shown that since Cupid is surrounded by symbols which epitomize Giustiniani's own documented cultural activities and interests, the picture is to be understood allegorically, not simply as illustrating the theme of love conquering everything, but also that of Vincenzo conquering everything. As well as being an amateur of painting, Giustiniani was, in addition, a keen musician, architect and writer, and these interests were given obvious recognition in the picture through the inclusion of musical instruments and a score, a T-square and a compass, a book and a pen. The armour refers to that universally admired virtue among Renaissance noblemen, martial prowess, while the crown and sceptre may allude to the almost regal sway which the Giustiniani family had held over the Aegean island of Chios prior to its annexation by the Turks in 1566. Stylistically speaking, Caravaggio, as in the Capitolina *St. John the Baptist* (Plate 23), produced a hedonistic and almost satirical variant on the pose of one of Michelangelo's masterpieces, in this case the famous 1528 statue of *Victory* in the Palazzo Vecchio, Florence.

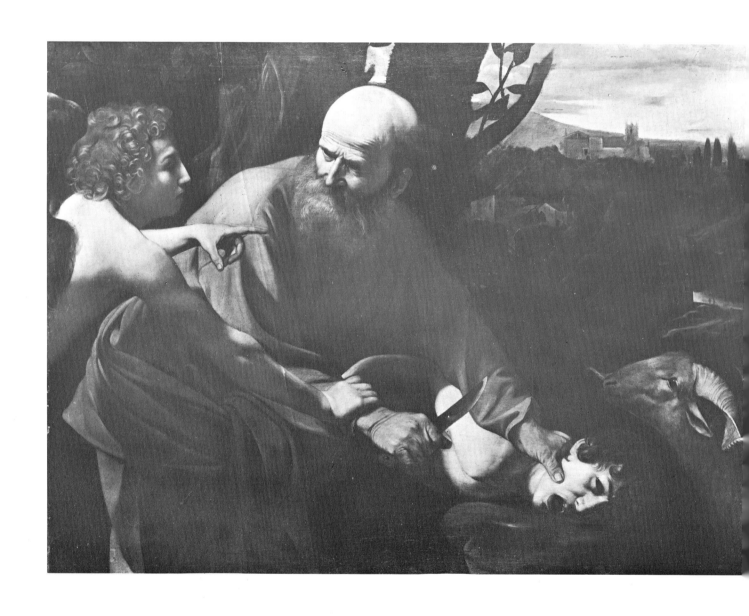

35 *The Sacrifice of Isaac*
FLORENCE, Galleria degli Uffizi. c. 1603. Canvas 104 × 135 cm.

Almost certainly the work mentioned by Bellori as having been painted for Maffeo Barberini
(Plates 18 and 19), *The Sacrifice of Isaac* could well have been the reason for a series of payments,
amounting to one hundred scudi, made by Barberini to Caravaggio between May 1603
and January 1604. It entered the Colonna di Sciarra collection in 1812 and was later bought by
John Fairfax Murray, who donated it to the Uffizi in 1917. Some stylistic features seem to link it to
such works of the late 1590s as the *Medusa* (Plate 20), which has a similarity to Isaac's head, or *The
Martyrdom of St. Matthew* (Plate III), which provides an antecedent for the firm grip of the angel's
hand round Abraham's wrist. The composition is also extremely close to that of *Judith and Holofernes*
(Plate 17). But the handling seems to date from a later period, and the colour scheme, in which
chiaroscuro and local colour are fused under a magical half-light (Plate 35a), is of an unprecedented
subtlety, although it in some ways recalls the Giorgionesque and Savoldesque lighting of certain early
works by Caravaggio. For all his concern with atmosphere, however, Caravaggio maintained an even
developed his incisive sense of design, most ingeniously in the imaginary curve which descends from
the angel's pointing finger to the horn of the sacrificial ram, which is then twisted forwards out of
the edge of the picture.

35a *The Sacrifice of Isaac*, detail of landscape

V *The Supper at Emmaus*
MILAN, Pinacoteca di Brera. 1605/06. Canvas 141 × 175 cm.

In the collection of the Marchese Patrizi by 1624, the Brera *Supper at Emmaus* was possibly
commissioned by him during Caravaggio's late Roman period. Ambiguous references in Mancini
and Bellori, however, suggest that it may have been painted at Zagarolo immediately after
Caravaggio's flight from Rome in June 1606, when he was staying on the estates of the Principe
Marzio Colonna, brother-in-law of the Marchese di Caravaggio. The picture inevitably invites
comparison with the earlier National Gallery version of the same episode (Plate 29), and it can be
seen how Caravaggio replaced expansive with restrained gestures and brought the figures slightly
closer to the picture plane. Presence is more important than performance in this mute drama in
which the dark shadows and saturated colours evoke a feeling of religious mystery. The drawing of
certain details, such as the small glass tucked away behind the wine jug and the oddly
proportioned right hand of the innkeeper's wife, is as clumsy as ever but there is also a new fluidity
in the handling of paint which lends cohesion to an otherwise slightly uneasy composition.
Nevertheless the compression of the figure-units as a result of the abandonment of spatially
suggestive gestures necessitated the introduction of an extra figure, the innkeeper's wife, who rather
gives the impression of having been a last-minute insert. Neither the innkeeper nor his wife is
mentioned in the biblical account in *Luke* XXIV:28–32, but they, and indeed other guests, had
been introduced by Renaissance painters such as Titian to act as a foil to the amazement of the
the two disciples when they recognize the resurrected Christ.

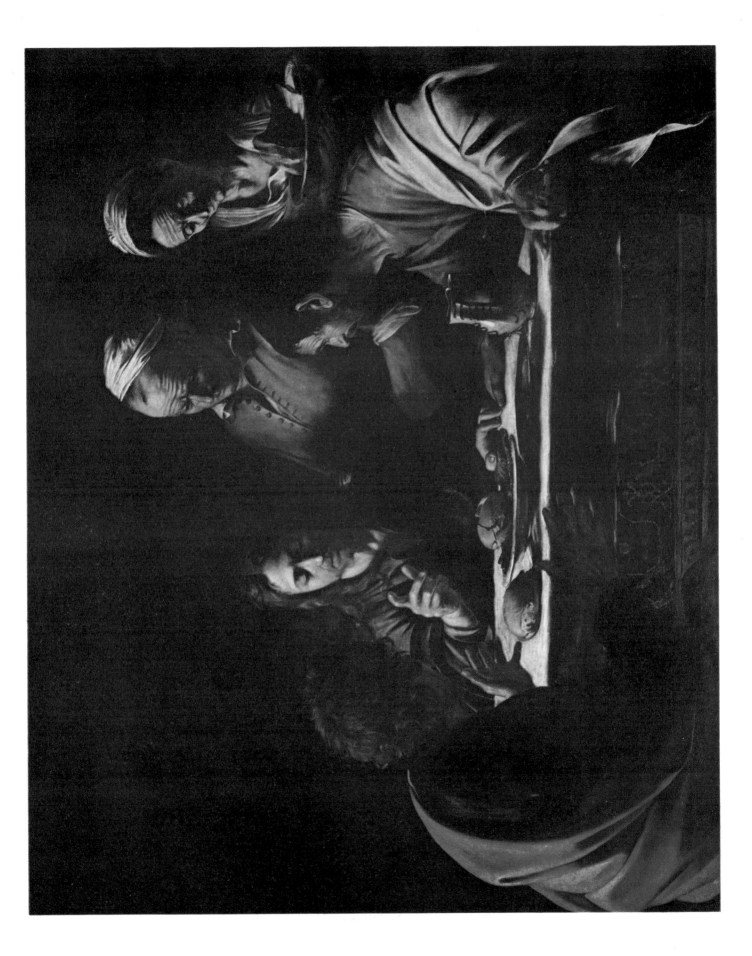

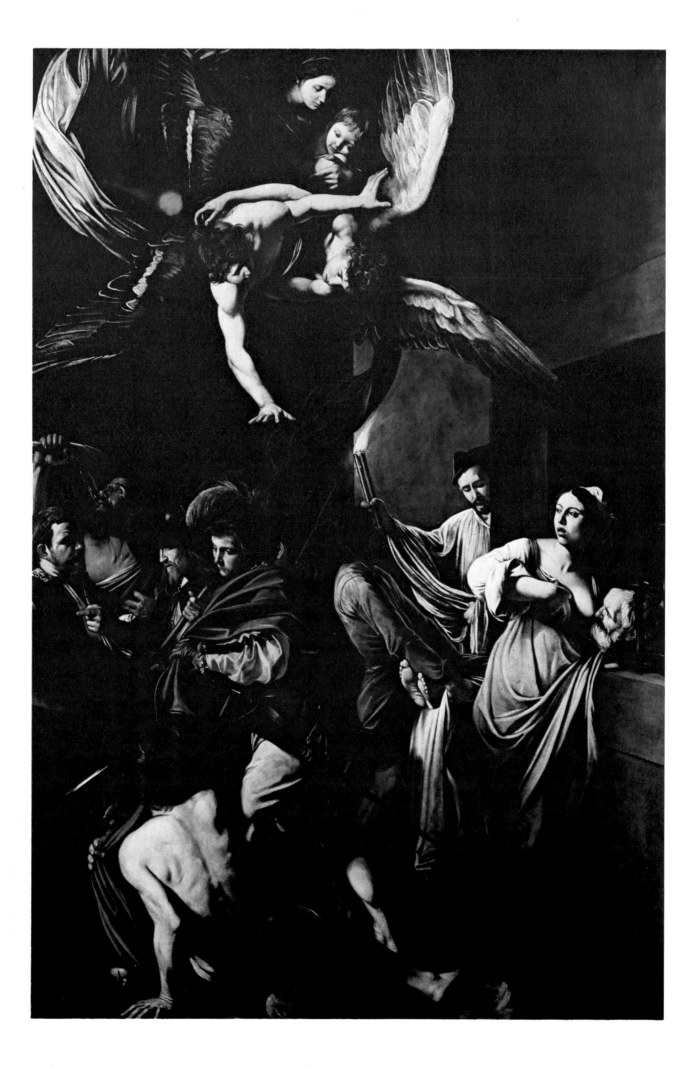

VI *Madonna of Mercy (The Seven Works of Mercy)*
NAPLES, Church of the Pio Monte della Misericordia. September–October 1606/9 January 1607.
Canvas 390 × 260 cm.

After the brutal suppression by the Spaniards of the popular uprising of 1585, much of the energy which had previously gone into the struggle for local Neapolitan liberties was channelled into the creation of charitable institutions, which served not simply to dispense alms to the poor but also to pursue the interests of their own members. They flourished at all levels of society, but the Confraternity of the Pio Monte della Misericordia, founded on 17 April 1601 and accorded papal recognition on 15 November 1605, was a wealthy and upper-class brotherhood. Early references to the picture commissioned by them call it '*Our Lady of Mercy*', although the subject of the lower half of the composition was based on the six works of mercy referred to in *Matthew* XXV:31-37.

'When the Son of Man comes in glory . . . he will sit in state on his throne . . . He will separate men into two groups . . . and he will place the sheep on the right hand and the goats on the left. Then the King will say to those on his right hand "You have my father's blessing; come, enter and possess the Kingdom that has been ready for you since the world was made. For when I was hungry, you gave me food; when thirsty, you gave me drink; when I was a stranger, you took me into your home, when naked, you clothed me; when I was ill, you came to my help, when in prison, you visited me." '

The seventh act of mercy, burial of the dead, was added to the canon in the thirteenth century. It is interesting to note how the theme was bound up with that of the Last Judgment, and how Caravaggio managed to invest his charitable deeds with a feverish urgency which seems appropriate given that death, in the form of the corpse, is literally just round the corner. For compositional reasons two of the acts, visiting prisoners and feeding the hungry, were combined into one [the 'Roman charity' motif on the right (Plate VIa)], but even more striking is the literate use which Caravaggio made of learned allusions so as to deepen the picture's associations. Not only do we have this reference to the *Caritas romana* story of Cimon and Pero, but also the Old Testament hero Samon, drinking from an ass's jawbone in the left background (Plate VIb) and the Giorgionesque figure of St. Martin (Plate VIc), patron saint of Naples, cutting his cloak in half to cloth the naked. The figure behind St. Martin with his broad-brimmed hat and shell badge is almost certainly Christ the Pilgrim, present not only in his own right as one of the strangers being offered shelter, but also as a symbol—the anonymous, everyman Christ—of the picture's prevailing ethos. The work was originally placed in the then unfinished church of the confraternity, designed by Giovanni Conforto, but this building was later thought inadequate to house so prestigious a painting and was replaced by Francesco Picchiatti's impressive octagonal structure of 1658-78.

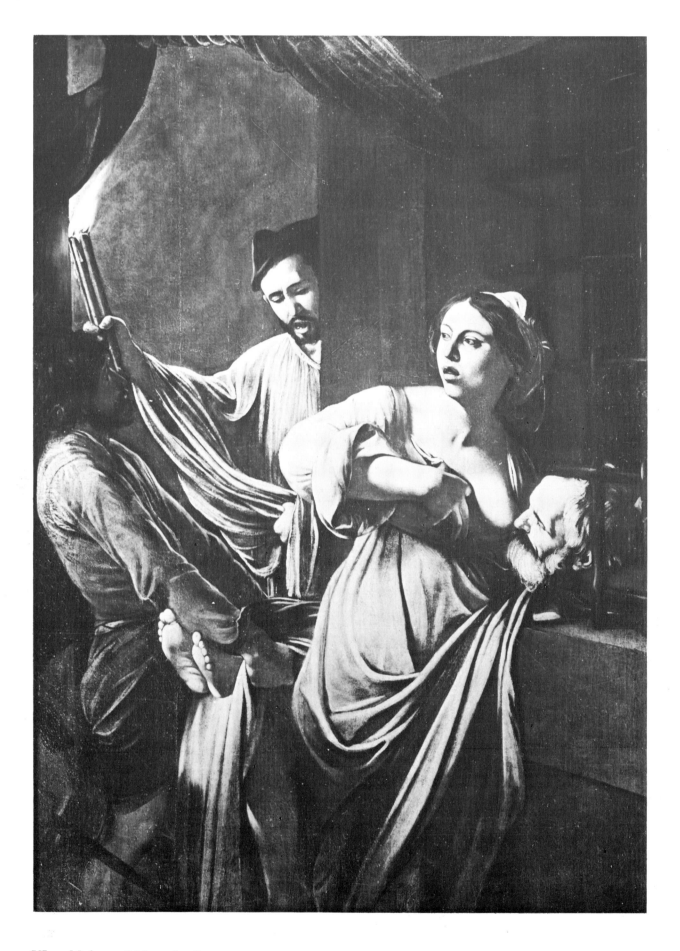

VIa *Madonna of Mercy*, detail

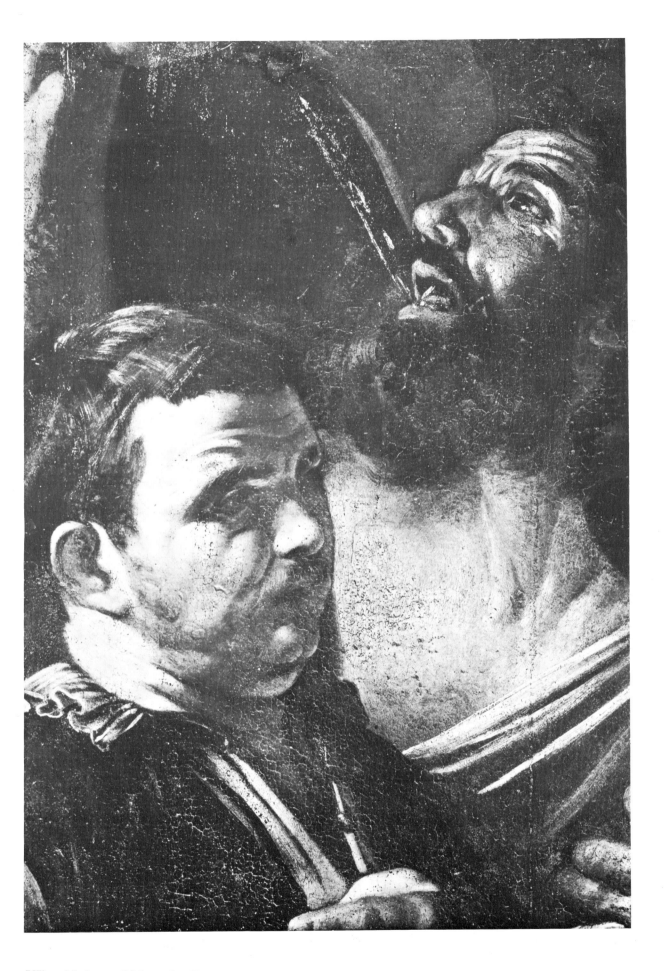

VIb *Madonna of Mercy*, detail

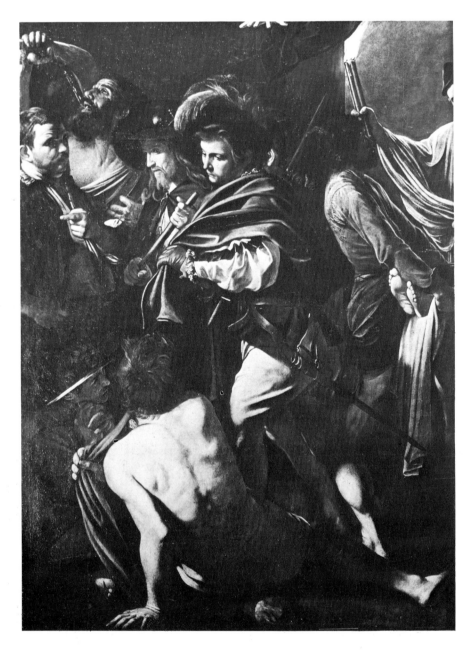

36 *The Entombment*
VATICAN CITY, Musei Vaticani. 9 January 1602/ 6 September 1604. Canvas 300 × 203 cm.

The entrance to the tomb is just perceptible on the left of the actual picture. *The Entombment* was painted for a chapel belonging to the Vittrice family in the Oratorian Church of Santa Maria in Vallicella, the 'Chiesa Nuova'. Pietro Vittrice, who died in 1600, had been an intimate of the Order's founder, St. Filippo Neri, and it is interesting to speculate on Caravaggio's links with this highly influential religious movement which, with its emphasis on charitable works, congregational involvement, a minimum of ritual and a simple faith in keeping with the spirit of the Gospels, seems to have been as progressive a force in the popularization of religion as Caravaggio's own paintings. Paradoxically, however, despite the picture's vivid realism, its artistic idiom is, for Caravaggio, relatively conservative, displaying a carefully orchestrated and somewhat pantomimic range of responses to the weighty reality of death. This classical quality of frozen rhetoric, combined with the architectonic figure grouping, obviously sweetened the pill of Caravaggio's naturalism for the more conservative, and the work enjoyed immense popularity throughout the seventeenth and eighteenth centuries. There are at least sixteen known painted copies and several drawings in addition to paintings (by artists such as Valentin and Baburen) which clearly derived from Caravaggio's example. The picture's powerful blend of realism and classicism prefigured Annibale Carracci's comparable treatment of a similar theme in his slightly later *Dead Christ Mourned* (fig. 3). It is nevertheless interesting to note that whereas High Renaissance artists and Annibale Carracci would have depicted the Virgin as a young woman, to symbolize her ageless virginity, Caravaggio, more literally, showed her as the mother of a man in his thirties.

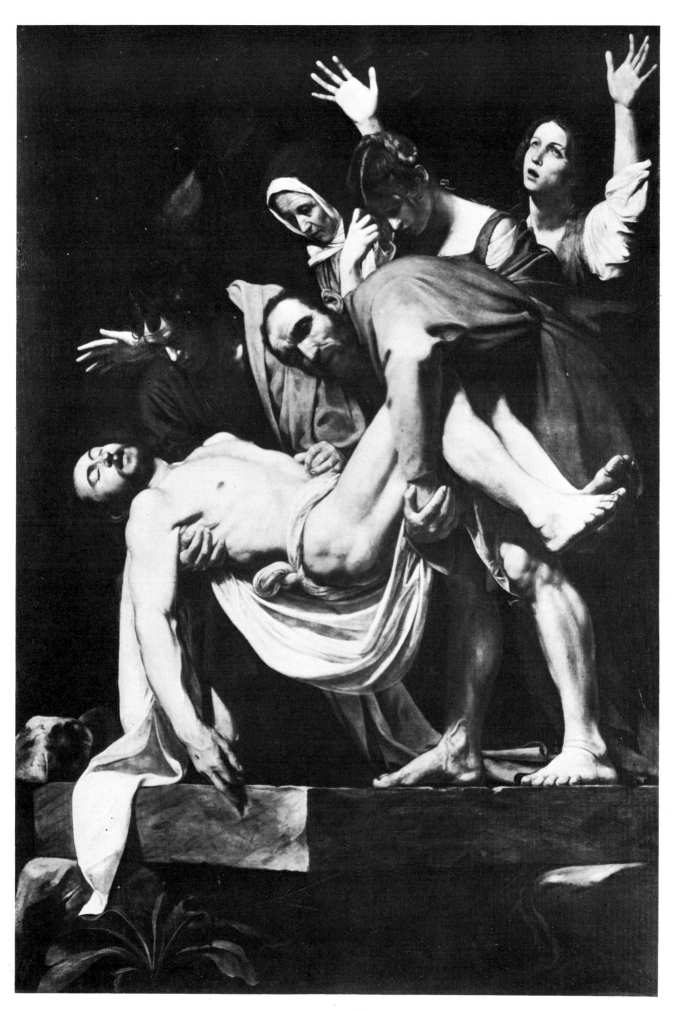

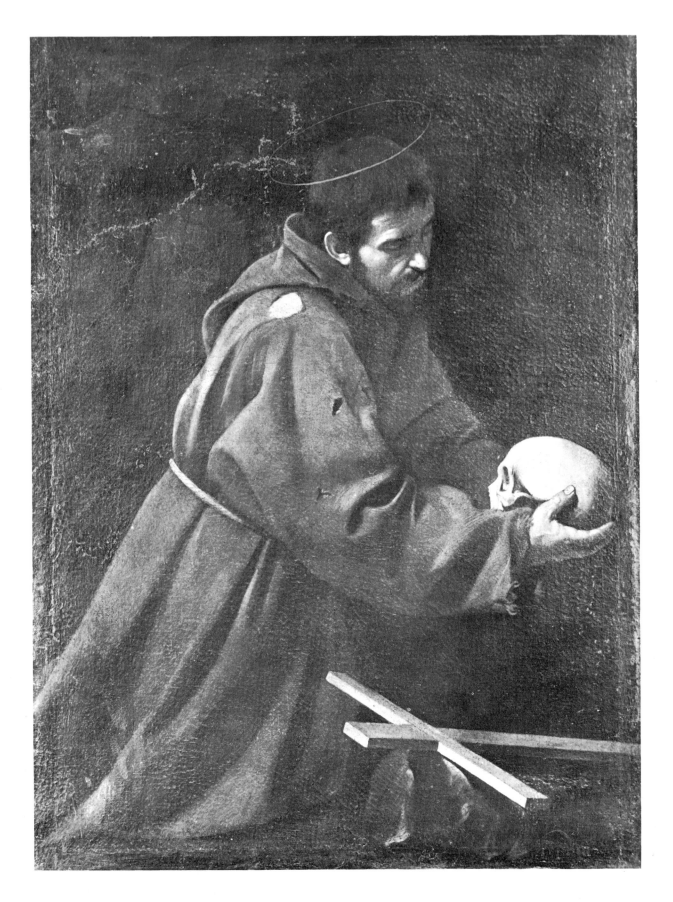

37 *St. Francis Praying*, copy
ROME, Chiesa dei Cappuccini. Canvas 130 × 98 cm.

This is a good copy of a lost original which has been recently identified by some scholars with a picture in the Church of San Pietro, Carpineto Romano. The original would appear to have dated from the period of approximately 1603–04, and it could be that Caravaggio dressed his model in the Capuchin's frock which he had borrowed from Orazio Gentileschi (see Biography, 14 September 1603).

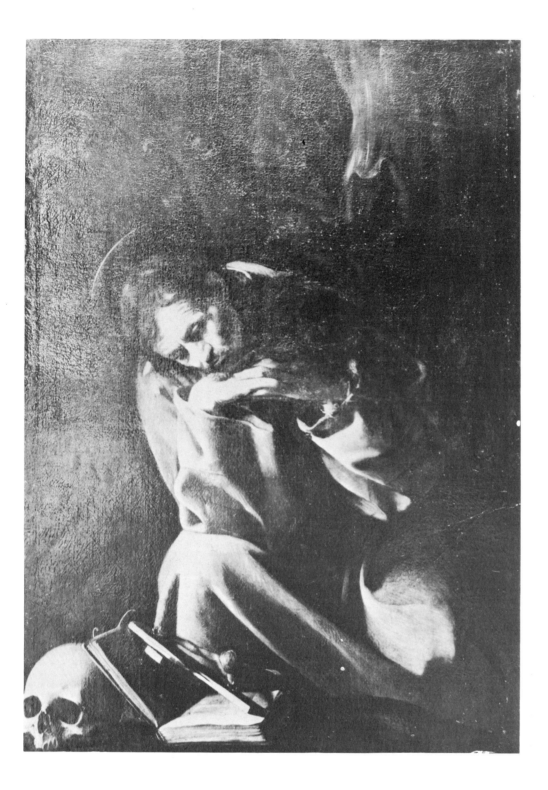

38 *St. Francis in Prayer*, original?
CREMONA, Museo Civico. c. 1604/06. Canvas 130 × 90 cm.

The only two documented pictures of St. Francis by Caravaggio are the Hartford picture (Plate 6),
which dates from early in the artist's career, and a lost work of *St. Francis Receiving the Stigmata*,
painted for the Neapolitan Church of Sant' Anna dei Lombardi in 1607 or 1610. It seems unlikely
on grounds of subject-matter that the Cremona picture could be the latter, even more so in that
the Sant' Anna picture was very probably destroyed in the earthquake which devastated both
church and city in 1805. Nevertheless, although the picture is in bad condition, its handling,
[especially the skull, the book and the background tree, the last having an undoubted affinity with
the tree in the Corsini *St. John The Baptist* (Plate 42)] is not dissimilar to works of the late Roman
and first Neapolitan periods. The composition, with its calculated play between the frontally
disposed and architecturally conceived figure of St. Francis, recalling the similarly arched figure of
Narcissus (Plate 21), and the diagonally foreshortened book and cross, is also typical of
Caravaggio's work. Depictions of St. Francis were popular during the Counter-Reformation period,
and one might expect Caravaggio to have identified with Francis's cult of poverty and his suspicion
of established institutions.

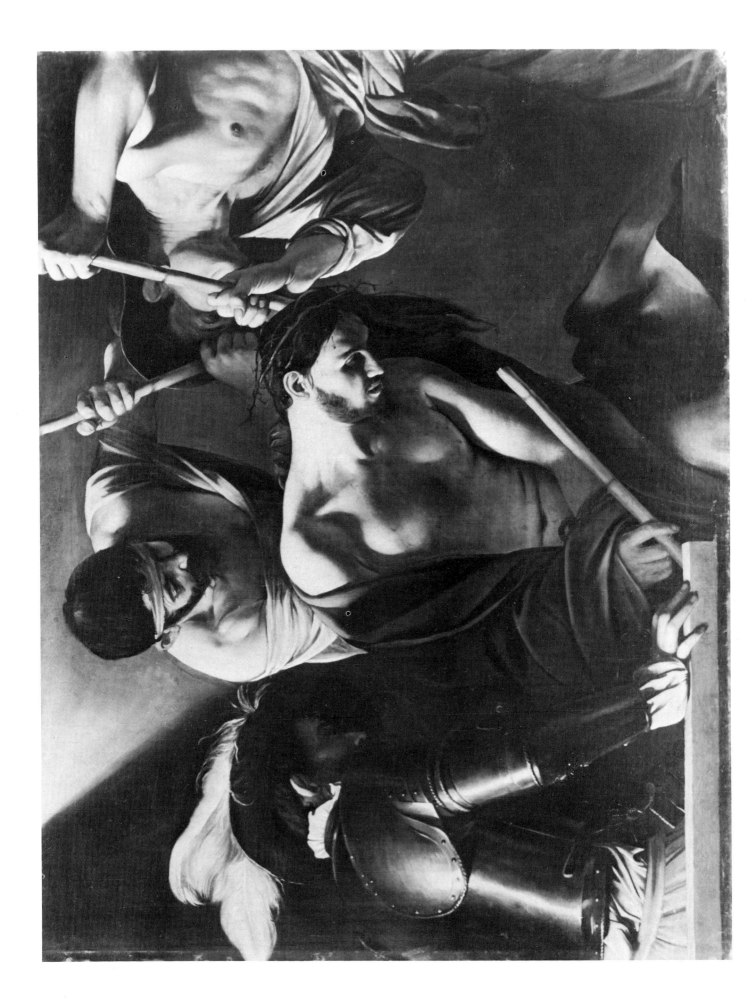

39 *The Crowning with Thorns*
VIENNA, Kunsthistorisches Museum. ?1603/06. Canvas 127 × 165·5 cm.

An important reason for linking this neglected picture with the name of Caravaggio is an entry in the Giustiniani inventory of 1638 which refers to a picture by him of the same title with four half-figures and remarkably similar measurements. Furthermore, Bellori referred in 1672 to a picture of this subject having been painted for Vincenzo Giustiniani, and the picture was actually acquired in Rome in 1816, at the very time that the Giustiniani collection was being dismembered. The rather classical composition, with its emphasis on the play between horizontals and diagonals, may have been encouraged by Giustiniani and seems to confirm his characterization of Caravaggio as a painter who combined realism and stylization in the most supremely accomplished manner. In fact, on close inspection one finds that the tormentors' bamboo canes are not merely posed symbolically, but are so conceived as to convey a genuine, if orchestrated, sense of real movement. The figure on the right knocks the crown of thorns against the far side of Christ's head with the bottom of his cane, while the left-hand torturer raises his so as to bring it down, from the top, on the near, visible side of Christ's brow: a rhythmic and sadistic hammering. The Kunsthistorisches Museum does not accept the picture as autograph (written communication).

40 *Madonna of Loreto* (*Madonna of the Pilgrims*)
ROME, Church of Sant' Agostino, Cavalletti Chapel. 1603/05. Canvas 260 × 150 cm.

The town of Loreto, just south of Ancona in the region of the Marches, was the site of a famous shrine known as the Holy House of Loreto which, during the sixteenth century, was encased in beautiful marble facades designed by Bramante and others. The ancient wooden statue of the Madonna which was housed inside this structure was, however, the real attraction, and pilgrims travelled from far and wide, barefoot, in order to worship before her. The statue is said to have come alive on certain occasions, and it seems as if Caravaggio attempted to render this miracle by lending a certain stiffness and artificiality to the pose of his otherwise palpably alive model. The work was commissioned by the Bolognese Cavalletti family at the instigation of Ermes Cavalletti who, in 1602, had bequeathed money for the purchase of the first chapel on the left in the Church of Sant' Agostino and for its decoration with an image of the Madonna of Loreto. Caravaggio's picture was criticized by later seventeenth-century critics for its disrespectful and indecorous treatment of a holy theme, all the more so because it became such a popular devotional image among the poor. The old man with dirty feet was singled out for special attack. But one should not deduce from this that it was frowned on by the connoisseurs of the time. Its appeal for the populace may not have been completely unrelated to the long-standing popularity of the Church of Sant' Agostino itself, which held a special place in the life of Renaissance Rome, when it was patronized by many of the great humanists and courtesans. It seems to have attracted in the sixteenth century an additional stream of visitors to see Andrea Sansovino's touching sculpture of *St. Anne with the Virgin and Child* (1512).

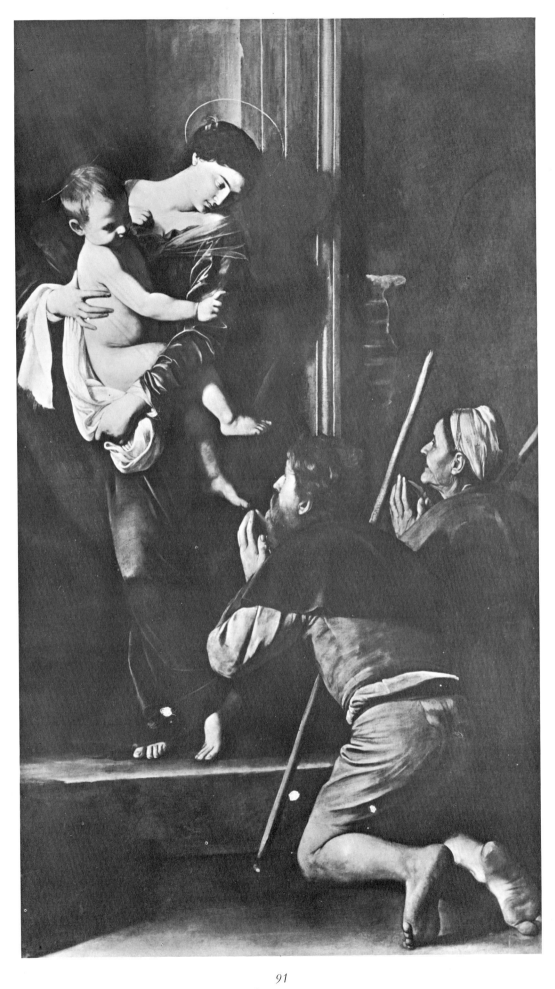

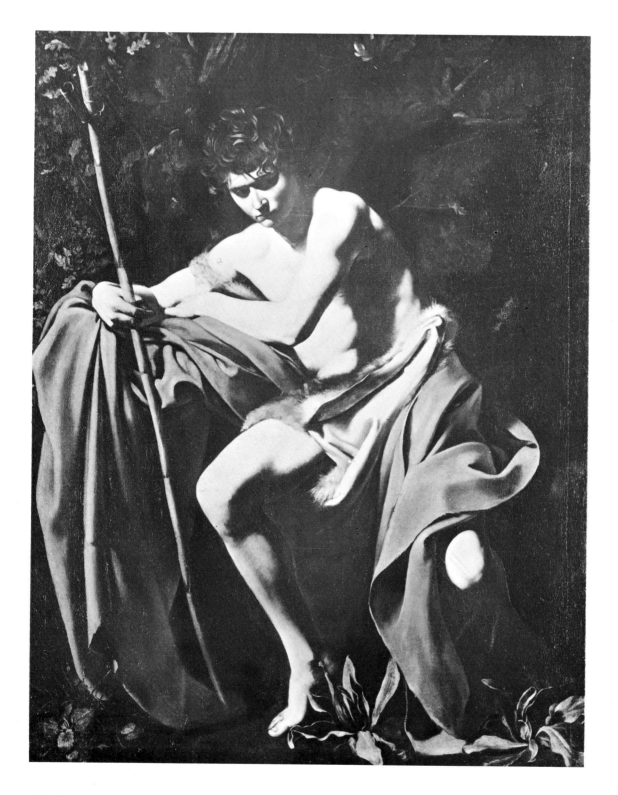

41 *St. John the Baptist*

KANSAS CITY, William Rockhill Nelson Gallery of Art—Atkins Museum of Fine Arts (Nelson fund). c. 1604/05. Canvas 173·35 × 132·08 cm.

As pointed out by Spear, the characterization of St. John the Baptist as a melancholic youth was unusual, and the painting makes an interesting contrast with Caravaggio's equally novel rendering of him as an extremely sanguine youth in the Capitolina picture (Plate 23). Such perceptive essays in mood do not necessarily contradict the subject of the painting, but they are nevertheless, in an important sense, independent of it, and, as such, may well have augmented Caravaggio's popularity among people who were not particularly religious. Although the picture is undocumented, a copy of it in a church built by the Costa family at Conscente, Liguria, suggests that it may have been commissioned by Ottavio Costa for the church and replaced by the copy when it was subsequently sold. The inclusion in the picture of such details as the dock leaves and the fur wrap, also present in the earlier *St. John*, in conjunction, on this occasion, with the Baptist's well-authenticated attribute of a bamboo cross, helps to confirm that the iconographically more ambiguous Capitolina picture is, indeed, also of St. John.

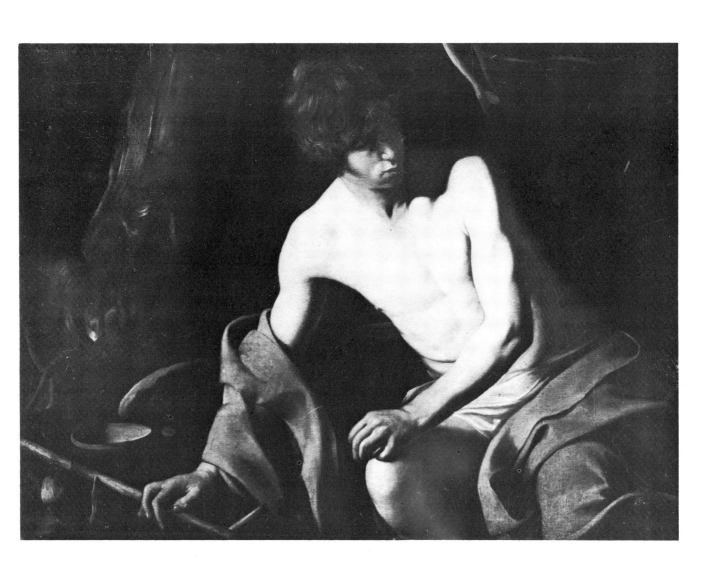

42 *St. John the Baptist*
ROME, Galleria Nazionale d'Arte Antica, Palazzo Corsini. 1604/06. Canvas 97 × 131·9 cm.

Although the authenticity of the Corsini *St. John* is doubted by some scholars the handling, especially in the hair and the drape, is close to works of Caravaggio's late Roman period such as the Brera *Supper at Emmaus* (Plate V). The treatment of the foliage, trees and shrubs, barely perceptible through the darkness, may seem extremely loose, but Caravaggio had even used an analogous technique for some of the landscape details in the much earlier *Rest on the Flight into Egypt* (Plate 13).

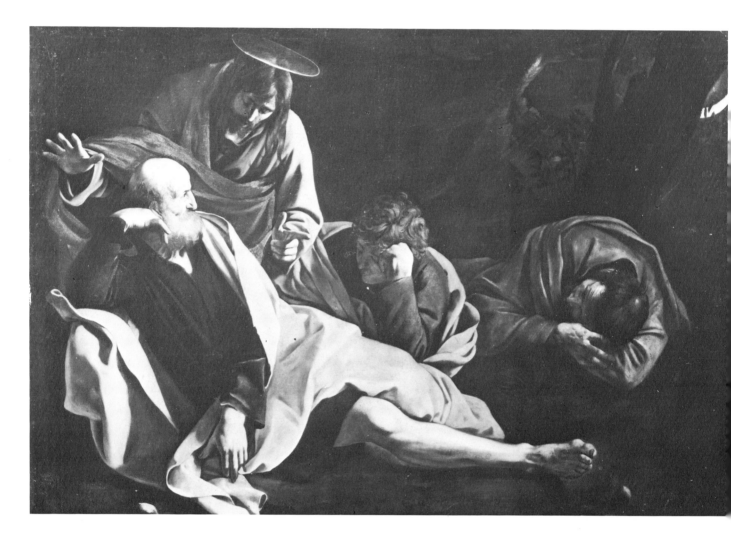

43 *Christ on the Mount of Olives*
formerly BERLIN, Kaiser-Friedrich-Museum (destroyed in the bombardments of 1945). 1604/06.
Canvas 154 × 222 cm.

This attractive composition, now regrettably only known to us through photographs, has not
received universal recognition as an authentic work. Yet its style and figure-types are remarkably
close to other works of the late Roman period, and its provenance from the Giustiniani collection is
firmly attested: its measurements were, in fact, virtually identical to the Caravaggio painting of the
same subject listed in the Giustiniani inventory. The figure of St. Peter in the lower left-hand corner
is slightly reminiscent of one of the figures in Annibale Carracci's *Assumption* (fig. 2), but it is
misleading to argue from this that the work was not by Caravaggio. We have ample evidence of
Caravaggio's penchant for intellectually constructed figure poses, and, in any case, the details in
this instance are typical of his style—Christ's elegantly raised little finger, for instance, with its
echoes of the Uffizi *Bacchus* (Plate 8), the fall of the drape which parallel that of the Corsini
St. John (Plate 42), and St. Peter's face, surely based on the same model as the two late Roman
pictures of St. Jerome (Plates 44 and 45). But beyond such stylistic considerations, the inspired
treatment of the subject betrays the imprint of Caravaggio's imagination. Rather than the more
frequently depicted episode when the anguished Christ prays to have his bitter cup taken from him,
while his disciples sleep, Caravaggio chose to depict the less mystical, but certainly more dramatic
moment when Jesus returns from prayer to find his followers asleep and wakens Peter with the
rebuke 'What, would none of you stay awake with me one hour? Stay awake, and pray that you
may be spared the test. The spirit is willing but the flesh is weak' (*Matthew* XXVI: 40–41).
These words precede the arrival of Judas and the soldiers, and Christ's pointing finger should be
seen as indicating the imminent catastrophe. The other two disciples in the picture are John, in
the centre, and James.

44 *St. Jerome in Meditation*
MONTSERRAT, Monastery of Santa Maria de Montserrat. c. 1605/06. Canvas 110 × 81 cm.

Only acquired from Italy by its present owners in 1917, the Montserrat *St. Jerome* is possibly the
picture of similar measurements listed in the Giustiniani inventory of 1638. Caravaggio painted the
subject of St. Jerome quite often [there are three surviving works (Plates 44, 45 and 57) and five
others mentioned in the sources] but it is not known whether he did so through choice or the
exigencies of commissions. The subject certainly gave him an opportunity to portray the folds and

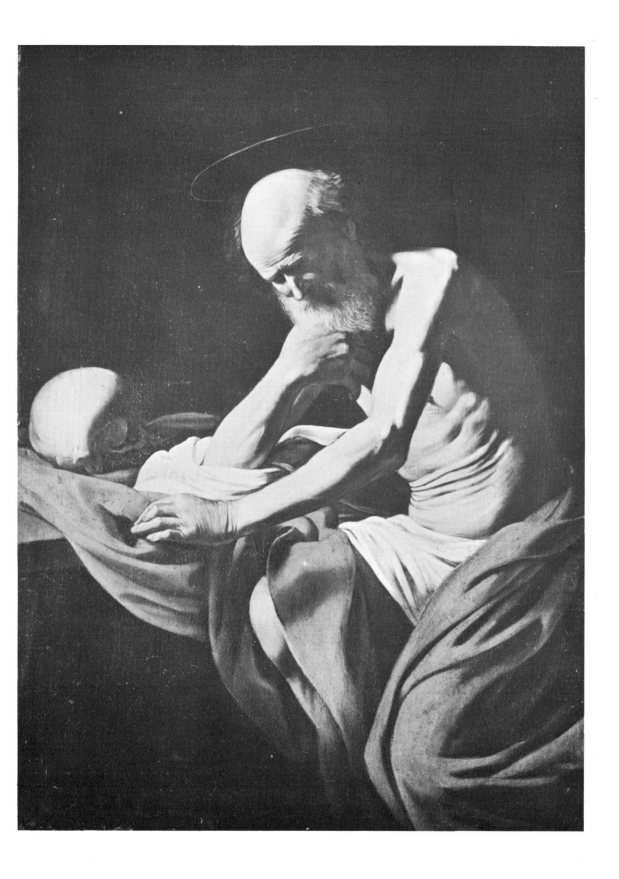

wrinkles of ageing male flesh, but one should not underestimate St. Jerome's wider and more specifically religious appeal for contemporaries. He was a mystic and hermit whose stern asceticism helped to kindle one strand of Counter-Reformation fervour, as witnessed by the increase in the number of Hieronymite hermits during the period, but he was also a great scholar who had translated the Bible into Latin and ranked, as one of the Four Fathers of the Church, almost as a second founder of the Christian religion. Furthermore, the graphic power of his message, with its insistence on the contemporaneity of the Gospels, must have seemed to the religious very much akin to Caravaggio's paintings: 'We have to translate the words of Scripture into deeds; instead of talking of holy things we must enact them.' The saint's pose in the picture recalls that of St. Matthew in the second version of *St. Matthew and the Angel* (Plate 26).

VII *Madonna of the Rosary*
VIENNA, Kunthistorisches Museum. 1606/July 1607. Canvas 364 × 249 cm.

St. Dominic (1170–1221), the Spanish founder of the Dominican Order, is said to have been handed a string of beads by the Virgin in a vision and to have referred to it as 'Our Lady's crown of roses'. The rosary later became a widespread device for counting prayers upon, and paintings of the *Madonna of the Rosary* or *The Vision of St. Dominic* became popular, especially in Dominican churches. We know from references in letters by Ottavio Gentili and Frans Pourbus that Caravaggio's picture of this subject was on sale in Naples during September 1607, and from Pourbus's letter that it had originally been painted as an altarpiece and was presumably rejected. The circumstances of the commission are undocumented, although Pourbus said that it was actually painted in Naples, but there is no indication why the picture had been rejected. Indeed, it is difficult to see how such a sober and deferential treatment of the subject could have proved unacceptable, unless it was because of the slightly unusual iconography involving St. Dominic, who was usually seen receiving the rosary from the Virgin, but who, in Caravaggio's composition, acts as a mediator, distributing rosaries to the poor on the Virgin's instructions (Plate VIIa). The most intelligent guess as to the original patron is that of Hess, who sees in the figure of the donor, in a ruff on the left, a portrait of the Principe Marzio Colonna, Caravaggio's protector in the Alban Hills. This view is corroborated by the positioning of a column, *colonna*, directly above him; the column was a prominent feature of the Colonna coat of arms. The price asked for the picture in Naples was the high one of 400 ducats. It was bought by the Flemish painter Louis Finson who took it back to the Netherlands where it was acquired from his heirs by a committee of artists and art lovers, including Rubens, in c. 1619 and presented by them to the Dominican Church of St. Paul in Antwerp, where it remained until it passed to Joseph II, Holy Roman Emperor, in 1780. It has been argued that the colouring of the picture is too light for Caravaggio's Neapolitan period, and that the *Madonna of the Rosary* must, therefore, have been begun in Rome, especially as there were so many other pictures apparently executed in Naples in 1607 that there would hardly have been time for another work of this size. This explanation is possible, all the more so since we now know that Caravaggio was in Malta by July 1607. Nevertheless, Friedlaender's attempt to link the picture with an unspecified one which Caravaggio was painting for Cesare d'Este, Duke of Modena, in 1605/06 and had not completed at the time of his flight from Rome in May would seem to founder on the relatively low price, fifty or sixty scudi, which the artist was asking from the duke, as compared with the price of 400 ducats asked for the *Madonna of the Rosary* in Naples.

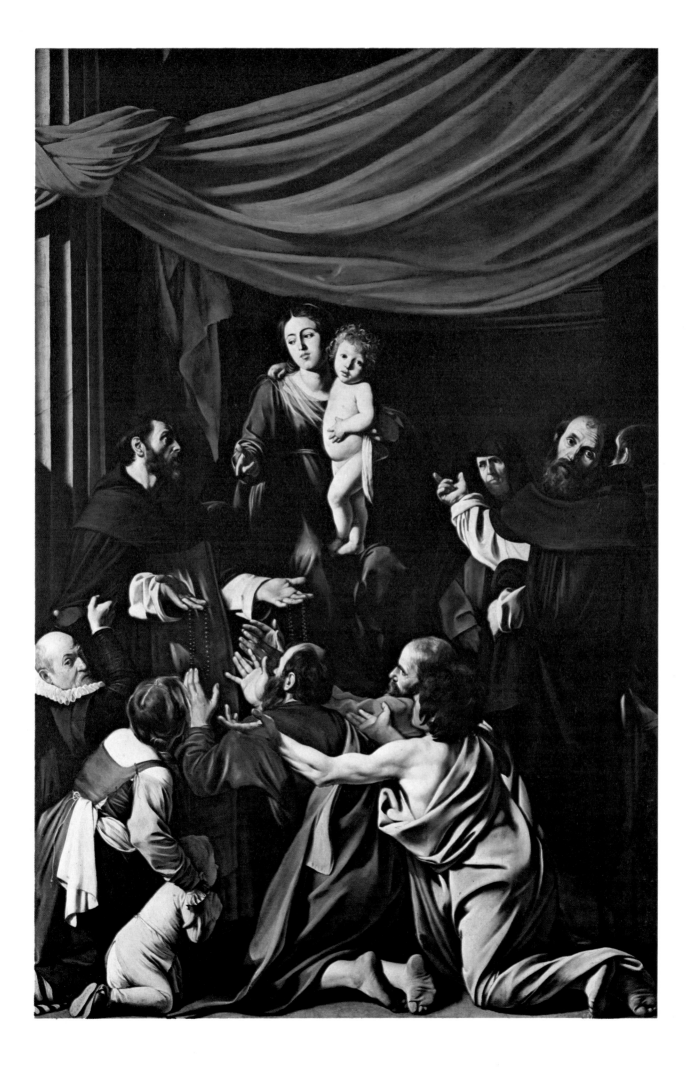

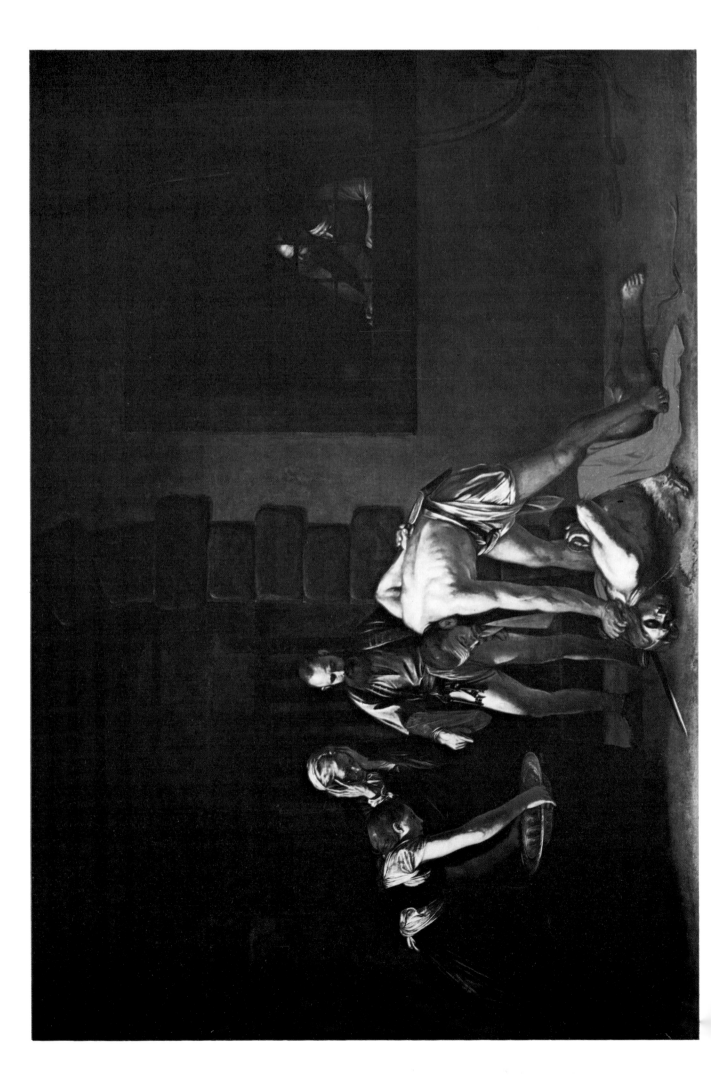

VIII *The Beheading of St. John the Baptist*
VALLETTA, Oratory of the co-Cathedral of St. John. 1608 (before October). Canvas 361 × 520 cm.

The Beheading of St. John the Baptist is Caravaggio's only surviving signed work; the 'f. michelan . . .' which is scrawled in the blood which flows from the Baptist's throat can be read either as 'fra ['frater' or 'brother'] michelan[gelo da Caravaggio]', in which case the work must date from after Caravaggio's appointment as a Knight of Obedience of the Order of St. John on 14 July 1608, or as the conventional designation 'facit michelan . . .'. The Latin word '*fecit*' means 'made' or 'did', and the word may well have been used with deliberate ambiguity in the present context. Caravaggio 'did' the painting, but did he also mean to suggest that he was in some sense responsible for the murder? Even if the word 'fra' was intended, Caravaggio's involvement in the drama was clearly implied, although this time by means of a more straightforward identification with the victim. The picture is distinguished by an extensive use of rich browns, rapid brushwork which allows the ground to show through in several places and what can only be described as the greatly increased 'classicism' of composition. Compared with the such works of his immediately preceding Neapolitan period as the *Madonna of Mercy* (Plate VI) or the *Madonna of the Rosary* (Plate VII), the main group of figures in *The Beheading* is as still and frozen as a monument (Plate VIIIa). The carefully articulated archway of figures, present in the Potsdam *Incredulity of St. Thomas* (Plate 32), was not a new device in Caravaggio's art, but its placement in front of a real, architectural gateway and the relative decrease in scale of the figures in relation to the rest of the picture somehow enhance our perception of the fixed and tragic fate of man within the universe.

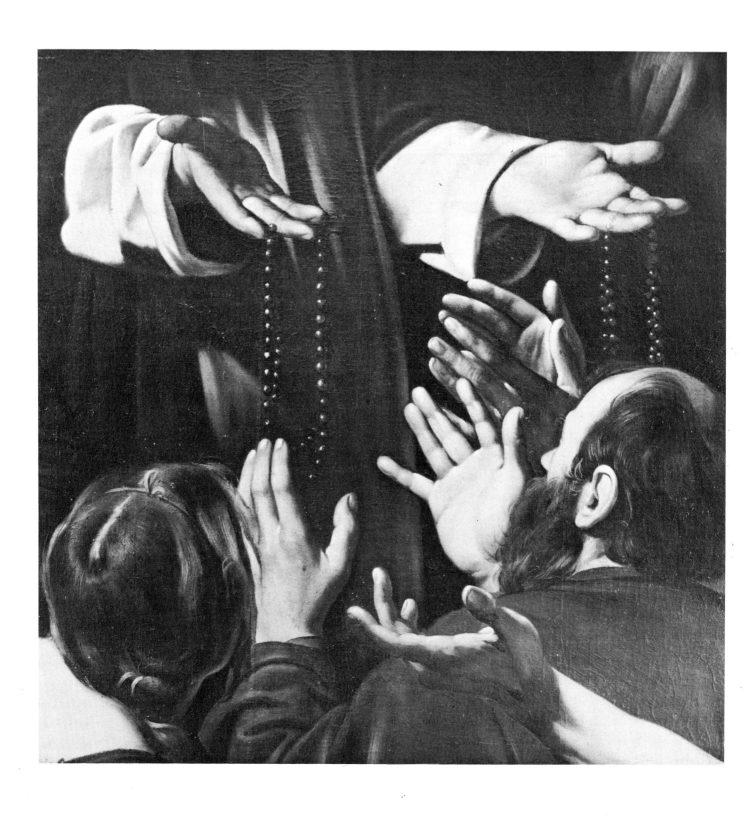

VIIa *Madonna of the Rosary*, detail

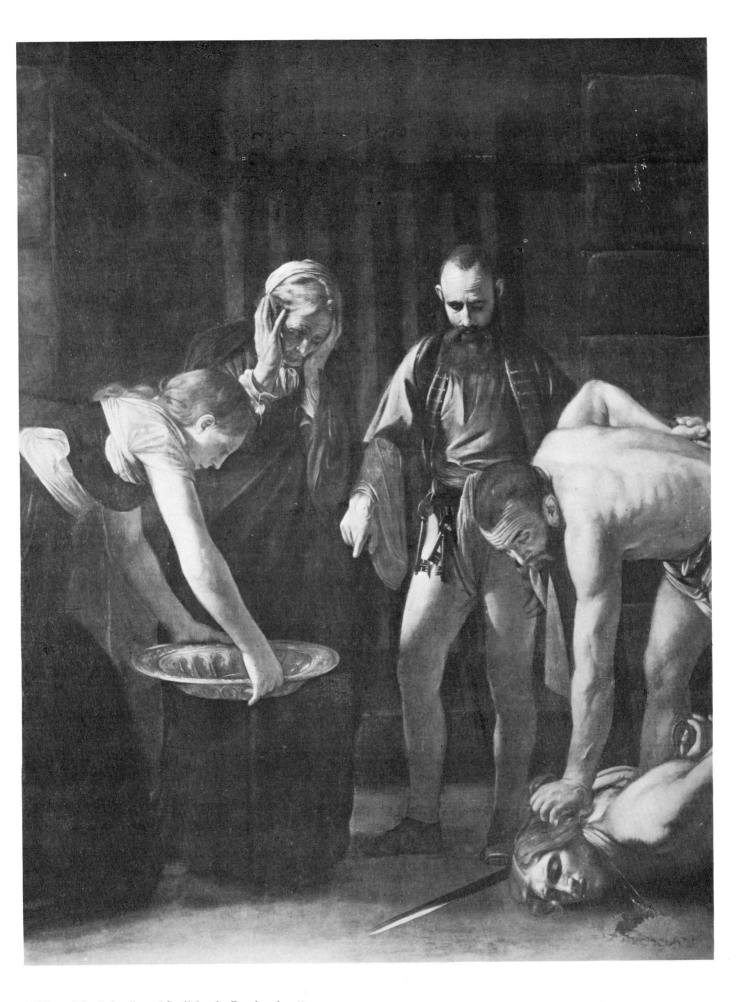

VIIIa *The Beheading of St. John the Baptist,* detail

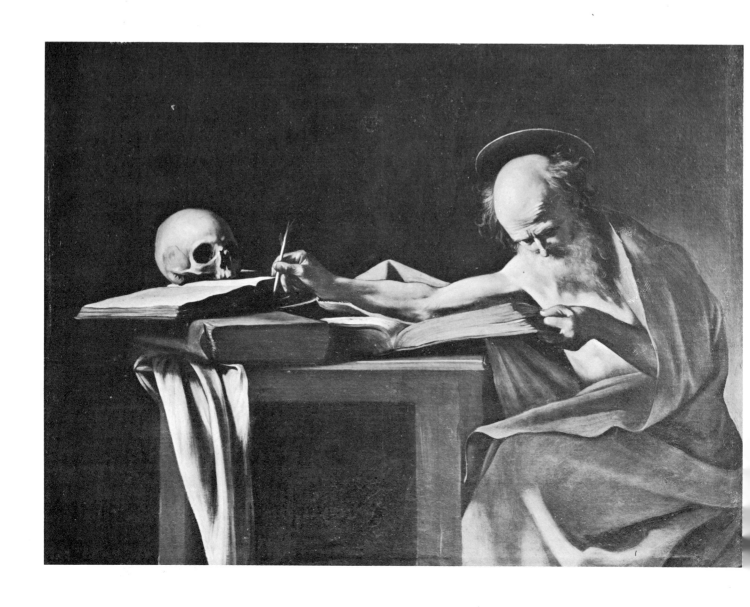

45 *St. Jerome Writing*
ROME, Galleria Borghese. 1605/06. Canvas 112 × 157 cm.

St. Jerome Writing was painted, according to Bellori, for Pope Paul V's nephew, Cardinal Scipione
Borghese, who only arrived in Rome in the summer of 1605, but rapidly became a keen collector
of Caravaggio's work (Plates I, 1, 29, 48, 67, 68). Obviously the model was the same as that for the
Montserrat *St. Jerome* (Plate 44), but the handling of the paint is here much more fluid, especially
in the head, face and left hand. Such a feature could either be interpreted as an exuberant,
incipiently Baroque moment in Caravaggio's development or possibly as a sign that the work was,
in fact, unfinished at the time of his flight from Rome in the summer of 1606. A similar, though
slightly less marked, quality is discernible in the contemporary *Ecce Homo* (Plate 46). The conception
of *St. Jerome Writing* is itself a remarkable achievement in which composition and subject-matter
strongly reinforce each other: the ageing saint, feverishly concentrating on what he has written,
absent-mindedly stretches out a sinewy arm to the inkwell on the far side of the table and, in so
doing, indicates the skull, a reminder of death which observes him, symmetrically, in his very
struggle to overcome it.

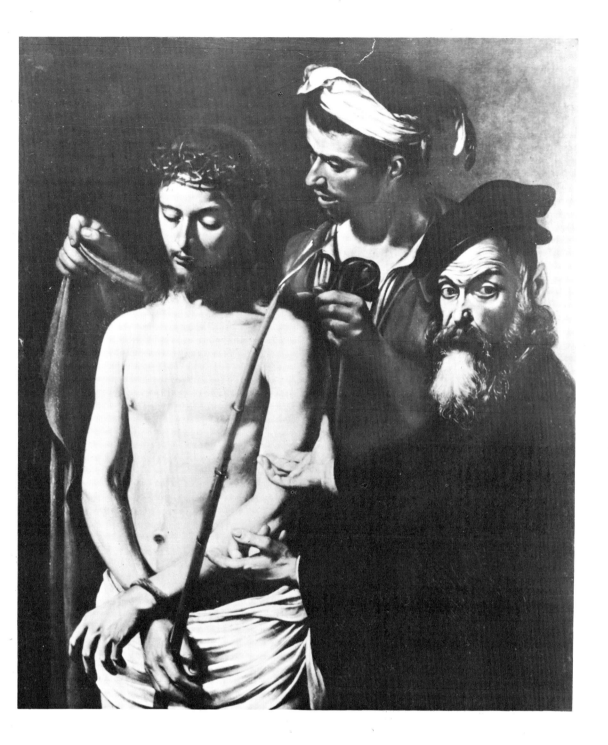

46 *Ecce Homo*
GENOA, Palazzo Rosso. 1605/06. Canvas 128 × 103 cm.

This is probably a picture mentioned by Giambattista Cardi, the nephew of the Florentine painter Cigoli, who related how Cardinal Massimi commissioned versions of *Ecce Homo* from three different painters, Caravaggio, Cigoli and Passignano, so that he might actually end up with a work which satisfied him. He apparently did not inform any of the artists that they were taking part in an undeclared competition. Cardi also reported that Massimi liked Cigoli's painting best. The looser handling of Caravaggio's picture is typical of his late Roman period and is particularly expressive in the case of Pilate's hands, his right hand being extremely close to that of one of the foreground figures in the *Madonna of the Rosary* (Plate VII). The unfinished appearance of the ears is also a feature which becomes more pronounced in Caravaggio's work from this time onwards. Caravaggio's interpretation of the subject is close to the story as recounted in *John* XIX, but he elided two separate incidents, the robing of Christ, which immediately followed the crowning with thorns, and the slightly later scene when Pilate displayed Christ to the crowd with the famous words 'Behold the Man!' The poignancy of the situation is thus heightened by the presence of the scornful and sadistic soldier—the fragile but single-minded figure of Jesus betrayed by an alliance of brute force and intellectual prevarication. The contemporaneity of the image is stressed by the standard official or academic costume worn by Pilate and by the fact that the scene is enacted on a balcony.

47 *Portrait of Pope Paul V*
ROME, Palazzo Borghese. 16 May 1605/06. Canvas 203 × 119 cm.

Camillo Borghese, who came from an old Siennese family, and whose father, Marcantonio, the
famous jurist, had married Flaminia Astalli, a member of the Roman aristocracy, was elected pope
on 16 May 1605 and took the title of Paul V, reigning from 1605 to 1621. We know from Bellori
that Caravaggio painted a seated portrait of him as pope, and this must have been executed
sometime before the artist's flight from Rome in the summer of 1606. The work was also mentioned
in Manilli's and Montelatici's guides to the Villa Borghese of 1650 and 1700 respectively and
was probably transferred from this suburban villa to the Borghese town palace at a subsequent
date. Many scholars have doubted the present painting's authenticity, considering its
composition altogether too tame for Caravaggio, but their reservations are probably unfounded.
Marini has stressed the high quality of handling which is not usually evident in photographs.
Furthermore, the supposedly uninspired pose was almost certainly a factor beyond Caravaggio's
control. Paul V was a tall, bulky figure renowned for his dignified and even taciturn demeanour,
and one cannot imagine him willingly adopting a more histrionic pose. Indeed, his unostentatious
bearing exemplifies the sober, cautious and, in fact, genuinely religious spirit both of the man
himself and of the Counter Reformation, and it is instructive to compare Caravaggio's portrait
with the similar portrait of Cardinal Guervara (New York, Metropolitan Museum of Art), by El
Greco, another painter of unusually expressive power who seems to have suffered but also gained
from the restrictions of protocol. For in the last resort Caravaggio derived advantage from the
formal restraint imposed on him by creating an intense and powerful image, full of presence, which
implies much more than it states overtly. Rather than an unsympathetic indication of the pope's
malevolence, the tense, narrowed eyes are simply well-observed details, for we know that he was
short-sighted.

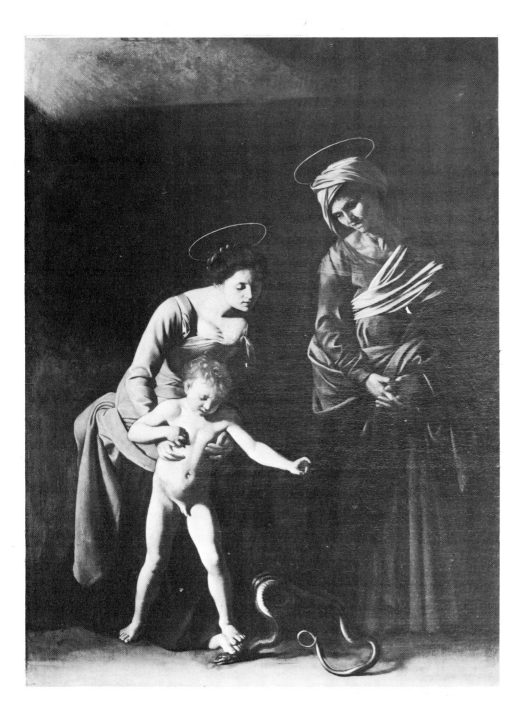

48 *Madonna of the Serpent (Madonna of the Grooms of St. Anne)*
ROME, Galleria Borghese. 1605/8 April 1606. Canvas 292 × 211 cm.

The Madonna of the Serpent was painted between 1605 and 8 April 1606, when a final payment to Caravaggio was recorded, for the Confraternity of Sant' Anna dei Palafrenieri, or Grooms, of the Vatican Palace. The composition depicts Christ and the Virgin treading simultaneously on the serpent of heresy, watched by the Virgin's mother, St. Anne, who was the patron saint of the Palafrenieri. It was an unusual although topical theme based on an ambiguous biblical passage, *Genesis* III:15, which does not make it clear whether it was Eve, the antetype of Mary, the 'New Eve', or her offspring who was meant to strike at the serpent's head. What started as a theological dispute became caught up in the wider debate between Roman Catholicism and Protestantism, with the Protestants not unnaturally arguing in favour of the offspring and, hence, Christ. The issue was resolved on the Roman Catholic side, however, with commendable textual accuracy, not to say religious tact, by a Bull of Pius V which ruled that 'the Virgin crushed the head of the serpent with the aid of him to whom she had given birth.' It is this interpretation which Caravaggio followed, possibly basing himself on a slightly earlier picture by the Milanese artist Figino. For all its evocative characterization, the *Madonna of the Serpent* is among the least successful of Caravaggio's mature works, with the somewhat stiff figures swamped by the darkness of the room. Despite its orthodox iconography, the picture was apparently thought indecent by the authorities and removed from its altar in St. Peter's after only two days (14–15 April). It was then kept in the church of the Palafrenieri until June, when it was sold to Cardinal Scipione Borghese, who housed it away from the public gaze in his own private collection.

49 *The Death of the Virgin*
PARIS, Musée du Louvre. 1605/06. Canvas 369 × 245 cm.

The Death of the Virgin was commissioned, probably in 1605, by the famous jurist, Laerzio Cherubin of Norcia, as the altarpiece for the chapel which he had just acquired in the Church of Santa Maria della Scala, Rome. The church was of recent date (1592) and was given over by Clement VIII to the Spanish Order of the Discalced (or Barefoot) Carmelites of St. Teresa in 1597. Unfortunately, the respective rôles played by Cherubini and the Carmelite fathers in the commissioning and subsequent rejection of Caravaggio's work remain obscure. What may appear to us a moving and indeed reverent portrayal of the sadness of death which actually benefits through the rejection of the more melodramatic formulae employed in the Vatican *Entombment* (Plate 36) in favour of a restrained and almost sacramental harmony of bowed heads, was clearly not to the taste of the clergy and possibly the patron as well. The reason given by Mancini for its rejection was that Caravaggio had used a prostitute as the model for the Virgin, and this explanation was echoed in most later accounts, which stressed the indecorous nature of the portrayal, Baglione drawing attention to the Madonna's bare legs. But this last feature ought not to have offended an Order such as the Barefoot Carmelites and, indeed, was probably intended as a tribute to their particular way of life. The subject of *The Death of the Virgin* presented special problems during the Counter Reformation, when the whole cult of the Virgin was under attack from the Protestants and when Roman Catholic theologians wished to reinforce the traditional belief that the Virgin's death was only really a kind of sleep and ecstatic surrender, which was not an end in itself but a transitional moment prior to her assumption into Heaven.
In fact one has to turn to northern prototypes, for instance those by Dürer and Bruegel, for comparably realistic renderings of the subject, but not even these show the Virgin as actually dead. That it was especially this detail that provoked the work's rejection is confirmed by the appearance of the altarpiece by Carlo Saraceni commissioned to replace it, painted according to the old convention with the Virgin seated and dying rather than prone and dead (fig. 14). But such was the desire of the Carmelites for clarification of the fact that the episode only represented a *transitio* to the next life that they even rejected this work and asked Saraceni to paint another version, which is today still in the church and shows a glory of angels welcoming the Virgin into Heaven (fig. 15). It is worth adding as a corollary to all this that Caravaggio's picture was extremely well thought of by artists, was publicly exhibited from 7 to 14 April 1607, was bought in 1607 by Vincenzo I Gonzaga, Duke of Mantua, on the advice of Rubens, and was later acquired by equally discerning collectors such as Charles I, King of England, in 1627–28, and Everhard Jabach in 1649, before finally entering the French royal collection in 1671.

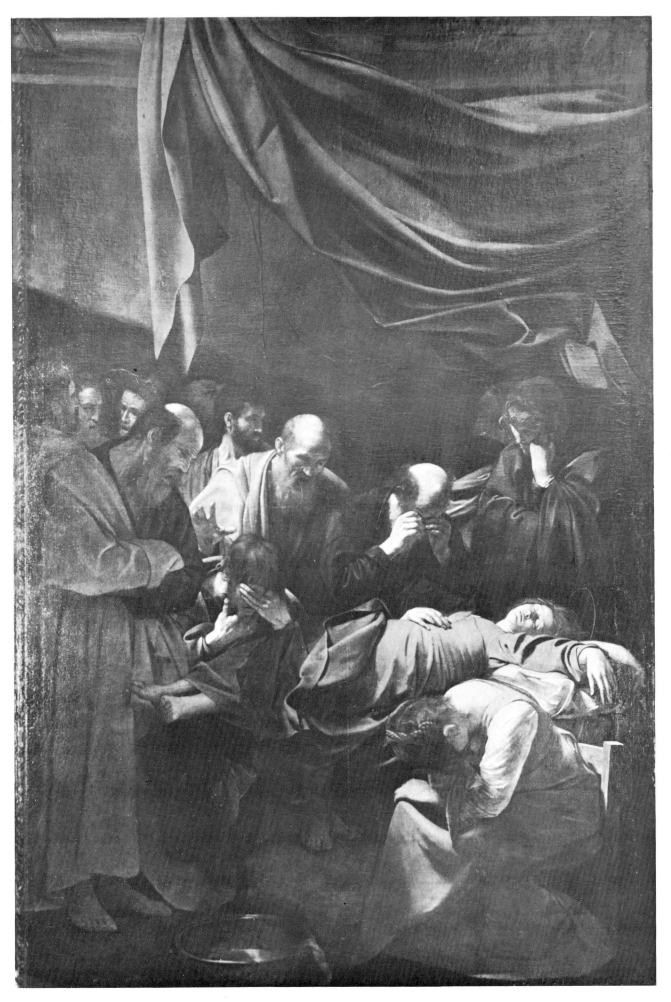

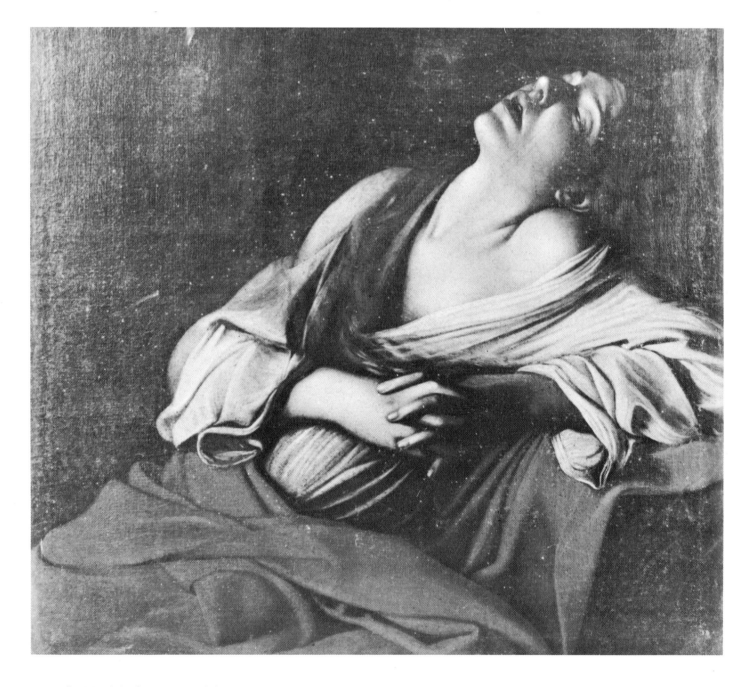

50 *The Magdalen in Ecstasy*, original?
ROME, private collection. 1606 (after 31 May). Canvas 106·5 × 91 cm.

Caravaggio probably painted *The Magdalen in Ecstasy* after he had killed Ranuccio Tommasoni on
29 May and while he was staying in hiding on the estates of the Principe Marzio Colonna, either at
Zagarolo, Palestrina or Paliano. The present picture is the best of eighteen known versions but has
only recently been claimed as the lost original by Marini—a view now supported by a number of
others. Although the sources refer simply to a *Magdalen*, Caravaggio has almost certainly
depicted one of her rapturous visions or ecstasies. According to *The Golden Legend* Mary Magdalen,
the penitent sinner, retired after Christ's death to a cave at Sainte-Baume near Aix-en-Provence to
live as a hermit; she ate nothing, her only nourishment being the food of the spirit, for she was
transported by angels seven times a day into Heaven where 'she heard, with her bodily ears, the
delightful harmonies of the celestial choirs'. It is clear from her abandoned posture and such a
carefully revealed detail as the ear, indicating that she is listening to the heavenly music, that
Caravaggio has depicted such a moment, although in doing so he was predictably original. In earlier
art the ecstasy had usually been shown as an actual levitation, or assumption, with Mary floating
up to Heaven and always accompanied by angels; and while later artists such as Rubens (Lille,
Musée des Beaux-Arts) or Vouet (Besançon, Musée des Beaux-Arts) adopted Caravaggio's earth-
bound interpretation they did not dispense with the angels. Nevertheless, if less literal, Caravaggio's
painting is more convincing than these later works, for while he deliberately, and influentially,
expressed the parallel between mystical surrender and erotic love, implied by the Magdalen's
posture and her bared left shoulder, he did not pruriently and inappropriately emphasize her
sexuality by uncovering her breasts. *The Magdalen in Ecstasy* was formerly in the Klain collection,
Naples.

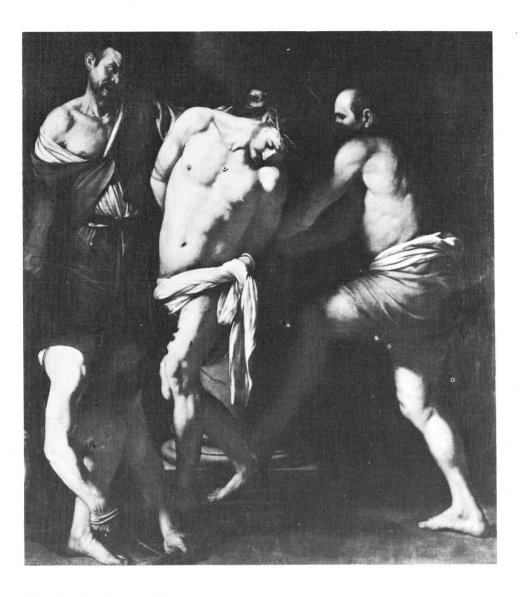

51 *The Flagellation of Christ*
NAPLES, Museo Nazionale di Capodimonte (on deposit from the Church of San Domenico
Maggiore, Naples). 1607. Canvas 286 × 213 cm.

Bellori placed this picture at the beginning of his list of Caravaggio's Neapolitan works and said
that it was commissioned by the Signori di Franco (or de Franchis) for their chapel in the
Dominican Church of San Domenico Maggiore. The de Franchis were an important Neapolitan
family with vice-regal connections, and Bellori's location of the work in the first Neapolitan period
would seem to be confirmed by the recent discovery by Vincenzo Pacelli of records of payments,
totalling 290 ducats, made by Tommaso de Franchis to Caravaggio on 11 and 29 May 1607. The
commission for *The Flagellation* was, however, probably due to the influence of Lorenzo de Franchis,
who in 1607 had become one of the officials of the Confraternity of the Pio Monte della
Misericordia, for whose church Caravaggio had already painted the *Madonna of Mercy* (Plate VI).
The Flagellation was first installed in the chapel of San Domenico donated to the de Franchis family
in 1602 by Ferdinando Gonzaga, principe di Molfetta, and was then subsequently removed to their
town house for safe-keeping while work was carried out on decorating and later extending the
chapel to incorporate an adjacent one acquired from the Spinelli family. The removal of the
picture during the rebuilding would account for the absence of references to it in the early
Neapolitan literature. But it was reinstalled in the enlarged chapel (the first on the left as one enters
the church and visible from the nave) in the 1650s and remained within San Domenico, although
not always in the same chapel, until it was taken to the gallery at Capodimonte in 1972.
The episode of the flagellation, which was ordered by Pilate, was usually depicted in front of a
column, possibly alluding to his *praetorium* or judgment hall, and the action was frequently
presented as a kind of ballet in which Christ and his tormenters interact gracefully, as for example
in Signorelli's composition in the Brera, Milan, and in Sebastiano del Piombo's fresco in the Church
of San Pietro in Monitorio, Rome. Caravaggio's presentation is, in a sense, equally balletic
(the pose of Christ's legs and the indefinable gait of the right-hand tormenter) but in
place of Sebastiano's languor we encounter a veritable dance of death, in which Christ's suffering is
strenuously conveyed through a ritual of impassioned mime. The high degree of finish and
brilliantly subtle treatment of the flesh tones, close to those of the nude in the *Madonna of Mercy*
(Plate VI), confirm the 1607 dating now indicated by the documents.

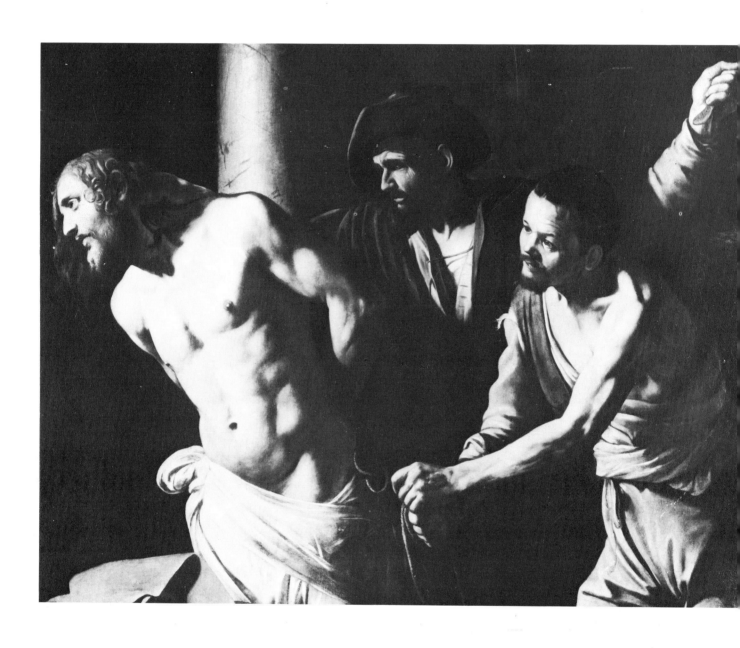

52 *The Flagellation of Christ*
ROUEN, Musée des Beaux-Arts. 1607. Canvas 134·5 × 175·4 cm.

The Rouen *Flagellation* was probably painted more or less concurrently with the Naples *Flagellation* (Plate 51), which it resembles in both handling and figures. Indeed, allowing for certain 'camouflaging' adjustments, it seems likely that Caravaggio used the same three models, the left-hand standing figure in the Naples picture becoming the right-hand tormenter in the Rouen version, the right-hand full-length figure becoming the central figure with a hat, and Christ, his eyes now open, unchanged. The compositional movement across the picture plane echoes that of earlier works such as *Judith and Holofernes* (Plate 17) and *The Sacrifice of Isaac* (Plate 35), but is perhaps also explicable iconographically. One of the problems inherent in locating Christ before a column was that it made it virtually impossible to make his flagellation look convincingly realistic, a pitfall which Caravaggio avoided in the Naples picture by moving him forward from the column and in the Rouen composition by turning him into profile. Some of the figures are surrounded by lines scored into the priming, an old-fashioned technique at one time used by tempera painters and one which Caravaggio seems to have adopted in several of his pictures as a substitute for drawing (Plates IV, 27, 35 and 41).

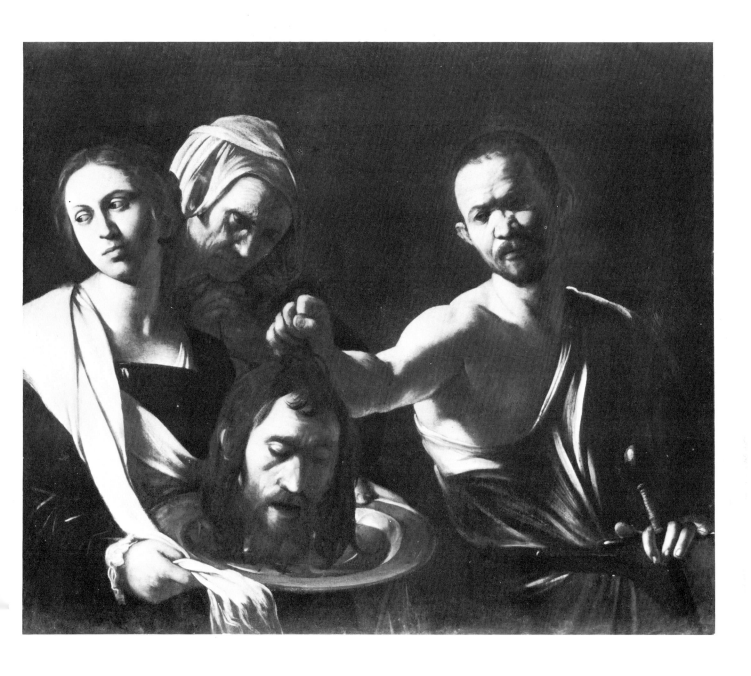

53 *Salome with the Head of John the Baptist*
LONDON, National Gallery. 1607. Canvas 91·5 × 106·7 cm.

This picture was discovered by Longhi in a Swiss private collection in 1959 and linked by him to a reference made by Bellori concerning a very late rendering of the subject which Caravaggio was said to have sent from Naples to Alof de Wignacourt (Plates 55 and 56) in Malta in hopes of regaining the Grand Master's favour after the artist's expulsion from the Order of the Knights of St. John. But that picture is far more likely to have been the one in the Palacio Real, Madrid (Plate 64), which, with its quiet, melancholic mood and colouring has definite affinities with works of Caravaggio's immediately preceding Sicilian sojourn. The National Gallery picture, on the other hand, is distinguished by a handling and raking light similar to canvases of 1606/07 and has an obvious link with the two *Flagellations* (Plates 51 and 52) of 1607 in the person of the executioner, who is facially similar to his counterparts in those paintings. There is also, as noted by Michael Kitson, a strong similarity between the head of Salome and that of the Virgin in the *Madonna of the Rosary* (Plate VII). It is, of course, still possible, although less likely, that the work was executed in 1609/10, but the fact that it was almost certainly painted in Naples is attested by the existence of a very old copy in the nearby Abbey of Montevergine at Avellino. The National Gallery picture is in reasonable condition and has only small passages of repainting, such as the executioner's left hand, but, despite the widespread acceptance of the work by scholars as an original, the National Gallery itself retains some doubts as to its authenticity and catalogues it as 'Ascribed to Caravaggio'. Some tempera, as well as oil paint, appeared to be present in a sample of paint taken from Salome's white scarf.

54 *The Crucifixion of St. Andrew*
CLEVELAND, Cleveland Museum of Art (Leonard C. Hanna Jr. bequest). 1607/08. Canvas 202·5 × 152·7 cm.

Previously known only through copies, the Cleveland picture recently emerged as the undoubted original of a work referred to by Bellori. It was taken to Spain by the Spanish Viceroy of Naples, the conde de Benavente, when his seven-year term of office ended in July 1610, and installed in his family palace at Valladolid where, in an inventory of 1653, it was valued at 1500 ducats, higher than any other picture in the collection. It was recently rediscovered in the Arnaiz collection, Madrid, and acquired by the Cleveland Museum of Art in 1976. The iconography presents some problems and would appear *not* to represent the process of St. Andrew's attachment to the cross. How, otherwise, can we account for the fact that he is, on the evidence of his face and his twisted fingers, on the verge of death, when we know from *The Golden Legend* that he survived for two days on the cross, discoursing about Christianity with the crowd? The answer suggested by Denis Mahon and Mrs. Lurie is surely correct: that Caravaggio has chosen a very rarely painted episode which is supposed to have occurred shortly before the saint's death on his cross. Having been subjected to Andrew's preaching for nearly two days, the crowd was impressed by his teaching and clamoured for his release, which Aegeas, Proconsul of Patras, pictured in a plumed hat, fearfully agreed to, only to find that when his men attempted to untie the body they were thwarted by a strange paralysis, the result of divine intervention in response to Andrew's plea that he should be allowed to die. Another seeming incongruity is that St. Andrew is tied to a standard vertical cross rather than to the 'X'-shaped *crux decussata* usually associated with his name. This is explicable by the fact that two important sixteenth-century writers, Joannes Molanus and Justus Lipsius, explicit asserted that the saint had, according to all the evidence, in fact been executed on a Latin cross like Christ himself. It was only during the seventeenth century that the *crux decussata* became widely accepted as the type of 'St. Andrew's Cross'.

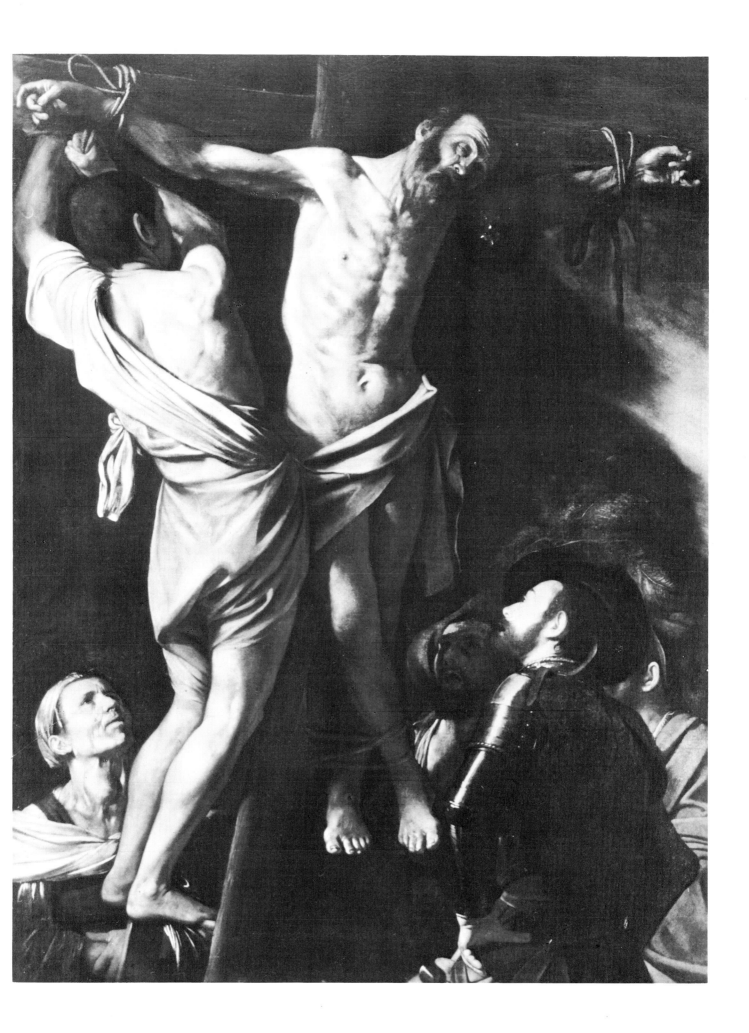

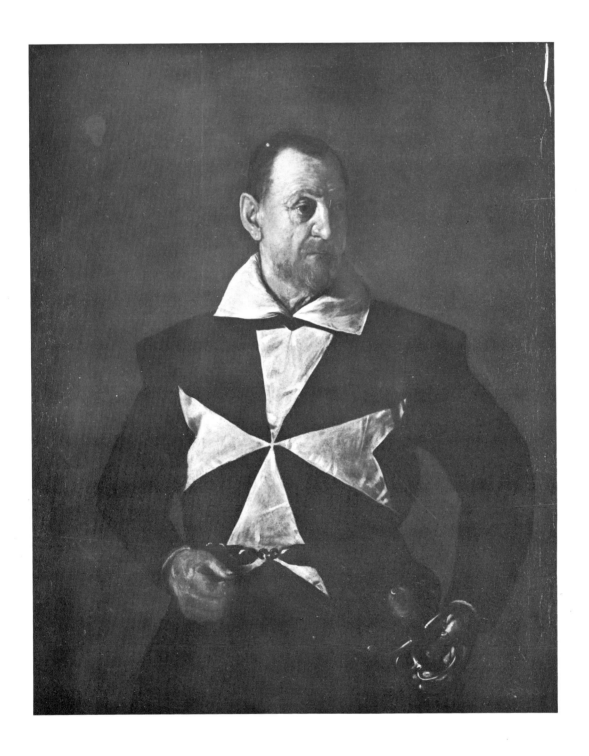

55 *Portrait of Alof de Wignacourt with a Sword and Rosary Beads*
FLORENCE, Palazzo Pitti. 1607/08 (before October). Canvas 118·5 × 95·5 cm.

Caravaggio was in Malta by July 1607. He had gone there, according to Bellori, because he 'was eager to receive the Cross of Malta which was usually given as an honour to notable persons for merit and virtue'. Whatever his motives, he was probably introduced to the island through Ippolito Malaspina, Prior of the Order of the Knights of St. John in Naples and a relative of Caravaggio's Roman patron, Ottavio Costa. While on the island Caravaggio is known to have painted at least two portraits of Alof de Wignacourt (1547–1622), the French Grand Master of the Order from 1601. One of them depicts Wignacourt standing and in armour and is now in the Louvre (Plate 56), the other showed him in robes and seated, a picture possibly represented by a copy surviving at Rabat, Malta. The present work has only recently been attributed to Caravaggio by Mina Gregori and interpreted as an unidealized 'study' for the Louvre portrait, which it resembles in the pose of the head and torso. The attribution to Caravaggio seems indisputable on technical grounds, and the identification of the sitter is also convincing. Even if we choose to define the work as a study, however, it is certainly neither unfinished nor merely a sketch, for the rather summary handling of some passages, such as the left hand, as well as the tendency of the reddish-brown ground to show through in several places, are features common to other late works.

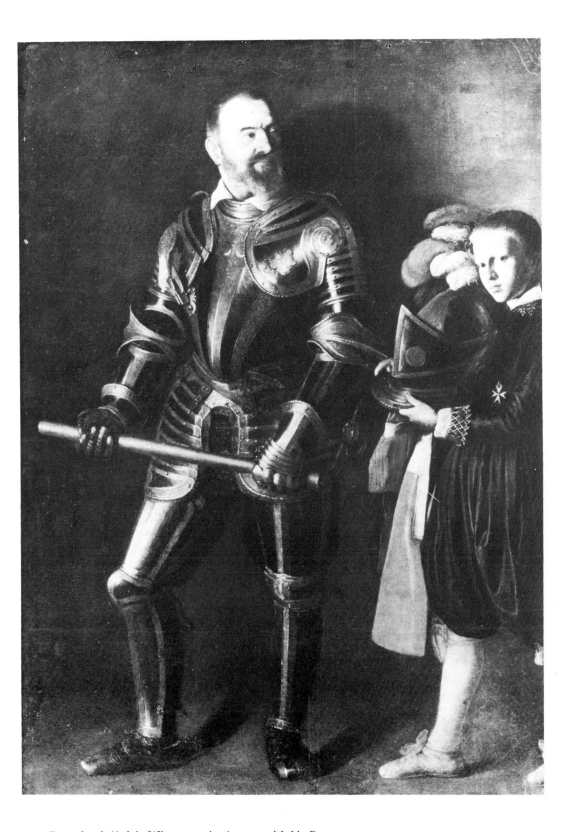

56 *Portrait of Alof de Wignacourt in Armour with his Page*
PARIS, Musée du Louvre. 1607/08 (before October). Canvas 195 × 134 cm.

Caravaggio here toned down and 'improved' certain physical peculiarities discernible in the Pitti portrait of Wignacourt (Plate 55): the ear is less pointed, the nose less pronounced and the skin less wrinkled. But he also transformed its restless, brooding and pessimistic quality into a more extrovert, 'sergeant-majorish' characterization which combines physical with mental alertness and stresses the public side of the Grand Master's powerful personality. Wignacourt, one of the outstanding Grand Masters, had joined the Order in 1564 at the age of seventeen and distinguished himself at the Great Siege of Malta of 1565. But despite the notable achievement of being responsible for building the Malta aqueduct and sponsoring several successful, if inconsequential, expeditions against the Turks, the superficial splendour of his rule concealed the Order's substantial decline by the early seventeenth century, both in terms of military power and ecclesiastical jurisdiction.

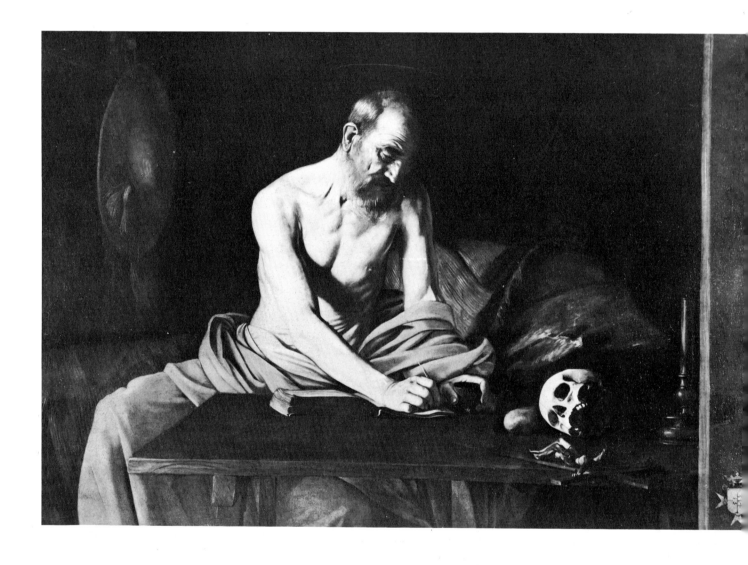

57 *St. Jerome Writing*
VALLETTA, Museum of St. John. 1607/08 (before October). Canvas
117 × 157 cm.

The arms in the bottom right-hand corner on the post are those of Ippolito Malaspina, Prior of the
Order of the Knights of St. John in Naples and probably the man responsible for introducing
Caravaggio to Malta. Certain writers have drawn attention to the facial resemblance (Plate 57a)
between St. Jerome and Alof de Wignacourt (Plates 55 and 56), but the similarity is not striking
enough to suggest that Wignacourt was actually used as a model. The composition, however, shows that
Caravaggio was here thinking in terms of a solution similar to that which he devised for *The
Beheading of St. John the Baptist* (Plate VIII). A subtle diagonal, implying movement, leads across the
composition only to be held in check by the emphatic vertical which marks its juncture with the
picture plane. Unlike certain earlier works such as *The Conversion of Saul* (Plate IV), asymmetry and
diagonal rhythm in *St. Jerome* are fully contained within the space of the picture. They help to
lead the eye into the picture, but no longer threaten to invade the physical and psychological
territory of the viewer. The distancing effect thereby achieved has more in common with the:
values of classicism than it does with the rhetorical exuberance of much Baroque art. The picture
was until recently in the Co-Cathedral's chapel of St. Catherine, which belonged to the Italian
'Langue' of the Order.

114

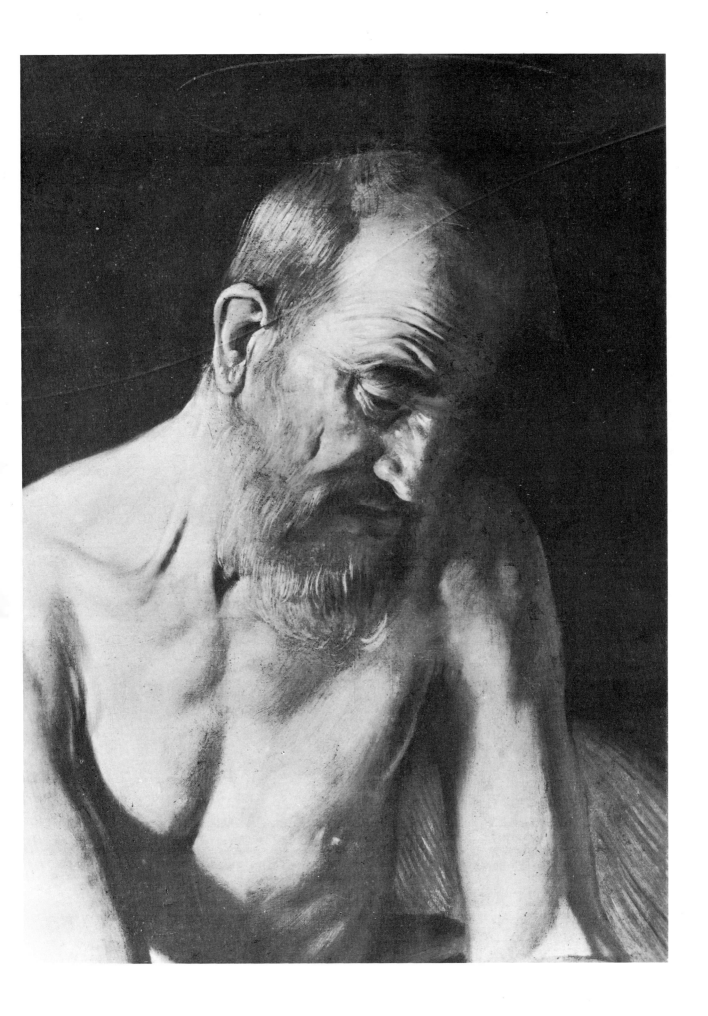

115

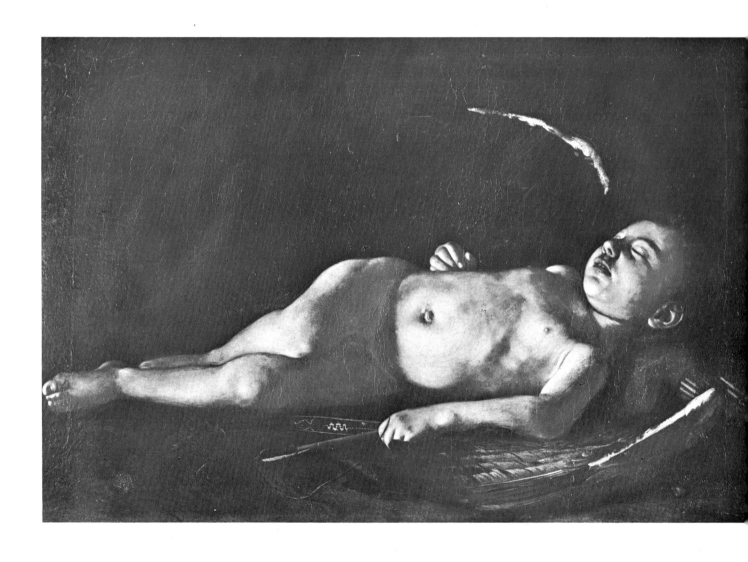

58 *Sleeping Cupid* :
FLORENCE, Palazzo Pitti. 1608 (before October). Canvas 72 × 105 cm.

The subject of Cupid asleep, his quiver and arrows discarded, his bow-string slackened, usually signified the abandonment of worldly pleasures: Marini has even speculated that the present picture may have been commissioned by a Knight of Justice of the Order of St. John as a reminder of his vow of chastity. We know from an old inscription on the back that it was painted in Malta in 1608 and, indeed, its warm glowing tones seem to bear comparison with other works of this phase in Caravaggio's career. Nevertheless, the opaque black background which, unusually for Caravaggio, completely conceals a large part of the form of Cupid's right wing, is very different from the lighter, brownish palette used in the contemporary *Beheading of St. John the Baptist* (Plate VIII) and may be seen as yet another example of the artist's tendency to explore different effects and styles more or less simultaneously. In the broader context of iconographical trends, it should be noted that the depiction of Cupid as a chubby infant rather than the graceful adolescent popular in the Renaissance, and evident in *Victorious Love* (Plate 34), was symptomatic of a new Counter-Reformation preference of characterization. But Caravaggio, as usual, infused the new form with his own potent blend of observation and construction: a child sleeping in the shape of a parallelogram.

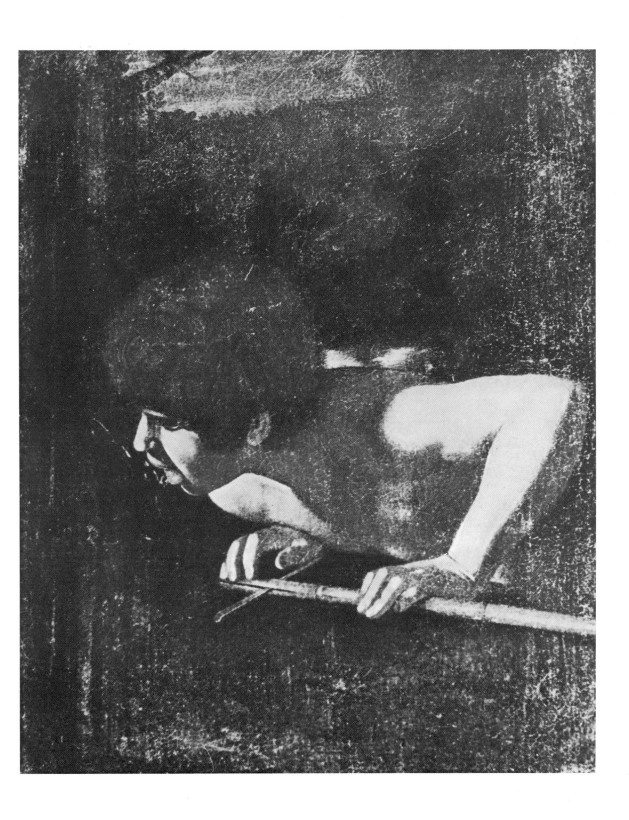

59 *St. John at the Spring*, original?
VALLETTA, Bonello collection. 1608 (before October)?. Canvas 100 × 73 cm.

Although very badly damaged and repainted, especially in the landscape, *St. John at the Spring* is similar in the treatment of the flesh to the *Sleeping Cupid* (Plate 58), and while some scholars have sought to place it in one of the Neapolitan periods, there is no clear-cut reason for doing so. The mechanics of drinking and the psychology of thirst are beautifully conveyed through the artful manipulation of limbs and the carefully constructed head. A non-autograph version of the picture, formerly in Naples, shows St. John standing with a sheep at his feet, but similar amplifications of compositions were not uncommon during the seventeenth century and the existence of a larger version does not necessarily imply that the Bonello *St. John* was cut down in size.

60 *The Burial of St. Lucy*

SYRACUSE (Borgo Santa Lucia), Church of Santa Lucia al Sepolcro (Church of Santa Lucia 'alla Marina'). 1608 (after 6 October). Canvas 408 × 300 cm.

Caravaggio was imprisoned in the Castel Sant' Angelo, Vittoriosa, Malta, for an unspecified offence but managed to escape by 6 October and soon found his way to Syracuse, where he met an old friend of his Roman days, Mario Minniti who, according to Francesco Susinno's *Lives of the Painters of Messina* (1724), was instrumental in persuading the Senate of Syracuse to give Caravaggio the commission for *The Burial of St. Lucy*. Lucy was an important Sicilian saint often associated with the gifts of the Holy Spirit and had been immortally characterized by Dante as 'Lucy, the foe to every cruelty'. In a composition which broke new ground, Caravaggio managed to convey her proverbial gentleness by a variety of means: the soft, generalized and still features of her pale face seem in tune with the restrained but reverential sadness of the background mourners but also generate an added poignancy by contrast with the urgent movements of the colossal gravediggers, whose rhythmic activity threatens to efface her image in a matter of seconds. As Friedlaender has noted the subject of her burial is an extremely unusual one; artists more frequently used the explicitly sensational image of the saint holding her gouged-out eyes on a platter. But the choice of the burial as Caravaggio's theme enabled him to construct a composition in which movement and stillness, physical power and spiritual presence interact with effective precision. The greatly increased space within which the figures are located has a similar effect to that produced by *The Beheading of St. John the Baptist* (Plate VIII), the void acting as an echo chamber to the strained emotions and brutal deeds of the protagonists. The picture was in very poor condition prior to the latest restoration, which is still to be completed.

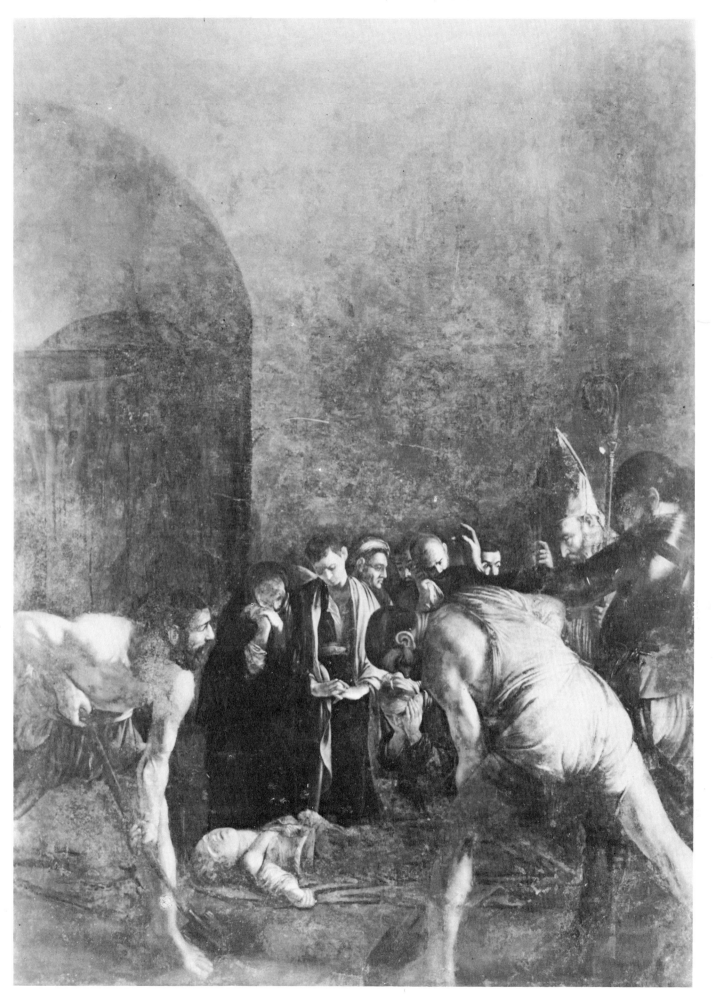

61 *The Raising of Lazarus*
MESSINA, Museo Nazionale. 1609 (before 10 June). Canvas 380 × 275 cm.

Despite the careful restoration carried out at the Istituto Centrale del Restauro, Rome, in 1950–51, *The Raising of Lazarus* is in poor condition and covered with a fair amount of repainting. It is also possible that some distinctly weak passages were due to the assistance at the time of painting of certain local artists such as Mario Minniti. Yet the work remains one of Caravaggio's outstanding achievements, in which the broad handling of his late style activates the picture surface and contributes to the tense drama of the multi-figure composition. As in *The Burial of St. Lucy* (Plate 60), Caravaggio made use of a tightly-knit frieze of figures which cuts into the lower part of what is, for him, a greatly heightened and deepened space. This interaction of an almost classical relief of figures, in which individuals are subsumed in a surge of corporate emotion and effort, with a substantial void which both echoes and absorbs that emotion, is different from the more closely focused and individualized dramas of his earlier and middle periods and in some ways anticipates the spiritual feeling of Rembrandt. Light is, more than ever, presented as a metaphor for the power of the spirit in the way in which it falls on the palm of Lazarus's right hand, opened to embrace the resurrection effected through Christ, and the involvement of everyone in the mystery is stressed as much by light as it is through the close proximity of bodies. Various sources have been suggested for the unusually powerful pose of Lazarus, and the most plausible of these would seem to be an engraving by Diana Ghisi after Giulio Romano showing the battle raging round the body of Patroclus; Susinno's description (1724) of how Caravaggio had two men hold up a freshly exhumed corpse for him to copy is probably apocryphal, but not beyond the bounds of possibility. The picture was presented to the Church of the 'Padri Crociferi', or 'Ministri degli Infermi', in Messina by the Genoese merchant Giovanni Battista de' Lazzari on 10 June 1609. A document of 6 December 1608 reveals that Lazzari had undertaken to construct the main chapel in the church and to decorate it with a painting of *The Virgin, Child, St. John the Baptist and Other Saints*. Caravaggio had almost certainly not come to Messina by that date, and it seems probable, therefore, that when he did arrive and was awarded the commission the subject was changed at his own request. Susinno, in fact, said that Caravaggio himself suggested the subject as being appropriate for an altarpiece commissioned by the Lazzari family, the Italian word for 'Lazarus' being 'Lazzaro'.

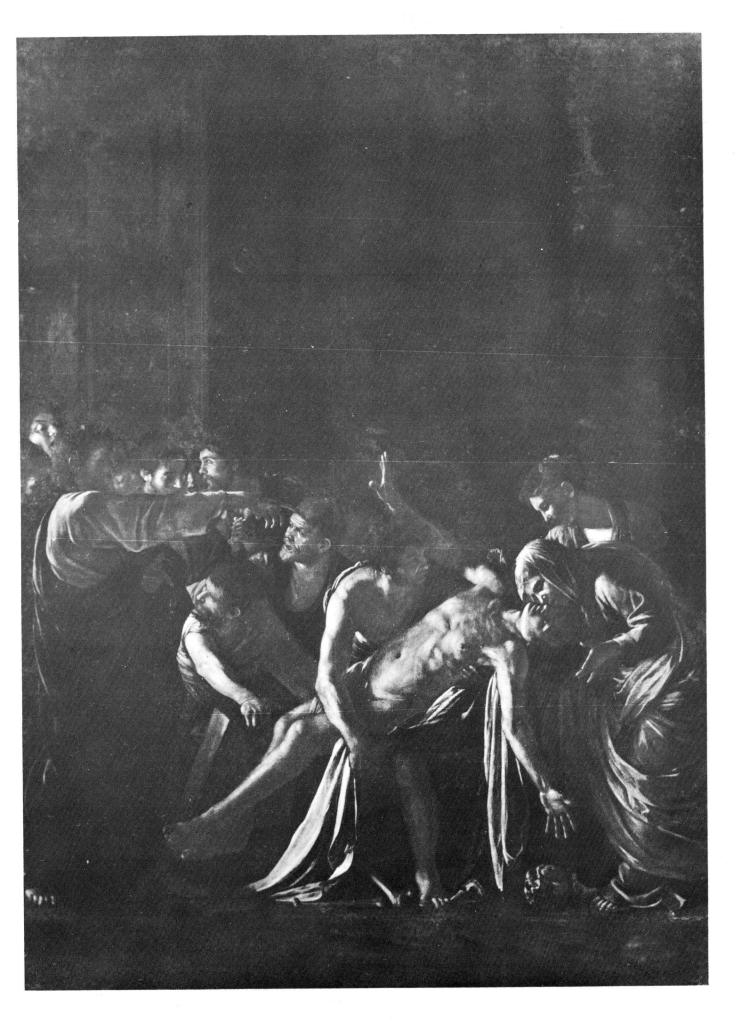

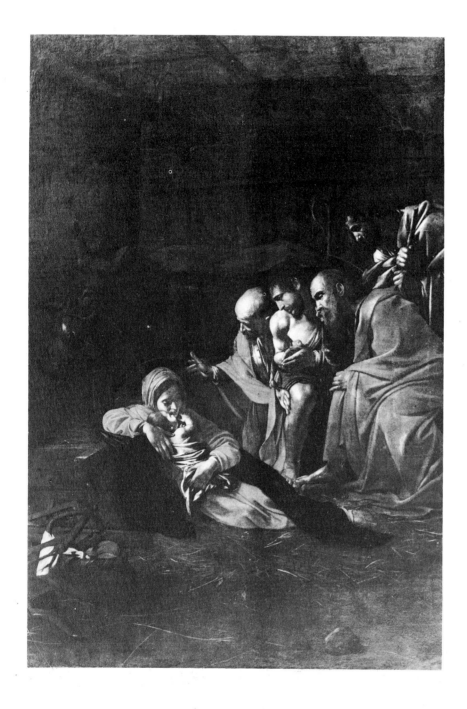

62 *The Adoration of the Shepherds*
MESSINA, Museo Nazionale. 1609. Canvas 314 × 211 cm.

Susinno, unlike Bellori, placed *The Adoration* after *The Raising of Lazarus* (Plate 61) in Carravaggio's
chronology, and since his account was in many respects closely dependent on Bellori's, he probably
had access in this instance to some additional local information which I am inclined to accept.
Susinno also recounted that the canvas was originally much taller, which would tally with our
conception of Caravaggio's Sicilian style as seen in the heightened space of *The Burial of St. Lucy*
(Plate 60) and *The Raising of Lazarus* (Plate 61), and that it had to be cut down to fit into its chapel.
The Adoration was restored in 1950–51 and is in good condition. Its mood of gentleness and rapt
concentration on the figure of the Christ Child is in marked contrast to *The Raising of Lazarus*,
but just as in that picture Caravaggio attained new heights in his evocation of turbulent dramatic
movement, so here he developed his conception of the simple faith of the poor one stage further.
The motif of the Madonna seated on the ground might be expected to have irritated some of the
Roman intellectuals of the late seventeenth century, and the work has, in fact, received some sharp
criticism from various sources for its vulgarity, but it became the favourite of subsequent Sicilian
commentators and, indeed, the image harks back to the fourteenth-century conception of the
Madonna of Humility, who was usually shown on, or very close to, the ground, sometimes seated
on a cushion. It is also remarkable how Caravaggio's feeling for the innocence of animals, apparent
in such earlier works as *The Rest on the Flight into Egypt* (Plate 13) and *The Conversion of Saul* (Plate
IV), once again contributes to the poignancy of the scene. *The Adoration* was commissioned
by the Senate of Messina for the Capuchin Church of Santa Maria degli Angeli.

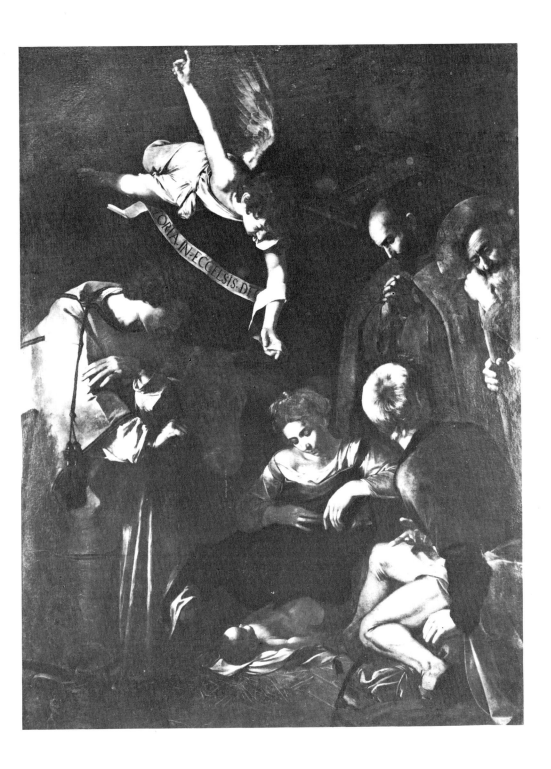

63 *The Nativity with St. Francis and St. Lawrence*
formerly PALERMO, Oratory of San Lorenzo (stolen on the night of 17/18 October 1969).
August/October 1609. Canvas 268 × 197 cm.

The Nativity is the only known work associated with Caravaggio's brief stay in Palermo and is much
more traditional than the Messina *Adoration* (Plate 62), not only because the Christ Child is alone
on the ground while the Madonna sits on a low seat (a more customary combination in earlier art)
but equally because of the more conventional poses and well-dressed appearances of the
surrounding figures. Such presentation may have reflected some stipulation from the patron, as,
perhaps, did the foreshortened angel, with his scroll inscribed 'Gloria in Eccelsis Deo', who recalls
the rather rhetorical mood of such earlier works as *The Martyrdom of St. Matthew* (Plate III), the
second version of *St. Matthew and the Angel* (Plate 26) and the *Madonna of Mercy* (Plate VI). The
handling of paint is also much more precise and finished-looking than in many of Caravaggio's late
pictures. Yet his newly acquired depth of humble feeling was not entirely lost, and the peasant-like
figure of St. Joseph on·the right, with his broad-brimmed hat and swarthy hands, seems to have
been a prototype for the many similar figures which people the compositions of popular realists
in the next two centuries—from Louis Le Nain to Giacomo Ceruti. The picture was, according to
Bellori, painted for the Oratory of the Compagnia di San Lorenzo, where it remained until stolen
in 1969.

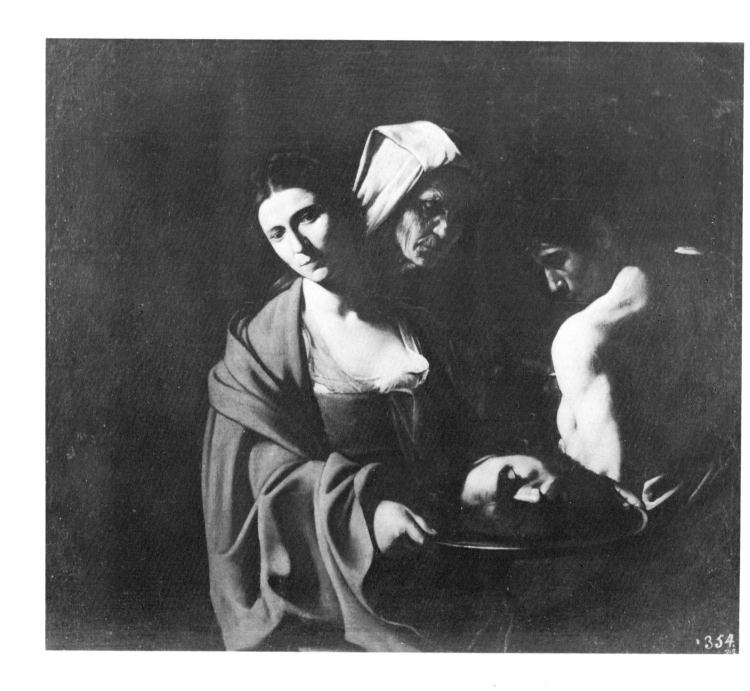

64 *Salome with the Head of John the Baptist*
MADRID, Palacio Real. 1609. Canvas 116 × 140 cm.

The Madrid *Salome* is quite possibly the picture which, according to Bellori, Caravaggio sent from
Naples to Alof de Wignacourt in Malta in order to regain favour with the Grand Master after his
flight from the island and subsequent expulsion from the Order. Yet it has been suggested that the
work must have remained in Naples for several years, since certain pictures by Caracciolo—
particularly his *Salome* in the Uffizi—seem indebted to it. Caravaggio's *Salome* was, in fact,
not listed in the inventory of the Escorial until 1686. Stylistically and emotionally close to the
Sicilian paintings, it could well have been painted in Messina and then taken back to Naples, even
if it was the work sent to Wignacourt. Indeed, there could have been little time in Naples itself to
paint and dispatch the picture before Caravaggio was wounded in October 1609. The broad and
confident handling of the drapery is reminiscent of a work such as the Messina *Adoration* (Plate 62),
as is the melancholy and pensive mood. Caravaggio here returned to one of his favourite
compositional formulae, an archway of figures, and used the monumental geometry to achieve an
effect of deep meditation and tragic acceptance. The reactions of the figures are less dramatic,
more restrained and classical, than those in the National Gallery version (Plate 53) or in the Valletta
Beheading of St. John the Baptist (Plate VIII). Indeed, the classically posed executioner, who is
reminiscent of figures by Annibale Carracci and who stares down at the serene, horizontally placed
head of the Baptist, helps to transform the subject from a provocative spectacle into a profound
meditation on death and human malevolence.

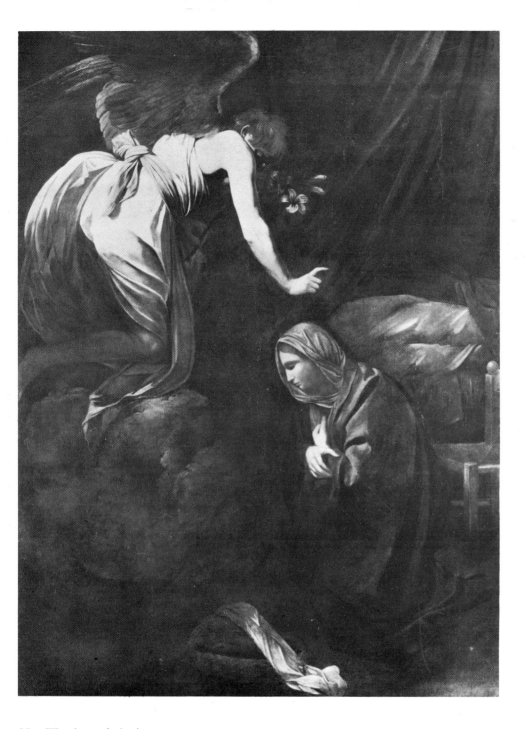

65 *The Annunciation*
NANCY, Musée des Beaux-Arts. 1609/10. Canvas 285 × 205 cm.

The Annunciation was given by Henry II, Duke of Lorraine, to the newly founded primatial church
in his capital city, Nancy, sometime between his accession to the throne in 1608 and 1616, the date
of a freely rendered engraving after the picture by Jacques Bellange. Nancy had become a bishopric
in 1603, and the picture was placed on the high altar of the new primatial church, begun in 1607,
possibly as early as 1609, when the as yet unfinished building was provisionally opened to the
public. Its loose and summary handling is unquestionably in Caravaggio's very late manner and is
certainly not pre-Sicilian. It seems probable that the work was acquired and perhaps even
commissioned (in which case a Neapolitan origin seems most likely) through the Mantuan Gonzaga
connection. Henry II was married to Margherita Gonzaga, whose brother, Cardinal Ferdinando,
was, according to Bellori, the person responsible for obtaining a papal pardon for Caravaggio on
the eve of the artist's death. The somewhat mannered figure of the angel seems at first rather
unusual for Caravaggio, but the contrast between his energetic pose and the Virgin's calm
receptivity is dramatically and psychologically very effective. It has been pointed out that the
illusionistic treatment of the angel, who seems to protrude partially outside the space of the picture,
parallels that of the head of Goliath in the Borghese *David* (Plate 67) and represents a more
advanced, 'Baroque' treatment of space than that in any of Caravaggio's previous works. It might
be noted that even a figure such as that of Saul in the earlier *Conversion of Saul* (Plate IV) is,
despite his outward-moving gesture, located behind the picture plane.

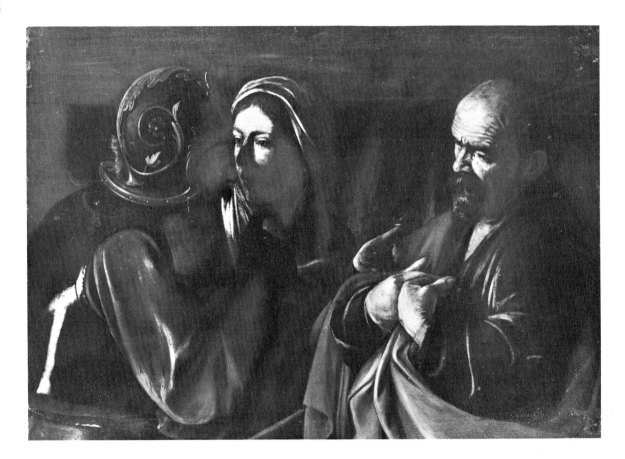

66 *The Denial of St. Peter*
SWITZERLAND, private collection. 1610? Canvas 94 × 125·6 cm.

The episode from *Mark* XIV:66–72 in which Peter, soon after Christ's arrest, is challenged by the serving maid of Caiaphas, the High Priest, to admit his identity as one of Christ's disciples, was not often depicted during the Counter Reformation. But its dramatic possibilities clearly appealed more to Caravaggio than the more popular but also more sentimental subject of the penitence of St. Peter. The flames leaping up in the background cast intense reflections on the saint and his accuser and thereby add an unusual dimension to Caravaggio's dramatic *chiaroscuro*. Only in *The Taking of Christ* (Plate 33) and the *Madonna of Mercy* (Plate VI) do we equally find exceptions to his normal practice of using only a light source external to the composition. Yet, ironically, it was just such a use of an internal light source—a candle, a fire or a lantern—which frequently characterized the work of Caravaggio's numerous disciples. *The Denial of St. Peter* is not to be confused with a multi-figure composition referred to by Bellori, which is still in the Sacristy of San Martino and which is clearly by another hand. The extremely fluid and energetic handling of the present picture could suggest a very late dating of 1610. The picture was formerly in the Caracciolo collection, Naples.

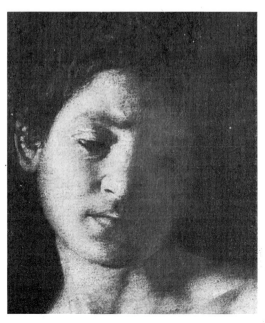

67a *David with the Head of Goliath*, detail

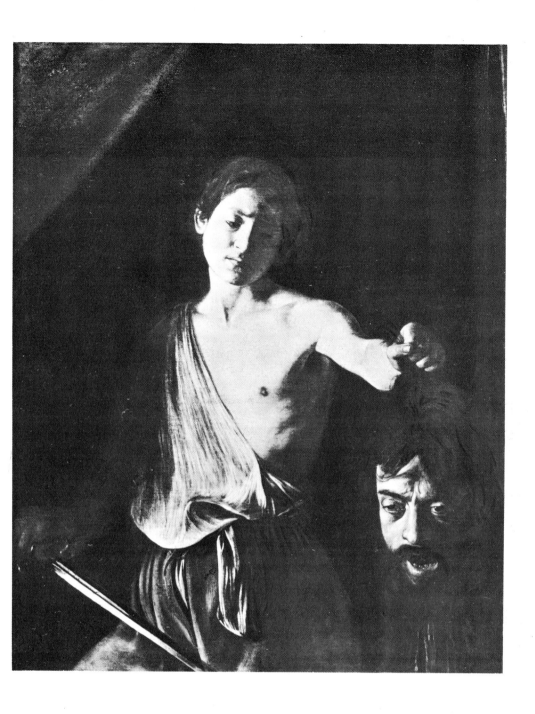

67 *David with the Head of Goliath*
ROME, Galleria Borghese. 1609/10? Canvas 125·5 × 99 cm.

This horrific yet beautiful picture was in the collection of Cardinal Scipione Borghese by 1613 and contains, according to Manilli, a self-portrait in the head of Goliath, which is plausible, and a portrait of 'il suo Caravaggino' (his 'boy'?) in the figure of David. The picture certainly seems to imply a great deal about human destructiveness, regret and despair and to achieve a pathos scarcely paralleled in Caravaggio's *œuvre*. The pallor of both David and Goliath against the extremely dark background, the facial expressions (Plate 67a) and the fragility of the tensed arm, with its hand crooked up to support the weighty trophy, are all important features. The tent-flap in the top left corner suggests that Caravaggio depicted not the split second after Goliath's decapitation, but the slightly later episode referred to in I *Samuel* XVII:57: 'When David came back after killing the Philistine, Abner took him and presented him to Saul with the Philistine's head still in his hand.' The pose, displaying the head direct to the viewer, seems to be connected with earlier depictions of the related themes of Judith and Holofernes—for instance one by Botticelli in the Rijksmuseum, Amsterdam—or of Salome with the head of the Baptist—such as the one by Cesare de Sesto in the National Gallery, London—rather than that of David and Goliath itself: David was usually shown walking or riding in triumph with the head in his hand. Although its Borghese provenance has led many historians, including Bellori, to place it at the end of the Roman period, the more recent tendency to see *David with the Head of Goliath* as a product of the second Neapolitan period is probably correct. As Benedict Nicolson observed, 'psychologically as well as stylistically, it does seem to belong to the very end'.

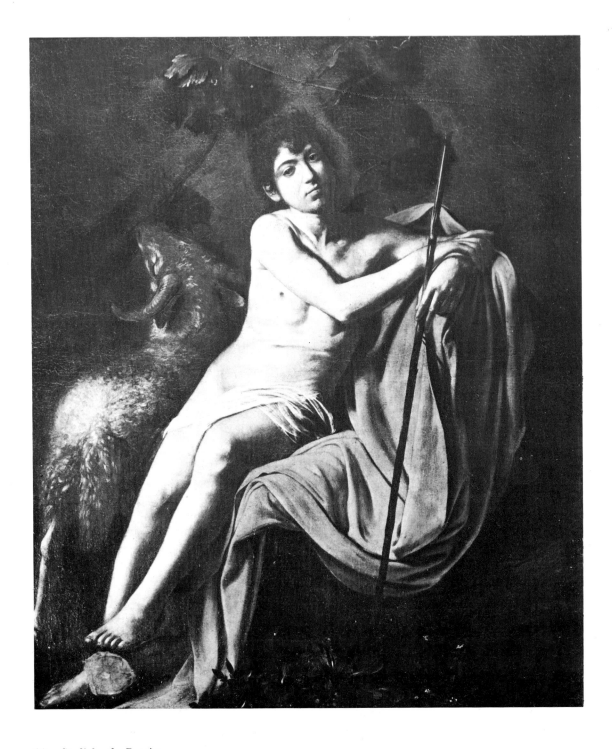

68 *St. John the Baptist*
ROME, Galleria Borghese. 1610? Canvas 152 × 124·5 cm.

In the Borghese collection by 1613, when it was referred to in a poem by S. Francucci, this work
was previously assumed to have been acquired directly from Caravaggio by Scipione Borghese,
sometime between his arrival in Rome in the summer of 1605 and Caravaggio's flight from the city
a year later. But Longhi has drawn attention to qualities of handling and colour which are close to
the Sicilian paintings, and in fact it seems more likely that this *St. John the Baptist* is a late work.
It may even be the picture of the subject which Caravaggio was meant to have had with him when
he put ashore at Port' Ercole immediately prior to his death. A letter dated 19 August 1610, just
after Caravaggio's death, from the Spanish Viceroy in Naples, the conde de Lemos, instructed the
'auditor' of the garrisons in Tuscany to recover a picture of *St. John the Baptist* by Caravaggio and send it
back to Naples as soon as possible. But it is quite conceivable that Scipione Borghese (not renowned as a
respecter of other people's property, as was shown by the unorthodox manner in which he acquired
many of d'Arpino's pictures in 1607 and Raphael's *Entombment* the following year) may have got
there first. Compared with the earlier Capitolina (Plate 23) and Kansas City (Plate 41) versions of
the subject, the Borhese picture is more richly colouristic—an expressive essay in reds, whites and
golden browns. It also represents a less idealized and more sensuous approach to the male nude,
as already prefigured in the stout-limbed figures of certain of Caravaggio's post-Roman works, such
as the Naples *Flagellation* (Plate 51) and the Valletta *Beheading of St. John the Baptist* (Plate VIII).